folktales *of the* Peak District

folktales of the
Peak District

MARK P. HENDERSON

AMBERLEY

First published 2011

Amberley Publishing
The Hill, Stroud
Gloucestershire, GL5 4EP

www.amberleybooks.com

Cover image: Howden Reservoir, Upper Derwent Valley.
Courtesy LightSwitchr | deviantart.com

British Library Cataloguing in Publication Data.
A catalogue record for this book is available from the British Library.

ISBN 978 1 4456 0107 6

Typesetting and Origination by Amberley Publishing.
Printed in Great Britain.

Contents

Acknowledgements

Thanks are due to Derbyshire County Libraries for helping me to find earlier published collections of Peak District folktales, particularly to the staff of the Local Studies Library in Matlock and the public libraries in Glossop and Buxton; and to the storytellers and other informants from whom I learned variants of several tales.

I'm grateful to Robert Drew, my Project Editor, and his colleagues at Amberley Publishing, for guidance and support during the final stage of preparation of this book. Robert's courtesy and efficiency proved exemplary.

Any author or collector is likely to become too close to his/her material to judge its quality objectively – or to spot typing errors – so independent editing of manuscripts is essential. I was fortunate to have the help of B's Editing Service (bmla2@cantab.net), which I strongly recommend. The sketch maps were prepared to a high professional standard by Mark Franklin Arts (http://www.markfranklinarts.co.uk), also recommended.

Finally, I wish to thank my audiences at storytelling gatherings for helping me to hone these versions of the folktales. Without their responses, I couldn't have judged whether my recitations were satisfactory.

MPH

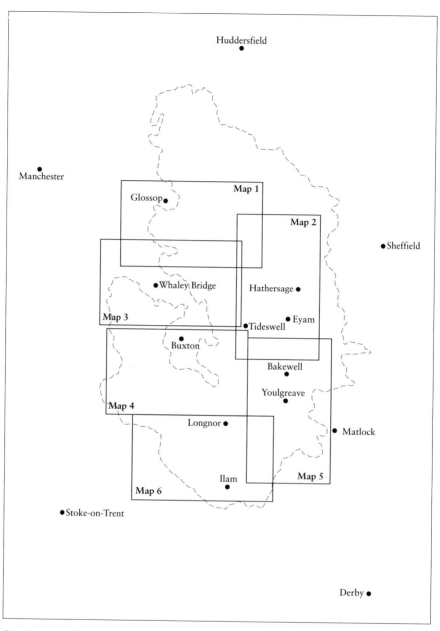

Sketch map showing the location of the Peak District between the major cities of Manchester and Sheffield. Major towns and villages are named. The dashed line indicates the border of the Peak District National Park. The rectangles, numbered 1–6, indicate the relative positions of the six larger-scale sketch maps distributed throughout this book, showing the geographical settings of the stories.

Introduction

Folktales are for telling aloud. A written anthology is like a butterfly collection: each specimen retains much of its beauty but lacks the vitality of flight. Unless they're recited to an audience, folktales don't fly. On the other hand, a collection of living butterflies can save species from extinction, and a folktale anthology can conserve almost-forgotten stories so they might fly again.

No one has ever balanced the conflicting requirements of written and oral narratives better than the pioneers of folktale collecting, Jacob and Wilhelm Grimm. In this respect, Richard Litchfield's *Strange Tales of the Peak* stands out among the many compilations of traditional Peak District stories. *Strange Tales of the Peak* is only a slim volume, but I've tried to follow its example: the sixty-two stories in the present book are told (in so far as written English can simulate spoken English) just as I recite them. Of course, my versions have no claim to authority; other storytellers can, and should, alter the tales to suit their listeners and their own personal tastes.

My sources have included local storytellers, professional and otherwise, and the aforementioned compilations of Peak District folktales. Among these compilations, Merrill's and Clarke's seem the most extensively researched. The collection most admired by folklorists is Sidney Addy's *Household Tales with Other Traditional Remains* (reprinted as *Folk Tales and Superstitions*). Addy recorded stories as he heard them, as nearly as he could. However, if you recite his versions to an audience, most of them fall flat. Like Merrill's, they are almost all short fragments, residues surviving in the tellers' memories after the flesh of narrative had decayed. They represent the "final stage" of the contraction process revealed by Allport and Postman in *The Psychology of Rumor*. Allport and Postman showed that when a story is passed orally from listener to listener, most details are lost and only a skeleton of the original remains – sometimes a distorted skeleton. It is as though the butterfly has been reduced to a chrysalis and awaits rebirth. Addy, a scholarly man, recognised this. In the introduction to *Household Tales* he wrote that "still the ancient stories, beautiful or lightly humorous *even in their decay*, linger with us ... some of the stories here printed illustrate the *poverty* of the present tradition".

If folklorists cavil at my attempts to release Addy's tales from their chrysalis forms, they might also cavil at my seeming use of Thomas Middleton's *Legends of Longdendale*, many of which were composed (more or less) by Middleton himself. However, I've used only those stories from Middleton's collection that are now recited in variant forms by storytellers; in other words, stories that have *become* folktales despite their dubious origins. After all, whatever the antiquity of a folktale, it began as someone's invention; the 'someone' might just as well be Middleton. (And there's a sense in which every folktale is only as old as its latest telling, because storytellers – at least in a literate culture – invariably recreate their material from memory.)

Stylistically, most published collections lie between the extremes represented by Addy and Middleton. I've used many of them, from Wood's important (albeit melodramatic) mid-nineteenth-century compilation to the various anthologies published during the past thirty years. I've also used relevant parts of Jennifer Westwood and Jacqueline Simpson's *The Lore of the Land*, the best of all compilations of English legends, at once scholarly and a delight to read. Most of the stories to be found in the following pages amalgamate two or more of the versions obtained from these sources, sometimes with my own elaborations, though all modern collectors build largely on the legacies of Addy and Wood.

The Grimm brothers categorised folktales into Wonder Tales (fairy tales), *Märchen*, and local legends, *Sagn*. Wonder Tales tend to be elaborate and involve magic, giants, monsters, faerie folk and imaginary settings. Local legends tend to be shorter and simpler and usually have recognisable historical and geographical roots. The distinction is valid but it isn't sharp. This anthology contains both categories, but there are "supernatural" features in many of the legends and contingent local details in the Wonder Tales. It also contains straightforwardly historical stories, such as 'The Murder of William Wood' and 'The Red Shoes', which have so caught the popular imagination as to become tales for telling, with various elaborations. Some of the stories are tragic, some comic; some are anecdotes that can be told in two or three minutes, others take fifteen or twenty minutes to recite. Several have religious themes; until very recently the church was at the centre of Peak District village life. Many (even the historical ones) have ghost-story elements, which can quickly attach themselves to real-life stories. Some feature the Devil, usually in his folklore guise, more stupid than menacing. What all these tales have in common is that they reflect aspects of Peak District life, character, scenery and history.

The Peak District is located in the north midlands of England. Much of it lies in North Derbyshire, but it also overlaps East Staffordshire and Cheshire, parts of Greater Manchester, and South Yorkshire. The boundaries of the Peak District National Park (the oldest national park in Britain; globally, it is second only to Yellowstone in terms of annual numbers of visitors) exclude major towns such as Buxton and Glossop, but those towns are otherwise considered part of

the Peak District, so I've included stories relating to them in this volume. The scenery is varied, the rugged sandstone moors of the Dark Peak contrasting with the gentler limestone hills and valleys of the White Peak. The tales in this collection reflect that contrast.

It's thanks to the Glossop storytelling group that I became interested in Peak District folktales. I was invited to join the group when I returned to the area in 2002. After a few meetings I discovered that no one told traditional stories with *local* connections. I knew a few such stories, having heard them during the 1950s and early 1960s when I was a teenager. Surely more existed? I soon located the recently published collections, and from there I progressed to older compilations housed in the local studies library in Matlock and in other libraries throughout the region. *Folktales of the Peak District* is by no means a comprehensive anthology, but I hope it's fairly representative. If anyone knows a Peak District folktale I haven't included and can tell me its provenance (e.g. the name of the storyteller who recited it, or the publication in which it's written), I'd be delighted if they'd send it to me via my website, www.markphenderson.com

The backgrounds to the stories, as I understand them, are summarised in the notes at the end of the book. These summaries are mostly short, but the interested reader can find more detail from the bibliography.

One notable omission from the anthology, the murders in the Winnats Pass, was the subject of my 2010 book from Amberley Publishing. In that book, I analysed the background to a single local legend in as much detail as I could find. *Murders in the Winnats Pass* was my attempt to be a respectable folklorist. *Folktales of the Peak District* is not; it's a collection of stories to be enjoyed – and, above all, to be told.

MPH

Summer 2011

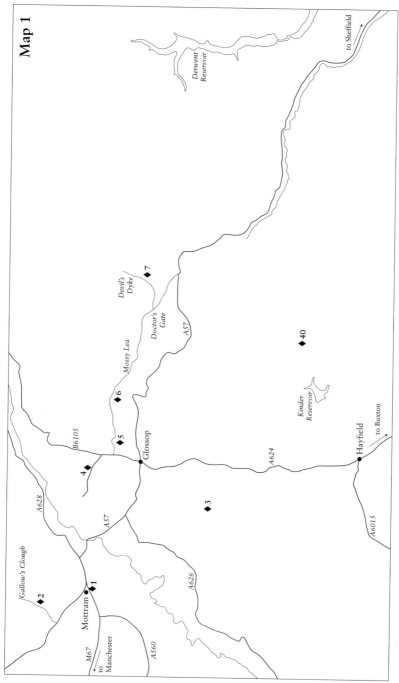

The first seven stories in this collection are located around Glossop, a town at the north-western tip of Derbyshire, sometimes dubbed "The Gateway to the Peak". The geographical settings of the stories are indicated as closely as possible. Story number 40 seems out of place, but it has three separate locations (see also sketch maps 4 and 6).

1

The Butcher and the Devil

Nicholas Booth was born and brought up in Castleton but he moved to Mottram and set up in trade as a butcher. He was liked and trusted, honest in his dealings, slow to speak but a quick thinker. He was never unkind, though he laughed to himself at the follies and foibles of his fellow men.

Nick's brothers and cousins were farmers in Castleton, and he bought cattle and sheep from them. He'd stay with them overnight and then drive the animals back to Mottram, taking the long road through Woodley and Godley and selling some of his stock along the way. When he got home he'd slaughter the rest of the animals and sell the fresh meat at fair prices to the good folk of Longdendale.

When he returned from a trip to Castleton, or when he closed his shop in Mottram for the evening, Nick went for a drink at the Bull's Head with other local tradesmen. They all had keen eyes for bargains and fair dealings, and they complained that George the landlord sold short measure. George denied it, but Nick and his friends Harry and Jack knew better, and so did the other tradesmen. So did George's wife.

"One o' these neets, George, th' Devil's goin' fer t' come fer thee an' drag thee down to 'Ell, way tha goes on robbin' folk!"

But George took no notice and went on selling short measure.

One day, when winter was setting in and the farmers were selling their stock for slaughter, Nick went to Castleton and bought a dozen sheep from his eldest brother, John.

John asked him, "Nick lad, would tha mind tekkin' yon owd tup? 'E's past 'is prime and 'e's a menace – canna trust 'im fer a minute. Ah doubt 'e'll be no use for nowt only mekkin' stock, but Ah'd be glad to see th' back on 'im."

The tup was a big black animal with long curling horns and evil yellow eyes. Nick studied the creature and thought, and then he agreed. After a good meal and a night's sleep at John's house, he set off home with thirteen sheep, the dozen he'd bought and the old black ram with the long curling horns and the evil yellow eyes.

The village butchers along Nick's route home were looking for good quality meat on the hoof, so he'd sold every sheep by the time he reached Mottram

– except for the old black ram with the long curling horns and the evil yellow eyes. None of the village butchers had wanted it. In any case, Nick hadn't wanted to sell it. He had other plans.

The weather had turned foul. It was dark night, and the wind was rising and sleet was falling by the time Nick reached Mottram, and he was cold and wet and weary. But he wasn't too weary for a little fun. He crept to the back of the Bull's Head, driving the ram in front of him, and shooed it into the corridor and down to the cellar. Then he went around the inn and into the taproom through the usual door.

Old George and his wife were there, and Stephen Fullalove the parish clerk, and Tinker the sexton, and Nick's friends Harry and Jack. They were huddled round the fire, drinking by the light of a single candle, while the wind howled around the inn and sleet hammered on the shutters.

"Ah've 'ad a reet good day," said Nick, "so Ah'll stand everybody a mug o' yer new ale, George."

He placed a bag of money on the table and George's eyes lit up.

"Get down to th' cellar, woman, an oppen yon cask o' new ale," he ordered.

Off went George's wife to the cellar, taking the candle, leaving the men in the taproom with only the fire to light them and the noise of the wind and sleet on the shutters to entertain them. A few moments later there came a loud scream, and the poor woman rushed back into the taproom with her eyes staring and her hair on end.

"Oh, George, George, didna Ah tell thee as th' Devil 'ud come fer thee one o' these neets? 'E's i' th' cellar now! Ah've left th' candle on a barrel – Ah darena go back down theere!"

George grumbled about stupid women and their stupid imaginations and stumped off to the cellar. He was back again in no time, yelling for the parish clerk.

"Stephen! Th' Devil's i' th' cellar aw reet! Go an fetch th' parson wi' th' Book and get 'im shifted!"

Stephen Fullalove the parish clerk was not prepared to disturb the parson without good reason, so he tiptoed down to the cellar to see for himself what might be seen. There among the barrels he beheld a black hairy beast with long curved horns and evil yellow eyes that glowed menacingly in the candlelight. He ran at top speed for the parson, and Tinker the sexton was close at his heels.

In the taproom, George's wife was shrieking at her husband, "Ow many times 'ave Ah towd thee about them short measure pots, an' what'll 'appen if tha keeps on usin' 'em?" George was quaking in his boots. Nick sat quietly against the wall beside the fire. He winked at Harry and Jack. They grinned.

The parish clerk and the sexton came back, pushing the parson in front of them, and everyone crept down to the cellar. There they saw the black hairy beast with the long curved horns and the evil glowing yellow eyes, trapped between

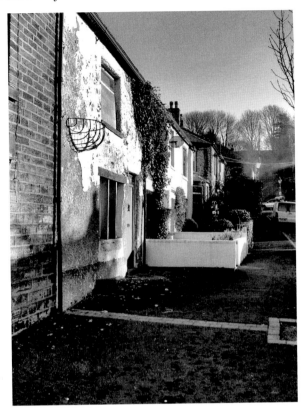

Cottages in present-day
Mottram. The former Bull's
Head stood further up the
lane, close to the church.

two barrels, glaring balefully at the man of the cloth. The parson trembled, but
he managed to open his Bible and started to read passages suitable for banishing
evil presences from the cellars of public houses.

Now whether it was the words of the Holy Book, or the unexpected company
of so many people, no one knows, but something made the old ram take fright.
He wriggled from between the barrels and charged down the passage, bleating at
the top of his voice, and knocked the parson down with his horns. The parson fell
against George the landlord, who fell against Tinker the sexton, who fell against
Stephen the parish clerk, who fell against the landlady, and the entire passage
became a sea of waving arms and legs and a din of screaming and swearing and
prayers for salvation and the noise of bleating ram and howling wind and driving
sleet. With one final unearthly bleat, the ram cleared the writhing bundle of
prone bodies and fled into the winter night. Nick followed him and caught him
in a nearby lane and took him home, laughing mightily.

His brother John was right; the old ram proved to be no good for anything
but stock. The meat was much too tough. But although Nick never told the
whole truth about that night, the story quickly spread. And old George never
again dared give short measure to a customer.

The Steward of Longdendale

During the middle ages, Longdendale was part of the earldom of Chester. So when Edward the Black Prince became Earl of Chester, he also became Lord of Longdendale. But the Black Prince was busy managing other estates and fighting the French, so he appointed a steward over Longdendale.

The Black Death had ruined the English economy because so few serfs were left alive to work the land, so the revenues from Longdendale were poor. Adam Kingsley was bailiff for a while, and he had an able deputy called Richard Birch. But few rents were collected, so Kingsley was dismissed. In his place, the Black Prince's advisers appointed a hard-hearted steward called John Scollehaw. Good Richard Birch remained his deputy.

Richard and the new steward were soon at odds. John Scollehaw enforced the full rigour of Forest Law on Longdendale, determined to extract every last farthing in rents and fines from the poor. Richard had been born and bred in the valley, so he understood how the people suffered and he tried to be lenient. That was enough to cause disagreement, but there was a personal matter as well. Richard had a pretty young wife called Joan, and they had a baby son. The steward's wife died in childbirth, leaving him with a baby son of his own, the only thing in the world he loved. On the child's upper arm was a birthmark in the shape of a hawk, which delighted the proud father. But John Scollehaw needed a mother for his infant heir, and his eyes turned to Richard's wife, Joan.

John said that unless his deputy gave up his wife, he'd dismiss him and leave him with neither land nor money. Richard refused, and John dismissed him.

With no income, Richard Birch was forced to poach deer to feed his wife and child. The steward knew he'd forced his former deputy to become an outlaw, and it gave him the excuse to be rid of him once and for all. He sent men to patrol near Richard's cottage, and before long the poor man was caught red-handed with a deer and sentenced to be hanged.

Joan wept and cried and pleaded with the steward, but in vain. Richard was hanged on the hill above Mottram, near the stream called Gallows Clough, where all Longdendale's criminals were executed. And at the scene of execution, Joan Birch cursed John Scollehaw.

She and her baby son were both near to starving. She sat and wept beside the gallows, all that day and far into the night, holding the child in her arms. It grew dark and cold, but still she sat, all alone save for the infant boy. She lacked both the will and the strength to move. Then, at midnight, when the world was black under a starless sky, she sensed movement close at hand.

"Who's there?" she whispered, terrified.

The answer was a low, eerie cackle. It was a witch, who was cutting off Richard's right hand to use in her magic potions. Joan screamed at her to stop, but the witch laughed.

"Didna tha curse th' steward? Does t' na want fer t' see thy curse take 'owd? Do as Ah bid thee an' tha'll 'ave thy revenge. What will tha do otherwise? 'Ow willst tha live?"

Joan was horrified, but she was too weak with hunger and grief to resist. They talked for an hour, then she followed the witch to her hut on the edge of the forest. No one went there, for the place was haunted. But from that time onward, Joan lived in the hut with the witch, half-mad with misery and hunger, and she too became a witch.

Grief befell John Scollehaw, too. When he awoke the following morning, his little son, his heir, the only thing in the world that he loved, had gone. In his place in the crib lay a cold grey stone. Servants were sent to search, and Scollehaw grew frantic, but the baby couldn't be found. People said Joan's curse had turned steward's child to stone.

The steward was beside himself with rage and sorrow. He grew silent and dangerous. As the weeks and months and years passed, he imposed Forest Law more rigorously than ever, and extracted rents and fines from the beleaguered folk of Longdendale with implacable cruelty. Whenever he found boys or young men around the age his son would have been, he made them bare their upper arms to show whether they had a birthmark in the shape of a hawk. He couldn't accept that his beloved child was gone. But he never found the birthmark.

Word spread that Joan's son had grown into a villain of the worst kind, not an outlaw like Richard Birch who stole deer to feed his family, but a pitiless robber and murderer, feared by all. The old witch was dead, and Joan had taken her place, and the child of a witch would always grow up outside the law. But the lad had learned the witch's cunning, and although the steward's men searched everywhere, they couldn't find him. The forest held too many hiding places for one who'd grown up there; in those days, a squirrel could travel from Mottram to Woodhead without touching the ground. So the robberies and the killings continued, and all Longdendale was afraid.

But a rogue can't remain at large forever, no matter how clever he is, and at length he was caught and brought before the steward. Even an official less cruel and exacting than John Scollehaw would have hanged such a villain. So the young man was dragged to the place beside Gallows Clough above Mottram, and the rope was put around his neck.

Then Joan appeared. She was old before her time, she was filthy and ragged, and there was a light of madness in her eyes. John Scollehaw laughed when he saw her; men said that it was the first time the steward had laughed since his baby son had vanished from his crib, replaced by a lifeless stone.

The moors above Mottram, showing the valley of Gallows Clough.

He cried, "You must love this place, witch! You wept when you saw your husband hanged here; now your son is to die in the same fashion. So weep again!"

A crowd had assembled to see the robber hanged, and they shuddered when they heard the steward's words. But they shuddered even more, and cried out with fear and pity, when Joan also laughed.

"Ah wept aw me tears when tha murdered my Richard," she shouted. "Now Ah've nowt left in me but laughter."

And she laughed and kept on laughing while the young man was hanged by the neck and died for his crimes, until at last Scollehaw could stand the sound no longer and yelled, "Be silent and get you gone, or it's the cucking stool for you!"

"Ah'll be gone, Steward, an' reet gladly. But does tha wonder why Ah laugh? Tha thinks tha's 'anged me son. Tha 'asna. Me little son starved to death while 'e were a babby, an' it were thy fault. So yon lad swingin' on th' gallows isna my son. 'E's thine!"

John Scollehaw was struck with horror. He ordered the body to be brought down from the gallows, and he ripped the sleeve from the shirt; and there, on the upper arm, was the birthmark in the shape of a hawk. He was tongue-tied, frozen to the spot. He couldn't even order his men to arrest Joan. She fled over the hill, still laughing, and disappeared.

The steward's men followed her to the witch's hut on the edge of the forest, taking two priests with them, but they found place deserted. Joan Birch was never seen again in this world.

As for John Scollehaw the steward, he died of shock and grief within the week.

3

Married under the Ash Tree

Many years ago, when the centre of Glossopdale was forest and swamp, everyone lived in the villages that clung to the valley's sides: Glossop, Whitfield, Chunal, Simmondley, Charlesworth, Chisworth, Dinting. People usually married their neighbours, as they did in most rural communities, and so it was with Harry and Joanne. Harry was a farmer up on Whitely Nab, and Joanne lived in Chunal. They'd known each other most of their lives, and in time they'd fallen in love. They planned to marry in Charlesworth church. They spoke to the priest, and the wedding was arranged for a morning early in June.

On the morning of the wedding, Harry went to collect Joanne soon after dawn, while the larks were singing and the sun was climbing over the moors, and the couple set off hand in hand across the fields to Charlesworth. But they hadn't gone very far when the weather began to deteriorate, and before long they were walking through a torrential downpour. Harry thought it would just be a brief shower, but it didn't stop; instead, it got worse – much worse. The sky grew as black as night, and there was thunder and lightning, and the rain lashed down so heavily they could hardly see the path in front of them. Before long the way grew so dangerous that they had to stop and take shelter under the spreading branches of a great ash tree. The summer leaves kept the worst of the weather off them, but standing there waiting for the storm to stop, they were getting no nearer to Charlesworth. Eventually they realised that they'd no longer be able to reach the church for the time they'd arranged with the priest. Of course they were heartbroken; Joanne was in tears. This should have been a happy day for them, but it was turning out to be a very sad one as well as a very wet one.

Then, out of the pouring rain, there appeared a wandering Irish priest. He stopped for shelter under the very same ash tree as the young couple. He greeted them, as priests do, and they answered him politely; but he realised that something was badly wrong.

He asked, "Now, why are you two fine young people out here in this storm and looking so sad? Is there something you'll be wanting to tell me?"

An ash tree in Glossopdale.

Harry said, "We were goin' to th' church i' Charlesworth fer t' get married, but th' storm's 'indered us, and it's too late now. Th' priest winna wait no longer, and even if th' rain stops reet now, we'll ne'er get theere i' time."

"Well, well," exclaimed the priest, "is that all? If only all of life's problems could be solved as easily as yours!"

Joanne looked up at him and asked, "What do'st mean, Father? If we conna get to th' church we conna be married, and 'ow long will it tek afore th' priest i' Charlesworth 'll gi'e us another date?"

"Now, my dear girl, why would you be needing to get to the church in Charlesworth?" asked the Irishman. "I'm a priest; I can marry you here and now!"

And with that, he took his prayer book from under his cassock, and he married Harry and Joanne under the branches of the ash tree while the storm raged around them. At the end of the short ceremony, he said to them:

> *Under a tree in stormy weather*
> *I married this man and maid together.*
> *Let Him alone who rules the thunder*
> *Put this man and maid asunder.*

And so Harry and Joanne became man and wife, and they lived long and happily. For many years afterwards, you would see them walking of an evening along the path to the great ash tree, remembering their wedding day.

Bill Shepherd and the Ghost

Bill Shepherd was a quiet man who enjoyed a drink. Every evening, summer or winter, rain or shine, he walked from his cottage in Old Glossop up the fields, past the wood, across the road at Allman's Heath and through the cemetery to his favourite pub. The inn sign over the door said 'Arundel Arms', but everyone called the pub The Deadman's. It stood just beside the cemetery gates.

Warm and comfortable in the smoke room of The Deadman's, Bill would drink three or four pints, exchange gossip with the landlord and the regulars, and play a couple of games of dominoes or darts. Some evenings he'd sit by himself, quietly enjoying his beer. At closing time he'd put on his hat and coat and walk back home through the cemetery, across the road at Allman's Heath, past the wood and down the fields to the village.

Everyone liked Bill. There was only one odd thing about him, though it amused most people: while he was enjoying his last drink of the evening, Bill would thump the table with his fist and announce, "Ah'm none feart o' nowt!"

The former Arundel Arms ("The Deadman's"), now a cattery.

Then he'd finish his drink, put on his coat and hat, say "Goodneet", and walk home.

The years passed, and Bill walked more slowly and used a stick, but he still went up to The Deadman's nearly every night. He stopped thumping the table; instead, he'd bang his walking stick on the floor while he was drinking his last pint, announcing, "Ah'm none feart o' nowt!" Then he'd finish the drink, button up his coat, put on his flat cap and limp off into the night, through the cemetery, across the road at Allman's Heath, past the wood, down the fields and back home to bed.

One evening, three of the younger locals decided to test Bill's nightly boast. A quarter of an hour before closing time they sneaked out of the smoke room and scuttled off to the cemetery. They knew which path Bill would take on his way home, and they found their way to it, though it was pitch dark, and hid behind gravestones beside the path. One of them wrapped himself from head to foot in a white sheet. Then they waited.

About five minutes after closing time, they heard the crunch, crunch, crunch of boots and walking stick approaching them through the darkness along the gravel path.

They timed their surprise to perfection. Bill was about five or six yards away when the young man in the white sheet shuffled out on to the path in front of him, wailing, "Ah conna find me grave! Ah conna find me grave!"

Bill stopped dead in his tracks. Then he lifted his walking stick, brought it down – smack! – across the apparition's neck, and shouted, "Tha's no business out o' thy bloody grave at this time o' neet!"

<div align="center">5</div>

The Grey Lady of Glossop Rectory

Glossop's new rectory was built in 1850, a few yards further from the market square than the old vicarage. The old building had fronted on to Church Street; vicarages had stood there since the 1500s. The new rectory was a much grander building, aloof from the public road.

John Dickenson Knowles, the first rural dean of Glossop, moved into it in 1865 with his wife Mary Louisa and their ten children. Mr Knowles kept open house for his parishioners; they could call upon him for counselling at any time. But few days after they moved in, Mrs Knowles walked into the hall and saw a strange lady in an old-fashioned grey dress climbing the stairs.

"Open house is one thing," she thought, "but this is invasion of privacy. Who is that woman?"

The mid-nineteenth-century rectory of Glossop parish.

So Mrs Knowles followed the lady in grey upstairs. She watched her walk into one of the bedrooms and went in after her. The room was empty.

Shortly afterwards, Mr Knowles saw a woman on the croquet lawn to the south of the rectory.

"Why is Mary Louisa wearing that old grey dress?" he wondered, and went to join her. The woman walked away into the shrubbery and vanished.

A few days later, Mr Knowles's eldest daughter told him a strange woman in a grey dress was sitting in the dining room. He went to investigate, but no one was there.

The rural dean and his wife discussed these events and agreed they had all seen the same woman: she wore an antique grey dress.

A few weeks later, the cook awoke in the night to find someone leaning over her bed.

"Ah'm givin' me notice this minute, Reverend!" she wept. "Ah'm that upset!"

She refused to go back into her bedroom to pack her belongings, even in daylight.

Her successor, who was very young, suffered an even bigger fright. She was preparing lunch when a man garbed in black walked through the kitchen, reached the end wall, and disappeared. The poor girl ran out of the house in terror. However, she was able to give the rector a detailed description of the man's black attire. Mr Knowles recognised it as the apparel of a post-Reformation priest.

He made some historical inquiries and was led to the story of Ralph Bower, who had been vicar of Glossop from 1551 to 1574. The Revd Mr Bower was adaptable; he'd remained vicar during the reigns of Protestant Edward VI, Catholic Mary I and Protestant Elizabeth. His marriage had to be adaptable, too. He took a wife during the Protestant reign of Edward. When Mary came to the throne, no priest could be married, so Mrs Bower was set aside – only to be reinstated as the vicar's wife when Elizabeth became queen. Whether she understood the reasons or not, Mrs Bower resented the treatment and she and her husband quarrelled continually. In the end, during a particularly bad quarrel, she pushed Mr Bower down the well – or so it was rumoured. Mr Bower might have learned to swim with the tide, but he couldn't swim in the well.

Mr and Mrs Knowles supposed that the murderous Mrs Bower was unable to rest in her grave and had taken it upon herself to inspect the new rectory, and Mr Bower appeared from time to time to check on the welfare of his former parish. The spectral disturbances continued, but the Knowles family grew accustomed to them and they lived in the new rectory for twenty-three years – coincidentally, the same duration as Ralph Bower's tenure of the parish 300 years earlier.

All their successors have reported strange happenings and occasional sightings of the Grey Lady of Glossop Rectory. But whatever quarrels Mr and Mrs Bower might have had, they have never harmed any living occupant of the rectory – just scared them from time to time.

6

The Wizard of Mossy Lea

When the doctor first appeared in the valley, some of the older residents said he'd been born there, that his mother was a madwoman who'd known strange secrets, and his father was a nobleman or maybe a bishop. He'd left the valley many years earlier while he was still a boy. Now he'd returned a wealthy man, tall and broad-shouldered, with a velvet cap and cloak, and a long grey beard, and eyes that burned with the light of knowledge, and a pack mule laden with books and curious instruments. He was learned in medicine and philosophy, and perhaps in darker arts as well. Rumours began to spread: the doctor had sold his soul to the Devil to gain unearthly powers. A local verse tells us:

> *Well versed in mystic lore was he –*
> *A conjuror of high degree;*
> *He read the stars that deck the sky*
> *And told their rede of mystery.*

He went to live in a large house in Mossy Lea, beside the drove road that linked the manor of Glossop to Sheffield. People were wary of him, though they turned to him for help in times of need. Such was his reputation that doctors and alchemists and magicians came from far and wide to seek his guidance or to study with him.

Two of his young pupils, whose names were Ralph and Walter, had inquiring minds. The doctor encouraged them, but he knew it was dangerous to explore the world's dark places with too much enthusiasm, too little knowledge and too little care. That was something Ralph and Walter must learn.

After supper one night, he summoned them to his private room. They'd never entered that chamber before, and they were awed. The light of three black candles flickered over globes and planispheres, on strange apparatus and heavy leather tomes, and cast deep shadows on the doctor's wrinkled, bearded face. He sat beside an oak table laden with scrolls covered with mysterious writings and diagrams drawn with his own quill, and a human skull secured the scrolls against the draught from the unglazed window. The two youths trembled. Then the doctor spoke.

"You will leave here at sunrise tomorrow and go to a certain place in Staffordshire, taking this letter to my friend and brother in the magic arts. When he's read the letter he will give you a book of which I have great need, and you will bring that book back to me, guarding it jealously along the way. But by the shades of night, you must never open the pages of that book. At your peril, you must not unlock its clasp or loose its covers, either when you receive it, or while you're bearing it, or after you've brought it here."

And with those words he dismissed them.

The young men went to bed full of excitement, and they set out at dawn to begin the long walk into Staffordshire, carrying the doctor's letter with them. They took provisions, and money to pay for food and lodgings along the way, and they were sensible enough and strong enough to avoid robbers and swindlers. They reached their destination without mishap, handed over the letter and received the magic book – with renewed warnings against opening it – and then they set out on their return journey.

When they reached the high country near the village of Flash, where three counties meet, they sat down to rest, and curiosity overcame them.

Ralph said, "It seems to me we're carrying a book full of power, and our master isn't willing to share that power."

Walter agreed. "Those are my thoughts, too. We've paid a high fee to be tutored in magic, so we have the right to power. But the doctor wants to keep all the power for himself. There's knowledge in these pages, and it will make us strong and wise."

So they decided, contrary to their orders, to look inside the book. They placed the thick heavy tome on their knees, and they undid the silver clasp that locked

Mossy Lea in springtime.

it. But as soon as they opened the pages, the earth beneath them began to shake, and a great wind began to blow across the high moors, and below them they could see trees tossing and thatch flying and branches breaking and falling.

Walter cried, "We're undone! We've let loose an evil spirit and we can't control it!"

Ralph struggled to close the book and refasten the clasp, and Walter tried to help him, but the book wouldn't close. The earth shook more and more, and the sky grew dark, and the wind howled louder, and the two youths were terrified.

But the doctor had known what would happen when Walter and Ralph were carrying the book, and travelling by means known only to himself, he appeared beside them. He took hold of the book and uttered an incantation. Immediately the wind fell, and the sky cleared, and the earth ceased to shake; and then the doctor closed the book and fastened the clasp.

He had no need to chastise his pupils; instead, he led them home without a word, and never again did they disobey him. From that day onwards, they progressed in learning by following his commands, for they knew that if he gave them an order, he gave it with good reason.

The Doctor and the Devil

After the agreed term of years had elapsed, the Devil rode to the doctor's house in Mossy Lea to claim his soul. The doctor was expecting him. So when the thundering hooves stopped outside his door, and the sky darkened, and the candles went out, and the fire faded, he knew what was happening.

The Devil flung open the door and growled, "The time has come!"

The doctor said, "What a very fine horse you have! I believe it could almost outpace my bay mare!"

Now the Devil was very proud of his jet black horse, which ran like a storm-cloud before a gale.

"Almost? My horse can outrun any horse in the mortal world!"

The doctor smiled. "That sounds like a challenge. So I offer a wager. We'll start from here and we'll race upstream to the headwaters of the brook, where the clough runs south. Whoever reaches the bank of the clough first is the winner."

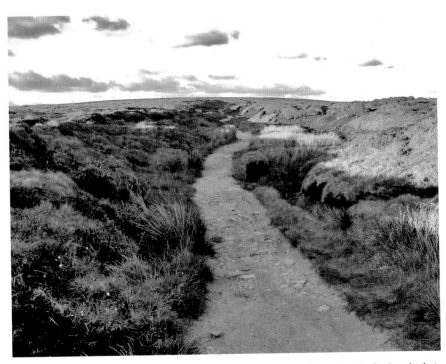

The Devil's Dyke. The path of the Pennine Way now passes through this ditch, which is believed to have been cut during medieval times as a boundary marker.

The Devil laughed. It wasn't a pleasant sound. "Ha! And what's to be my prize when I win? Your soul is already mine. What else have you to offer?"

The doctor said, "I'll give you all my books, all my implements of magic, all my store of knowledge. You'd profit from my life's learning. Of course, if I were to win, I'd claim my soul back from you as my prize."

The Devil chewed his lips, but he couldn't resist the challenge. In any case he didn't doubt that his horse would win the race. So he accepted. He mounted his black horse again, and the doctor mounted his bay mare, and they galloped eastwards neck and neck, up the drove road and then on to the rugged moor.

The bay mare was fast, and the doctor cast spells to hasten her, but when the bank of the south-bound clough came into view the Devil was ahead by a length and he was laughing triumphantly. There was hardly a furlong to go, and he knew there was no way the doctor could catch him now.

But the wily doctor was not so easily beaten. Leaning forward in his saddle, he took hold of the Devil's tail and pulled him back. At the same time he repeated his incantation and dug his heels into the mare's flanks. In a moment the horses were level again; and then the doctor tweaked the Devil's tail one more time and rode into the lead. And so he rescued his soul.

So enraged was the Devil when his adversary reached the bank of the clough ahead of him that he let out a bellow of fury and gouged a great ditch into the moor with his claw. You can see that ditch today; on the map, it's marked as the Devil's Dyke. As for the clough that marked the winning post of the race, it's called Crooked Clough; and the drove road that climbs up to the moor, where the doctor raced against the Devil, is called Doctor's Gate.

<div style="text-align:center">

8

Tip's Ghost

</div>

On the western side of Howden Reservoir in the Upper Derwent Valley there's a stone memorial to Tip, the faithful collie bitch who belonged to a hill farmer called Joe Tagg. Joe had tended sheep on the high moors for the whole of his life, and Tip was the latest of his long line of sheepdogs. She'd grown old, like her master, though both master and dog were still fit and strong and equal to the work they did. But one winter day, snow fell heavily and gathered in deep drifts in a strong east wind. The sky was dark with the threat of further falls, and Joe was concerned for his sheep. He was well into his eighties, but out he went over Howden Moor with Tip at his heels to bring his flock to safety, just as he'd always done. He'd been on the hills in heavy snow for more winters than he cared to remember. But that day, 12 December 1953, he never returned.

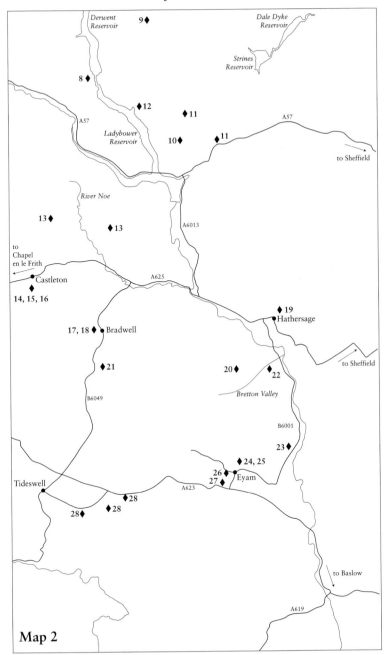

Stories 8–28. The settings of these stories range from the Upper Derwent Valley in the Dark Peak to the lovely villages of Tideswell and Eyam in the White Peak. The apparent concentration of stories around Eyam can be attributed to the influence of the nineteenth-century collector William Wood, a resident of that village. The two locations indicated for story 11 ("Cutthroat Bridge") are the Devil's Coach Horses (upper left) and Cutthroat Bridge itself (lower right). The three positions indicated for story 28 ("The Red Shoes") are, reading from left to right, Litton Village, the Peter Stone, and the Three Stags Head inn at Wardlow Mires.

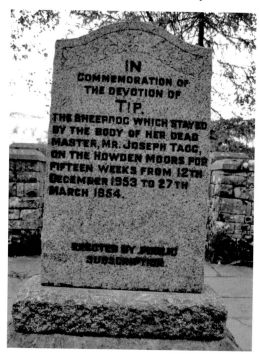

Tip's memorial, beside the Derwent Dam.

He lived alone, but his family lived close by and they soon noticed his absence and alerted the police. Rescue parties were called out and many volunteers joined in the search for Joe and Tip. All the moors were covered with deep snow, driven into great drifts by a bitter east wind, and although they followed every route that master and dog might have taken, the searchers returned day after day empty-handed. Joe was lost, and certainly dead, and his old dog with him.

Not until fifteen weeks later, when the worst of the snow had thawed, was Joe at last found. A local man called Samuel Bingham was walking up to Howden Moor on the afternoon of 27 March 1954 when he noticed something moving feebly beside the path. It was Tip. Her coat was dirty and ragged, she was thin to emaciation and she was exhausted, but she'd survived. Joe's body was beside her. For fifteen weeks, all throughout that bitter winter of wind and snow, the old collie had kept vigil over her dead master.

Joe's niece, Mrs Thorp, took Tip home with her and nursed her back to health. She cared for her and gave her a comfortable home for the rest of her life, but that wasn't long; the old dog died a year later. Soon afterwards, on 30 April 1955, a stone memorial was erected beside Howden Reservoir by public subscription, and there it stands today.

So much is history. But the December 1964 issue of *Derbyshire Life* recounted the following (anonymous) story. If it's true, it might be no more than coincidence. But it might not.

One winter's night, a traveller in the Peak District went into a public house near Bamford. He found the bar deserted, except for a large black and white collie lying beside the fire. He called to the dog but it didn't respond. Shortly afterwards, a farmer entered the bar and the landlord came out of his living room to attend to his two customers. The three men talked and drank together for a while, and then the visitor glanced towards the fire and noticed the dog had gone.

"That's odd," he said. "I didn't see the dog go out. It isn't very friendly, is it?"

The farmer and the landlord exchanged glances. The landlord asked, "What dog?"

"The black and white collie that was lying beside the fire."

The farmer immediately swallowed his beer, put on his coat and left the bar, with no explanation and no farewell.

The visitor was surprised.

"He seemed in a hurry all of a sudden."

"Aye, 'e'll 'ave gone fer t' fetch 'is sheep down off th''ill to th' lower pastures," explained the landlord. "Yon dog al'ays appears when there's bound fer t' be a bad snowfall."

9

The Lost Lad

Abraham Lowe helped his widowed mother to run a small farm on the edge of Derwent village. He looked after the sheep, grazing them on the moors during the summer and bringing them down to the lower pastures when winter closed in, as our hill farmers still do today. When Abraham was thirteen, the autumn was wet and cold, and winter began in late October. Soon, Derwent was cut off by ice and snow. The poor widow looked out over the white landscape and said, "Th' sheep 'll 'ave to come down off o' th''ill, lad. They conna manage i' this."

So Abraham and his sheepdog, Bob, climbed the side of the valley to Derwent Edge and on to the moors to round up the sheep and bring them down to the farm.

The moors around the head of the Derwent were covered in deep snow, but the air was cold and clear when Abraham and Bob set out. They found some of the sheep on the high moors and gathered them into a tight flock. But so intent was Abraham on rounding up the remainder of the animals that he didn't notice the weather worsening again. Before he could start to move the flock down into the valley, it began to snow, and thick cloud gathered all around him. He knew all the landmarks, even when they were covered with snow, but the cloud grew so dense he couldn't see them.

The Lost Lad. Beyond the cairn stretches Howden Moor, where Joe Tagg died in 1953–4.

Trusting Bob to find the way, he sent the dog ahead with the sheep and followed, struggling through the ever-deepening snow and repeatedly falling into peat groughs and the frozen springs. Hours passed and he grew tired, cold and hungry. As night fell, he realised he was hopelessly lost. He crawled under a rock for shelter, with Bob beside him, and hoped the weather would clear again so he could see where he was. But it didn't.

Exhausted and numb with cold, Abraham realised that he would soon fall asleep. Would anyone find him? With his remaining strength, he dug up a stone and scratched the words "Lost lad" on the rock under which he and his dog had taken shelter. Then he slept. He never awoke; he died of exposure during the night. Bob stayed beside him, refusing to leave his young master, and he too died.

The poor widow watched the hill to see her son returning with his dog and the sheep, but she watched in vain. When the weather turned bad again she feared the worst. The next day, she and six of her neighbours set out to search for the boy, but they couldn't find him. The blizzard had wiped out all his footsteps and had covered the rock under which his body lay.

Not until spring came and the snow melted were Abraham and his dog found by another shepherd walking on Back Tor. He spotted the words "Lost Lad" scratched on the rock and went to investigate. He built a small cairn to mark the

place, and every shepherd who passed by the place over the next hundred years added another stone, till the cairn became huge. It's marked on the Ordnance Survey map. Walkers now add stones as they pass, as they do to all cairns, but not all of them know the story.

<div style="text-align:center">

10

The Parson's Sheep

</div>

A poor cottager who lived in a remote part of Derwent Woodlands struggled to feed his family. He was determined to provide a big meal for them every Christmas time, and to make sure he did so, he would steal a sheep. Everyone knew about his thefts, but by the time they came to question him, the sheep had been eaten and the remains were buried.

One year he stole a sheep that belonged to the parson. The parson was angry and prayed for help in catching the thief, and the very next day it seemed his prayers had been answered. As he passed the thief's cottage, the children were playing in the yard, and one of the little boys was singing:

> *My Dad stole th' parson's sheep*
> *So a reet good Christmas we will keep;*
> *We'll 'ave puddin' an' we'll 'ave meat*
> *An' 'e conna do nowt about it.*

"What a fine voice you have, my boy," said the parson, rubbing his hands with glee. "Come to church next Sunday and sing that song to the congregation. Then everyone in the parish will know what a good singer you are."

"A conna do that, Mester," said the boy. "Ah've nowt fer t' wear only these 'ere rags."

"My dear boy, that doesn't matter!" cried the parson. "I'll give you fine new clothes to wear, and boots too, so everyone will see you're a handsome lad as well as a singer!"

So the boy went to church that Sunday, and the parson took him into the vestry and dressed him in good new clothes and boots. At the end of the service, the parson climbed back into the pulpit and announced, "My friends, we have a special pleasure before us today: a new singer, a charming young boy whose voice – and words – will delight you all."

Then he brought the boy forward from the back of the church, stood him in front of the altar facing the congregation, and encouraged him to sing. And the little boy sang:

Out in th' field th' other day
Ah seed th' owd parson kiss a maid;
'E give me a shillin' not to tell,
An' these new clothes suit me reet well.

11

Cutthroat Bridge

A little to the north of the modern A57, near Ladybower Reservoir, the medieval drove road crosses Highshaw Clough. There's a bridge at the crossing called Cutthroat Bridge. This is how it got its name.

A farmer from over the hill had come down to Highshaw Clough to dip his sheep. Just as he was dipping the last of them, another farmer appeared with a flock of his own.

The newcomer said, "Will you dip my sheep, too? You're good at it!"

The farmer hesitated. He didn't see why he should work for someone who was too lazy to do the job himself. In any case, he didn't know the area well and he

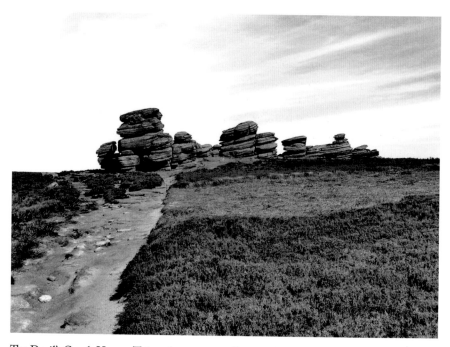

The Devil's Coach Horses. This rock outcrop on Derwent Edge is alternatively known as The Wheel Stones, and is so denoted on most Ordnance Survey maps.

wanted to get his sheep and himself home before nightfall. Also, there was a faint smell of sulphur about the newcomer and his sheep, which were all branded "D".

But the newcomer smiled and said, "I'll be glad to pay you for your trouble," and he took a bag of gold from under his long black cloak and handed it to the farmer.

The farmer still wasn't sure, but he'd never seen so much gold in his life. He thought about the use he could make of it. He nodded.

"Aw reet, then, Ah'll do it."

So he took the gold and started to dip the sheep. But as soon as he'd secured his bargain, the Devil cast his cloak aside and revealed himself in his true form. Then, with a hideous laugh, he transformed his flock into a coach and horses and rode away up the side of the hill bordering the Derwent Valley until he reached the skyline. There, the Devil vanished and the coach and horses were turned into a group of rocks. People today call that outcrop The Devil's Coach Horses.

So distressed was the farmer by what he'd witnessed that he cut his throat, right there on the bridge.

No gold was found in his pockets, or anywhere nearby.

12

The Sermon for the Dead

When Robert Walden became parson of Derwent Woodlands, he was captivated by the beauty of the moors and the gritstone edges that overlooked the village and its little church. Robert was a single man, assiduous in helping others but rather shy. He'd shown symptoms of what we now call tuberculosis, but the fresh air of his new parish and the exercise of walking among the scattered farmhouses soon lessened the dry rasping cough and the twisting pains in his chest. He felt better than he'd felt for years.

His predecessor had been a non-resident vicar, a distant relative of the Master of Derwent Hall. He'd grown careless and left all his church duties to an old curate, who was partly blind and unable to manage the work. So a new parson who lived in the village and took an interest in its people was warmly welcomed. The villagers responded to Robert with unaffected friendship, and he felt he could spend the rest of his life serving Derwent Woodlands in peace and happiness. The church was always full for his Sunday services, though no one ever sat in the west gallery. Robert thought that strange, for the west gallery was the best part of the church, beautifully carved and decorated.

He asked one of his churchwardens, Micah Harrison, an elderly hill farmer, "Why does no one ever sit in the west gallery?"

"Oh, no, nob'dy 'll go up theere," said Micah.

He seemed uncomfortable, so Robert asked no more, but he remained puzzled.

He obtained money to repair the church without spoiling it with improvements. The pews were replaced and the broken windows were mended, but the lovely old three-decker pulpit was left intact and the west gallery was not touched. The villagers were pleased with Robert's efforts. He'd made the nave and the chancel shine with a plain beauty that appealed to the Peakland character, and he hadn't changed what they most valued.

All went well for Robert until the second week of December, when the cold, damp weather brought back his chest pains. What disturbed him more seriously was an argument with Micah and another churchwarden, George. They wanted him to participate in what they said was an important local tradition.

"Tha conna be expected fer t' know about it, Vicar, seein' as 'ow th' art new round 'ere," said George. "It's thy sermon fer th' first Sunday after Christmas, tha sees."

Robert asked, "What about my sermon for the first Sunday after Christmas, George?"

"It's summat as 'as al'ays been done," said Micah. "First Sunday after Christmas, th' Vicar al'ays preaches 'is sermon to them what's bound fer t' pass away over th' comin' year."

Robert was stunned.

"That smacks of witchcraft! Such a sermon could have no place in a Christian church, gentlemen, and I'm amazed you ask it of me. I won't countenance it. Even if I did, the bishop would never permit it."

The churchwardens were taken aback.

"But it's al'ays done 'ere! Them in th' west gallery expects it, tha sees!"

Robert grew angry.

"What do you mean? In all the months I've been here I've never seen a single living soul in the west gallery!"

George agreed; not a single living soul had been in the gallery in all that time. "But," he added, "they say as 'ow th' spirits o' them in th' parish as 'll die o'er th' comin' year creeps out o' their bodies and gathers in th' gallery on th' last Sunday o' th' owd year. They wants fer t' 'ear God's words, and fer t' learn there's a better life a-waitin' for 'em after aw th' pain an' sufferin' o' this 'un."

Robert shouted, "That's a pagan belief! I'll hear no more of it!"

The two churchwardens shook their heads and left without a further word. The pain in Robert's chest returned, and he coughed up a little blood. The cold, damp weather had taken hold of him.

Christmas came and passed, and the parishioners gathered in the church as always, but Robert sensed they were more guarded, as though they were watching him, waiting for him to give the traditional Sermon for the Dead on

The inlet on the far side of the reservoir is the site of the now-vanished Derwent Village.

the following Sunday. He had no intention of doing any such thing. Instead, he'd take his text from Deuteronomy: *The secret things belong to the Lord our God; but those things which are revealed belong unto us and to our children for ever, that we may do all the words of the law.* He'd develop this text to show how superstition and ignorance were the enemies of faith. No true Christian could believe that the souls of those who were fated to die during the coming twelvemonth would gather to hear a sermon.

So on the morning of the first Sunday after Christmas, Robert Walden stepped into the three-tiered pulpit of his cold church, coughing a little, armed with his sermon. Every pew was crowded, but you could have heard a pin drop. He opened the great Bible on the eagle lectern at his chosen passage from Deuteronomy, looked around his parishioners with a loving smile, took a deep breath, opened his mouth to speak the first lines of his text, and froze in horror and disbelief. High in the beautifully carved and decorated west gallery, clustered close to the rail, was a score of shadowy, shroud-clad figures, their faces shining white in the gloom, waiting for a message of faith and hope and reassurance. And in the middle of those shadowy figures, he recognised himself.

He sank to his knees in the pulpit, unable to speak, and a buzz of concern rose from the congregation. But after a minute he gained control of himself and rose to his feet, knowing this was God's will. Then he began:

"Dearly beloved, I take for my text tonight, on this last Sunday of the year, these lines from the Book of Job: *For I know that my redeemer liveth, and that he shall stand at the latter day upon the earth...*"

He preached a wholly different sermon from the one he'd planned, a sermon of hope, and the shades of those who were soon to die drew closer and listened. He saw among the pews the living forms of those who would no longer be alive in a year's time, and he knew he couldn't warn them; but at least he could promise them the solace of a better place, free from suffering, and so he did. And at the end of the sermon, as he led his congregation in prayer, he could no longer feel the pain in his chest.

Late the following summer, a traveller passing through Derwent Woodlands noticed a new grave close to the church door. It was unmarked, because it was awaiting the most expensive and best-carved stone the parish could buy. He asked the sexton whose grave it was.

The sexton replied, "That were our parson. 'E weren't from round 'ere, but 'e were one of us."

<div align="center">13</div>

The Battle of Win Hill and Lose Hill

Edwin of Northumbria spent many years in exile during the early seventh century, and his life had often been in danger. On one occasion he was rescued from death by the Christian monk Paulinus of York, so he was no enemy of Christianity. After his return from exile he became king of a united Northumbria and his power grew. He annexed the minor kingdom of Lindsay, in present-day Lincolnshire, and allied himself with East Anglia. Then he secured an alliance with Kent by marrying the king's daughter, Aethelburg, who was a Christian. But when he annexed the Isle of Wight in the early 620s, he made enemies of the joint kings of Wessex, Cynegils and Cruichelm.

Cynegils was inclined to make peace with Edwin; but when Edwin took Wight, Cruichelm took umbrage. Around Easter in 626, Cruichelm sent an assassin called Eumer as envoy to Edwin's court, but the assassination bid failed. Edwin disposed of Eumer but he knew he would have to wage war against Cruichelm. He resolved to yield to Aethelburg's pleas and convert to Christianity if he won the battle.

Late in the summer of 626, Edwin's army met the army of Cruichelm, who was supported by his brother Cynegils and by the Mercians, on the border between Mercia and Northumbria. That border lay between the Mersey and the Humber and passed through the Peak District. The opposing armies occupied

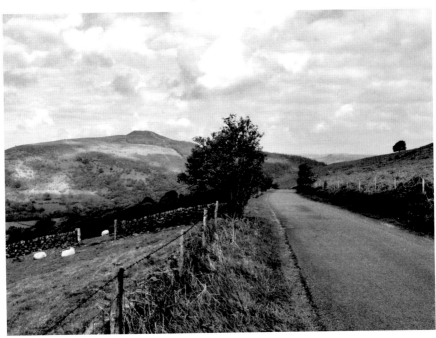

Win Hill is the conical peak near the left side of the picture. Lose Hill is the smaller eminence in the middle distance.

two heights on the land north of the Hope Valley, separated by the River Noe. Edwin's army was encamped on Win Hill, while the Wessex force was on Lose Hill. There was a great battle, which caused the Noe to run red. The turning point came when the Wessex army charged at the fortifications on Win Hill and Edwin's forces rolled great lumps of stone down the hillside at them, wiping out many of the attackers. The Northumbrians were victorious and Edwin duly became a Christian.

The stones were later collected from the bottom of the hill and turned into millstones. That is why the millstone became the symbol of the Peak District National Park, and how Win Hill and Lose Hill earned their names.

14

Lord of the Wind

When William Peveril was Warden of the Royal Forest of the Peak, there dwelt in the town below his castle a swineherd called Harold. Harold lived with his pigs, slept in their sty, and guarded them against wolves and robbers. He loved

them and understood their ways; he talked to them and they answered; and he fed them with scraps from Lord Peveril's own table. Lord Peveril had an appetite for pork, so Harold's charges were prized. But Harold was poorly paid for his work, and would gladly have eaten the food his pigs ate, especially during the cold, hard winter.

One autumn morning, after the harvest had been gathered and the leaves were starting to fall, Harold found that a sow heavy with litter had disappeared from her pen. He followed her tracks through the muddy fields, but when he reached the lane he could follow her no further. Many animals and people had passed that way and the tracks were covered.

The baker went by, and Harold asked him, "Have you seen my sow, friend baker? She's full of piglets. She vanished from her pen during the night, and I fear she may have been stolen."

"No, Harold. I've been all about the town taking bread to the people, but I haven't seen your sow."

Harold walked along the lane until he met the butcher.

"Have you seen my sow, friend butcher? She's full of piglets. She vanished from her pen during the night, and I fear she may have been stolen."

"No, Harold. I've been all about the town taking meat to the people, but I haven't seen your sow."

Harold walked further, dreading Lord Peveril's anger if the sow were not found, until he met the blacksmith.

"Have you seen my sow, friend blacksmith? She's full of piglets. She vanished from her pen during the night, and I fear she may have been stolen."

"Yes, Harold, I saw your sow about an hour ago. She was walking away westwards, towards Peak Hole, as I was returning from Mam Farm."

Harold thanked the blacksmith and set off towards Peak Cavern. Like all the people of the valley he was afraid of Peak Cavern because of the wind that eddied around it, but he had to find the sow. As he approached the cave entrance and the cliffs loomed dark above him, he became more and more frightened. But although all winds were created in Peak Cavern, they were not so strong that morning. So he pressed on bravely, and soon he entered the cave.

It was dark, and it grew darker, but Harold went on. Soon he could see nothing at all, not even his hand in front of his face. Stepping slowly, he called to the sow – quietly at first, then more loudly – but only echoes answered him, and the sound of water dripping. On he went, and at last he saw a glimmer of light ahead. He could see the ground before his feet again. Soon he could see the walls of the cave once more.

Then the cavern opened into a wide plain full of woods and well-cultivated fields, where men and women with scythes and sickles were gathering the harvest. In the distance stood a little town, and a great palace with shining towers. Closer to hand, beneath a tree of a kind he'd never seen, the sow lay on

her side. She had farrowed, and a dozen tiny piglets were feeding from her. She grunted contentedly.

Harold went to the sow and said, "Come, lady, we must go home to your pen beside the castle before Lord Peveril knows you've gone".

The sow rose to her feet, her piglets squealing around her, but Harold could take her no further. A dozen men bearing scythes had surrounded them.

"Who are you, stranger, who dares to steal a pig from the Lord of the Wind?"

"I'm Harold, Steward to Lord Peveril, and the pig is his, friends, not the Lord of the Wind's."

"This land and everything in it belongs to the Lord of the Wind," they said. "The pig is here, so it's his. If you want the beast, go to him and ask if you may buy it."

"Very well," said Harold, "take me to him. But the pig is my lord's property already, so I don't know why I should buy her."

"Tell that to the Lord of the Wind," they laughed, "and see how he answers you."

They led Harold to the little town and up to the gates of the palace with the shining towers, and the sow and all her piglets followed them. A guard at the palace gate stopped them and asked their business.

"This stranger demands the pig and her litter, claiming that they belong to his lord, though she farrowed on our land," said Harold's companions. "He must explain himself to the Lord of the Wind."

"Indeed he must," said the guard.

The guard summoned a servant, who spoke to a courtier, who disappeared into the palace; and a few minutes later a dozen guards carrying swords and spears and dressed in splendid uniforms came to take Harold to their master. They marched along marble corridors lined with brightly coloured tapestries, and up a wide marble staircase, and through a carved wooden doorway into a vast hall where the furnishings were inlaid with ivory and gold, and the hangings on the walls were woven with gold and silver threads, and finely dressed courtiers surrounded a throne of solid gold. On the throne sat the Lord of the Wind. His clothes and cap were of the finest velvet and decorated with costly jewels, and his shoes were of the softest leather and studded with diamonds. Gentle music sounded from behind the walls.

"So, stranger, you'd steal a pig and her litter from my domain, would you?" shouted the Lord of the Wind. "Why should I not order you to be hanged as a thief?"

Harold bowed.

"I'm the Steward of Lord Peveril, Warden of the Royal Forest of the Peak," he replied. "The pig belongs to my lord. She wandered from her pen last night, and I followed her into your domain. I'm sorry if I've trespassed, but I came only to reclaim my lord's property."

"Is that so?" sneered the Lord of the Wind. "Well, Lord Peveril's property or not, the pig entered my domain, so she may not leave unless you pay for her."

"Alas, sir, I brought no gold or silver," said Harold. "I didn't expect to have to buy what belongs to my lord and is under my care."

The Lord of the Wind thought for a moment.

"I must take counsel on this. You will wait until I've discussed the case with my advisers."

The guards took Harold to an anteroom, as splendidly furnished as the hall itself. Harold feasted his eyes on the beauty around him, but he was afraid of what might befall him next. A few minutes later he was summoned back to his lordship's presence.

"You're a trespasser and probably a thief, but you seem to be a man of courage," said the Lord of the Wind. "Are you also a man of wit?"

"Wit is no part of a steward's business, lord," replied Harold, "but perhaps I'll find it if I must."

"So be it," said the Lord of the Wind. "Since you've no money to buy the pig, you may purchase her by wit. I'll give you three riddles. For two nights you'll be housed in comfort close by and you'll be given food and wine. At noon on the third day you'll return to this hall and answer all three riddles. If you succeed, you may take the pig and her litter and return to your lord. If you fail, the pig will remain here and your life will be forfeit."

"It seems I've no choice," said Harold. "Pray tell me your riddles."

"The first riddle is this. You see me here, clad in costly raiment studded with jewels, seated upon a golden throne, surrounded by more wealth than may be found in all the world above. So tell me, Steward of Lord Peveril: what am I worth?"

Harold felt his face grow pale. How could he calculate so much wealth?

"The second riddle is this: the world is round, they say. How long would it take me, mounted upon my swiftest courser, to ride it all about and return here to my palace?"

Harold went paler still. How could he discover how big the world was, or how long it would take the swiftest courser to ride it all about?

"The third riddle is this: you see me seated here, ruler over a great domain, deep in thought. So tell me, Steward of Lord Peveril, what *am* I thinking?"

At that, Harold almost fainted. How could he know what was in another man's thoughts, especially the Lord of the Wind's?

"I will answer your riddles, Lord, at noon on the third day," he said.

He was led away from the hall and out of the palace, and into a house where the furnishings were plain but good, and the bed was soft, and the table was laid with better food than he had ever eaten in his life, and there was a flagon of good wine. But there was a guard at the door and another at the window, so there was no escape. The sow and her piglets lay down outside the house and waited.

The sun shone, and the birds sang, and the townspeople came and went about their business and were merry, but Harold was sad. How could he answer any of the Lord of the Wind's riddles? He tried to eat, but although the food was excellent he had no appetite. He tried to drink, but the wine turned sour in his mouth. He tried to sleep, but although the bed was soft and comfortable and the night was peaceful and quiet, he tossed and turned miserably; and when at last he dozed, his dreams were so frightful that it would have been better to be awake.

All the following day he paced the house, occasionally picking at the food and wine, sometimes lying on the bed and groaning. Not a single idea about the riddles came to him. The second night was the same as the first. The riddles loomed ever larger in his mind, mocking him. He couldn't solve them.

When the third day dawned, Harold said to himself, "The Lord of the Wind took counsel before he gave me the riddles. Perhaps I too should take counsel before I try to answer them." So he went to the door and said to the guard, "Let me talk to my sow and her piglets. At noon, I must return to the Lord of the Wind and answer his three riddles. If I can't do so, he will hang me."

"Very well," said the guard, "but don't try to run away or I'll put my spear through you, and chop off your hands and feet with my sword, and then chop off your head."

Harold went to the sow and said, "Oh, sow, I must answer three riddles at noon today, or you'll be kept here forever, and I shall be hanged; and I can't answer any of them. First, I must tell the Lord of the Wind, with all his wealth and his costly finery, how much he's worth."

The sow nuzzled one of her piglets and pushed him away from the others. He ran around and cried while the bells on the town church rang. Harold smiled.

"Ah, yes. That's a good answer!"

The piglet ran back to his mother and she nuzzled him again.

"The second thing I must tell the Lord of the Wind is how long it would take him to ride around the world and return to his palace," said Harold.

The sow looked up at the rising sun, then turned in a slow circle until she was looking at the sun again.

"Oh, yes, another clever answer!" laughed Harold. "I'd never have thought of that! But the third riddle is the worst of all: I must tell the Lord of the Wind what he's thinking."

The sow walked up to Harold and nuzzled his legs, and looked up at him with her small intelligent eyes. Harold frowned.

"I don't understand," he said.

Once again she nuzzled him and looked up at him, and this time he laughed loud and long.

"Oh, of course! It's simple, isn't it? Well, we'll see how he likes those answers. We shall soon know."

He went back into the house, and ate and drank heartily, and then lay on the bed and slept in dreamless peace until the guards came to take him to the palace

with the shining towers, and up the marble staircase, and into the beautiful hall where the Lord of the Wind awaited him upon his throne of gold.

"Well, Steward of Lord Peveril," said the Lord of the Wind, "can you answer my riddles?"

"I believe I can, Lord of the Wind," replied Harold.

"For your sake, I hope so. The first riddle is, to tell me what I'm worth. What's your answer to that, Steward?"

"Twenty-nine pence, Lord," said Harold.

There was total silence. The music behind the wall hangings ceased. The courtiers were frozen where they stood. The Lord of the Wind stared at Harold in disbelief.

"What did you say?"

"Twenty-nine pence," repeated Harold. "You're a great lord, and you have great wealth. But our Lord Jesus Christ was betrayed by one of his twelve disciples and He was sold for *thirty* pence. And I say He was worth a penny more than you."

The silence hung for another minute. Harold neither moved nor spoke. Then the Lord of the Wind smiled, and then he began to laugh, and then all the courtiers began to laugh as well, and the music played again, and the music and laughter grew louder and louder until they turned into applause.

"An excellent answer indeed, Steward!" cried the Lord of the Wind. "But now you must answer my second riddle: how quickly may I, upon my swiftest courser, ride the whole world about and return here to my palace?"

"Lord of the Wind," said Harold, "if you rise when the sun rises, and ride west so the sun is always rising behind you, you will come back to your palace in twenty-four hours, when the sun rises again the following morning. If, that is, your courser is swift enough."

This time there was no silence. The Lord of the Wind and all the courtiers cheered and applauded and the music rang out merrily.

"You have great wit indeed, Steward," said the Lord of the Wind. "But now tell me the answer to my third riddle: what am I thinking?"

"You are thinking, Lord, that I'm Lord Peveril's Steward, but I'm not; I'm Harold, his swineherd. I'm sorry I deceived you, but a steward might be permitted to speak to a great lord like you, whereas a swineherd would not; and I had to speak to you, or I couldn't have reclaimed Lord Peveril's sow and piglets and take them home to their master."

The Lord of the Wind rose from his throne and embraced Harold where he stood.

"Never have I heard such wit! Harold, you're too great a man for a swineherd. Remain here and be steward over all my domain, and you'll be richly rewarded!"

"My lord, I'm honoured," said Harold, "but I can't. I am bondsman to Lord Peveril, so unless I return to his service, my honour is naught."

"Aye, I thought you'd answer me so. It's a pity, but of course you're right."

The approach to Peak Cavern
(also known as Peak Hole or The
Devil's Arse).

He clapped his hands, and one of the courtiers stepped forward with a bag of gold, bowed, and gave it to Harold.

"Take that gold back to your own land, Harold, in token of my thanks for your merry jest; and may God go with you," said the Lord of the Wind.

Harold bowed, and the guards led him from the hall and out of the palace, and he took the sow and the piglets, and left the Lord of the Wind's domain, and went into the darkness of the cave, and returned at last to the valley where he'd lived all his life. To his astonishment, he saw the snow was melting from the hills, and buds were opening on the trees, and spring flowers were blooming.

"This is a great wonder, sow," he said. "How can it be that the whole winter has passed in three days?

He returned to the home he shared with his pigs, but he'd been absent for so long that another swineherd had been given his place. But this was a poor fellow who didn't understand his charges, and the place was filthy and the pigs were thin and unhappy. So Harold drove him away, and cleaned the sty, and used some of the gold that the Lord of the Wind had given him to buy food. The pigs grew fat and happy again, and Harold grew fat and happy with them.

He lived with the pigs all the rest of his days, but he ate better and slept more comfortably than he'd done before. He bought bread from the baker, and meat from the butcher, and in the evenings he drank at the inn with his friend the

blacksmith and the other men of the town. He never tired of telling them how he'd rescued the sow and her twelve piglets from the Lord of the Wind's domain behind Peak Hole; or how the sow, in return, had rescued him.

15

A Strange Banquet

Once upon a time, the great rogue Cock Laurel invited the Devil to dine with him in the Peak Cavern at Castleton. The Devil accepted the invitation, but his stomach was upset by his long journey over the rough roads of the Peak District. So he demanded a poached Puritan to settle him.

Once the Devil felt better and his appetite had returned, the banquet began. Cock Laurel served a first course of Informer in plum sauce. This was followed by a salad of sliced Tailors, Seamstresses, Milliners, Feather-men and Perfumers.

The salad was succeeded in turn by an entrée of a fat Usurer stewed in his marrow, with a Lawyer's head in Yeoman's brain sauce; then a brace of roast Sheriffs garnished with their chains of office. Another great dish followed: a Mayor in Page-boy jelly. Then came a dainty dish of Justice of the Peace with a side-dish of Clerks.

The banquet was concluded with a soused Constable, two Alderman-lobsters, a Deputy tart and a Churchwarden pie, all washed down with Derby ale.

So well satisfied was the Devil with Cock Laurel's hospitality that he broke wind thunderously, thus conferring upon Peak Cavern its alternative name, The Devil's Arse.

16

Kitty Green

Kitty Green was a little girl who lived with her mother and father on the north side of Castleton. One Sunday, when the weather was fine and warm, she was following her parents to church, but she decided to go for a walk instead. So she went right past the church and on to the path up Cave Dale, enjoying the sunlight, listening to the birds, watching the butterflies, and stopping now and again to pick brightly coloured flowers. On and on she walked, all the way up the hill until she was near Eldon Hole. Then she sat down beside the path and, being very tired, fell asleep.

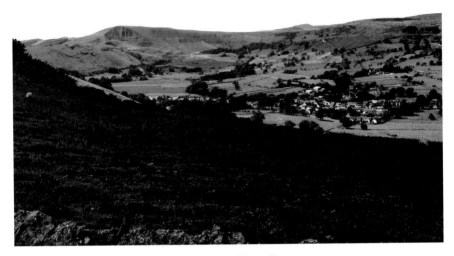

View over Castleton from the hill to the east of the village.

While she was sleeping, a giant found her and carried her away to his lair in the hills to be his servant.

"I won't 'urt thee," the giant promised her, "but tha mun do what Ah tells thee. An' tha sees this ball an' ring? When Ah gives thee yon ball an' ring to took after, tha munna put th' ball into th' ring. Not never. Does t''ear me?"

"Yes," whispered Kitty. "I won't put the ball into the ring."

The giant was as good as his word, and he treated Kitty kindly, though he made her work hard. But she wanted to be home with her mother and father again. She wished she'd gone to church that Sunday morning instead of walking away up Cave Dale.

One day the giant went down to the river to bathe and he made Kitty go with him to look after his clothes and jewels while he was in the water. Kitty sat on the river bank, wishing she were home in her cottage in Castleton. As she daydreamed, she absent-mindedly picked up the ball and ring from among the giant's clothes.

"I wish I were with my mother and father again," she sighed, and – without thinking about it – slipped the ball into the ring.

In an instant, she found herself back in Castleton, sitting up in her bed. It was Sunday morning.

"Come on, Kitty! It's time for church," called her mother.

Kitty ran downstairs and told her parents all about her adventure with the giant. They told her she'd been dreaming. But while they were on their way to church, she felt something round and hard in her pocket. It was the giant's ball and ring.

Kitty Green lived a long and happy life, for whenever she really wished for something, all she had to do to make her wish come true was to slip the ball into the ring.

17

The Bradwell Dog

Will and Sam were brothers, both lead miners. In the evenings after they returned from the mine, they went out drinking and playing cards with the other miners and the local farmers. It was often late when they walked home, and they were nearly always drunk.

One night they were returning from the inn, singing and joking together under the light of a full moon, when Sam saw something that terrified him even in his drunken state. They had just reached the outskirts of the village. Sam stopped dead in his tracks and pointed ahead of them, his tongue frozen. Will stared, but he couldn't see anything.

"What art th' starin' at, Sam lad? There's nowt theere."

Sam was still too frightened to speak. He just kept pointing. Could his brother not see the huge black dog padding towards them, its eyes glowing in the moonlight and its white fangs bared? Sam was petrified. As the beast grew closer he shut his eyes, and he could feel its hot breath on his face. Then, as suddenly as it had appeared, the dog vanished.

"That great big dog, Will. Tha must 'a seed it."

"What dog, Sam? There were no dog theere, an' nowt else neither, Ah tell thee! Th' art drunk, lad."

"Nay, Ah'm none that drunk. 'Uge ugly black thing, come reet up to us. 'As th' gone blind or what?"

"Th' art imaginin' things."

The two brothers argued all the rest of the way home; but the more Will mocked him, the more convinced Sam became that the strange black dog had a sinister purpose. He'd heard stories of lead miners seeing similar things in the past, and he knew such warnings should be heeded.

"Ah'm none goin' down th' mine tomorrow, Will, an' tha munna go neither."

"Dunna talk so daft," said Will. "Tha's goin' soft i' th' 'ead."

Bradwell village.

So early the following morning, Will went to the mine as usual. But Sam stayed at home. That day, there was a roof fall in the mine and several of the miners were killed. One of them was Will.

Sam was heartbroken at the death of his brother, but he knew he'd been foolish to ignore the appearance of the black dog. He remembered Will's words, though: "Th' art drunk, lad". After that night, Sam gave up drinking, and he never saw the black dog again.

18

The Bradwell Ghost

Long ago there was a house in Bradwell called Hill's Head. A young servant girl called Hannah was murdered there around 1760 and her body was hidden under the staircase.

Hannah's ghost haunted the owners of the house. To begin with she was seen only now and again, but her visits became more and more frequent as time passed, and sometimes she was seen outside Hill's Head as well as inside. Soon

the whole neighbourhood grew afraid. Many Bradwell people wouldn't go out at night in case they met Hannah.

Everyone agreed that the ghost had to be laid; but how? The vicar was unwilling to help because of the local upsurge of Methodism, which he blamed for the disturbance, but there was no full-time or regular Methodist minister. The Peak District villages were part of the Sheffield Methodist Circuit and ministers could only visit them when other commitments allowed. So a local wizard called Nicholas Hawthorne was invited to Hill's Head to carry out the exorcism.

Surrounded by a crowd of curious and excited villagers, Nicholas drew a circle of chalk on the floor, then knelt inside it and started to mutter prayers and incantations. He prayed and incanted so hard that beads of sweat ran down his face. Then the floor beneath him began to rise and fall. Nicholas leapt to his feet and shouted:

"Beroald, Beroald, Balbin, gab gabor agaba!"

Which, he later explained, meant "Arise, arise, I charge and command you!" The prayers and the spell worked, and Hannah's ghost appeared.

Nicholas ordered her to depart from the house and go to Lumb Mouth, where Bradwell Brook rises, and there to enter the water and swim in the form of a fish until the end of time. For variety and exercise, she would be allowed every Christmas Day to turn herself into a white ousel and fly to Lumbly Pool, two miles away. But she would have to return to Lumb Mouth by midnight, or the privilege would be withdrawn.

From that time onward, the villagers of Bradwell were left in peace, though a number of children claimed to have seen Hannah's ghost, either as a fish or as an ousel. And it is considered bad manners, if not downright dangerous, to go fishing near Lumb Mouth, or even in Lumbly Pool.

<div style="text-align:center">19</div>

Little John of Hathersage

Robin Hood and his men have many associations with the Peak District. Near Birchover stands the gritstone outcrop called Robin Hood's Stride, on Offerton Moor we find Robin Hood's Stoop, and on Abney Moor there is Robin Hood's Cross. There is a Robin Hood's Leap on the Chatsworth Estate and Robin Hood's Chair in the Hope Valley. On the northern moors are Robin Hood's Picking Rods near Glossop; Robin Hood's Moss, Robin Hood's Spring and Robin Hood's Croft near the headwaters of the Derwent; Robin Hood's Well and Little John's Well on the Longshaw Estate; and Robin Hood's Cave on Stanage Edge, overlooking the Derwent Valley near Hathersage.

Little John's Grave, Hathersage churchyard.

Robin Hood's Cave is interesting because it is within easy walking distance of the supposed birthplace, and grave, of the outlaw's most faithful lieutenant. The gentle giant known as Little John, originally John Little, was a nailor from Hathersage; nail-making is a traditional craft in that village. Little John spent many years in the company of Robin and his men, and after Robin died at Kirklees, Yorkshire, he returned to his birthplace. He was welcomed by his former friends and family, but so deeply did Robin's death affect him that he told them he would die within three days, and he showed them the spot in the churchyard where he was to be buried.

Little John's grave is still to be seen beside Hathersage church, between two yew trees; it is about ten feet long. His green cap and his longbow were hung in the chancel after his death, but they were taken away during the nineteenth century to Cannon Hall near Barnsley in Yorkshire. The bow is said to have required a pull of 160 pounds. The grave was excavated in the eighteenth century and an unusually large thigh bone was extracted.

Little John's cottage, which stood at the east end of Hathersage church, no longer exists; but many inhabitants of the village firmly believe that the giant was indeed born, and buried, there.

Nicholas Eyre of Highlow Hall

William le Eyr's great-great-grandson, Nicholas Eyre, was a notorious schemer. When he returned from war in France, where he'd profited from plunder, Nicholas set out to find a wife to add to his already considerable wealth. He wooed both the daughters of Archer of Highlow Hall, Elizabeth and Gertrude; they were the last of the Archer line, and one of them would inherit the estate. He schemed so cleverly that for some time, neither sister knew that he was also courting the other. When Elizabeth finally caught him in an amorous embrace with Gertrude, she disappeared and was never seen alive again. Nicholas married Gertrude. It was said he'd murdered Elizabeth and dragged her body downstairs and buried her in the grounds of the Hall.

A year or two after the wedding, Elizabeth's ghost appeared to Nicholas. He was alone in the banqueting chamber during the dark of the night. Only a few candles were burning, and the wind had risen and was rattling the shutters. He glanced up the great oak staircase to see Elizabeth gliding towards him, and

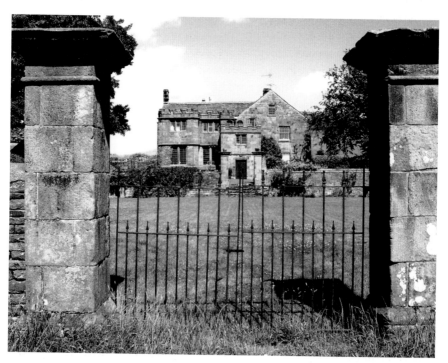

Highlow Hall.

he was frozen with terror. As he stood motionless in the hall, she laid a curse on all the family of Eyre. Although they'd gain the land and power they craved through good marriages, she told him, they'd lose it all after fifteen generations and be left "without a rood of soil". Sure enough, by 1842, the family's lands, titles and wealth had dwindled to almost nothing.

Elizabeth still haunts Highlow Hall. Her body can be heard bumping down the stairs. She's said to appear as a White Lady who gazes at her reflection in a water trough, perhaps wondering why Nicholas killed her. One farmhand who saw her regularly used to raise his cap to her but she never acknowledged him.

Despite his reputation for evil, Nicholas retained his wealth, and his son Robert inherited it. Robert rebuilt Highlow Hall, and he also built another seven halls, all within view of each other, one for each of his seven sons: Crookhill, Hazelford, Moorseats, North Lees, Offerton, Nether Shatton and Shatton. Robert Eyre's steward – and best friend – was called Fox. Robert built a house for Fox, close to Highlow Hall, and named it Call-o'er, saying, "We'll call thee o'er when we want thee." Today, the house on that site is called Callow Farm. Fox prospered, and after Robert's death he built himself a new house at the road junction above Longshaw Lodge. It is now a public house called Fox House Inn.

Robert was a man of fierce temper, who killed a mason whom he found loitering on his job, playing dice. Later, he gave much of his wealth to the church in Hathersage in expiation of his crime. The workman's ghost, like the spirit of poor Elizabeth Archer, is said to haunt Highlow Hall. There's also a male ghost, perhaps another of Nicholas's or Robert's victims, who seizes the bridle of passing horse-drawn vehicles and leads them a short distance along the road, to the discomfiture of the traveller.

Highlow Hall is said to be the most haunted house in Derbyshire.

21

Margaret of Hazelbadge

Above the mullioned window of Hazelbadge Hall in Bradwell Dale is the coat of arms of the Vernon family, and below the coat of arms you may discern a date: 1549. This dwelling was part of the dowry of Dorothy Vernon of Haddon Hall, who married Sir John Manners, and one line of the Vernon family lived at Hazelbadge for almost 300 years.

The last of that line was Margaret Vernon, who fell in love with Walter Eyre, a descendant of the notorious Nicholas Eyre of Highlow. Walter had asked Margaret to marry him and she was full of joy at the prospect. But shortly before

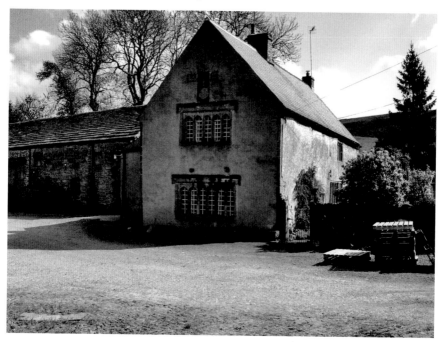

Hazelbadge Hall, now a working farm.

the wedding was due to be celebrated in Hope church, rumour reached her that her beloved Walter was on the point of marrying another woman in that very same church. He seems to have been a true descendant of Nicholas.

Margaret leapt on to her horse and rode like a madwoman down Bradwell Dale, through the village, and on past Brough to Hope. But by the time she reached the church it was too late. The ceremony was ending. Her fiancé had married her unknown rival.

She turned her horse and rode home as though pursued by fiends, her eyes starting from their sockets, and before she reached Hazelbadge Hall again was seized with a fever. She staggered indoors and her servants put her to bed and nursed her, but the fever affected her brain and her mind wandered. Three weeks later she died.

When storms rage in Bradwell Dale, and the wind howls and the rain falls in torrents, the spirit of a lady on horseback can be seen riding madly up the gorge south of the village towards Hazelbadge Hall. But you can never hear the sound of the galloping hooves over the noise of the wind among the rocks and trees, or over the noise of your own heart hammering with fear.

The Gabriel Hounds

In the valley of Bretton Clough between Hathersage and Eyam, downstream from Abney, there were once several farmhouses of which few now survive. At the time of this story, late in the eighteenth century, these farms had been leased by the same families for longer than anyone could recall. Near the bottom of the valley was the Bowmans' farm. The Bowmans had a son, John, and a daughter, Mary. Mary was a few years younger than her brother and she was very beautiful, tall and stately, with a high forehead and jet black hair and blue eyes. When she was eighteen, she fell in love with Will Birch, whose parents leased a farm higher up the valley. Mary's father said, "I'd rather graft on a better stock." But Mary and Will were resolute, and in due course a wedding was planned.

A few weeks before the wedding date, Mr Bowman received a letter from the owner of the land, Mr Eyre, asking him lodge a distant relative of his, a Mr Galliard. The letter suggested than Mr Bowman and his son John might wish to join Mr Galliard and Mr Eyre on hunting and shooting expeditions, in exchange for board and lodgings. Of course, Mr Bowman could hardly refuse, and in any case he saw how he might profit from the arrangement: he could enjoy hunting in the company of gentlemen.

Mr Galliard arrived one afternoon in July, and he proved to be an energetic and well-favoured young man. He was captivated by Mary and he soon made his feelings obvious. Mr Bowman was pleased; a rich young upper-class son-in-law would be more to his liking than Will Birch. So hunting and shooting were neglected, and Mr Bowman encouraged his guest to extend his stay.

But Mary wasn't moved. She liked Mr Galliard, and she respected her parents, but she'd set her heart on Will Birch. Her mother tried to persuade her, and her father entreated her and then lost his temper and issued orders. It began to look as though she was going to be married to Mr Galliard whether she liked it or not.

Fortunately for Mary, she had an ally, apart from Will Birch himself: her brother John. John and Will were good friends and John wanted Will and his sister to be happy together. Also, he didn't much care for Mr Galliard. So John, Mary and Will tried to work out how they could get rid of the attentive visitor and restore the status quo. They dreamed up various schemes, but none seemed likely to work.

Then, one day, Mary fell ill. It was sudden and frightening. She grew pale and feverish, and over the next few days she grew worse. Her parents became anxious, her mother applied all the remedies she knew, and Mr Galliard was

Farms at the lower end of the Bretton valley.

concerned. But the patient didn't recover. She remained ill and was confined to bed throughout the latter half of August.

One fine evening near the end of the month, Mr and Mrs Bowman and Mr Galliard were standing at Mary's bedside in the back parlour, thinking that the poor girl looked even worse in the feeble light of the single candle. Suddenly, through the lattice window, they heard the dreaded sound of yelping. Poor Mrs Bowman was beside herself.

"God save us, it's th' Gabriel 'Ounds! There's bound fer t' be death in th' 'ouse!"

Then the sound came again; and a few minutes later it was repeated yet again, this time more loudly. Now even Mr Bowman was afraid. Everyone in the Peak District knew what the Gabriel Hounds portended. The poor man cried out, "Oh, Mary, to 'ave thee tekken from us…" and burst into tears.

Mr Galliard was embarrassed, but the obvious grief of Mr and Mrs Bowman convinced him that Mary would not survive, so his continued presence in the house would become intrusive. He resolved to return home the following morning. At dawn, full of sorrow, he duly set out. Mr Bowman accompanied him for the first few miles of his journey, and the two men lamented together about Mary's impending death.

As soon as Mary's father and his guest had departed, John called his mother away on business about the farm. He told her, "If we keep usself busy, me an' thee, we winna grieve so much." And they kept themselves fully occupied for much of the day.

But when Mr Bowman returned home, he found his wife distracted. She ran to her husband and cried, "She's gone! My Mary's gone!"

The poor man wept again, and prayed: "Then may 'Eaven receive 'er spirit."

"No, no, she isna dead," shouted Mrs Bowman. "She's gone! She's up an' left!"

It was several days before they discovered the truth. Mary had taken an emetic to make herself ill, so she could act the part of invalid convincingly. The yelping of the Gabriel Hounds had been made by Will Birch. And as soon as Mr Bowman and Mr Galliard had left the house and John had taken his mother to attend to farm business, Mary had leapt out of bed and run to Will, and the couple had eloped to Peak Forest to be married.

The Bowmans were angry. But over the following weeks, John helped them to see the funny side of the elopement. They began to realise that Mary and Will wouldn't have done such a thing if there hadn't been real love between them. So the runaway couple were forgiven, and the families of Birch and Bowman were reunited.

23

Fair Flora of Stoke Hall

A ballad by the nineteenth-century Grindleford poet Joseph Castle Hall tells the following story.

Early in the nineteenth century, an old man of gypsy ancestry lived near Eyam with his beautiful granddaughter, Flora. They knew much about the ways of wild animals and the characters of flowers, and they foretold events by studying the stars. Despite their gypsy background and their dabbling in magic arts, they were respected by their neighbours, who often consulted them about the future.

Victor, the son of the local squire, fell in love with Flora and she returned his affections. Despite the squire's opposition to the match, they were married, and they went to live in a little cottage in the woods above Grindleford. But their happiness was cut short when Victor joined the army and was sent abroad to serve his country. He was away for more than a year.

When he returned to England, late in the following summer, he rode straight to his door to greet his wife. But he found the cottage empty and the furnishings gone. He was shocked and bewildered, and set off towards the village to ask what had happened. Then, to his relief, he saw his lovely Flora walking towards

Fair Flora.

him through the woods, dressed in white and carrying a white rose in her hand. He rushed towards her and threw his arms around her, but to his dismay his hands passed right through her and she disappeared before his eyes. Weeping with grief and confusion, he made his way down to the village and asked at the inn what had befallen his wife. The people of the village told him that poor Flora had died in childbirth. He was the father of a six-month-old daughter.

He never recovered from the shock, but he brought up his daughter well and saw her grow into a young woman who was the image of her mother. He had a statue of Flora made, exactly as she'd appeared to him in the wood when he returned from the foreign wars, and he placed it on the lonely hillside above Grindleford, where for a brief time they'd been happy together.

In time, the statue was moved to the front garden of Stoke Hall overlooking Froggatt. As she looked out of the window one day during the 1880s, the lady of Stoke Hall was alarmed to see the statue move. Not wanting such disturbances, the owners ordered the statue to be taken down and returned to its place above Grindleford.

Flora still stands there, damaged by weather and vandals, but passing gypsies occasionally stop to put posies of fresh flowers into her hands beside the stone roses she carries. The wood is now called Flora Wood.

Cockeye and the Boggart

At the bottom of the road from Eyam to Middleton Dale stood a hostelry called the Ball Inn, which in the early 1800s was frequented by lead miners. Tom Loxley, known as Cockeye, was a regular at the Ball Inn. Cockeye was popular because he was a wit and an entertainer; he was a widower, but he was never sorry for himself. However, he was a heavy drinker even by the standards of lead miners. People said he drank more than was good for him, and the local minister upbraided him, though to no effect.

About two hundred yards up the dell from the Ball Inn, hidden under a rocky ledge among dense woodland and thick undergrowth, was a dilapidated cottage. It was in a romantic setting, but everyone avoided it because it was haunted by a boggart, the spirit of an old woman dressed in a short bed-gown, a linsey petticoat, a mobbed cap and shoes with shining buckles. The boggart could pass through keyholes and small holes in walls, and she caused trepidation throughout Eyam. Sometimes she would cross the road at great speed, upsetting travellers. Sometimes she'd enter houses at night and pull the bedclothes off the beds.

One November evening, Cockeye and his friends were drinking at the Ball Inn and enjoying the usual banter, when talk turned to the boggart of the dell. Cockeye's fellow-drinkers began to tease him, because his journey home would take him past the haunted cottage.

"But you are not afraid of a woman, Cockeye – or of 'er speerit?" asked the landlady. She was a Frenchwoman, but the village accepted her because she was a good landlady and hated Bonaparte. They called her Blandy.

"No, nor th' Devil neither," replied Cockeye, "not wi' another quart o' ale inside me!"

Blandy said she'd heard the woman had met a violent and untimely death, which was why she remained on Earth as a boggart. She wanted to know whether the tale was true.

"Ah'll axe 'er toneet on me road 'ome," promised Cockeye.

Everyone cheered and more drink was bought.

Around three o'clock in the morning, Cockeye and his companions left the inn and took their several ways home, not walking in straight lines. Licensing laws in those days didn't specify opening and closing times. It was cold, so Cockeye's breath misted in front of his face as he staggered up the dell. The moon shone on the bare branches of the trees and on the rock faces above the village, and the night was silent. The further Cockeye went, the more anxious he grew. An undefined but profound fear took possession of him, and the cold of

the night penetrated his bones. Soon he reached the haunted cottage. The moon cast its shadow across the road, and the shadow had a human shape. He called "'Ello!" but the word came out as a faint squeak. And then the deadly glance of the boggart met his eye.

Cockeye sank to the ground, face downwards, and he felt the boggart seize his ankles with icy hands and drag him with the speed of a horse back down the dell. He remained conscious, but he was terrified; the worst part of the experience was the deadly cold that spread from the ghost's hands into his legs and feet and from there to the rest of his body. He grew colder and colder until at last he became unconscious.

At dawn the following morning, Stephen Swire, Blandy's husband, the landlord of the Ball Inn, found poor Cockeye lying on the bank of the little stream that runs down the dell. He shook him and finally managed to awaken him.

"Tha fell down drunk wi' thy legs i' th' brook on thy way 'ome," Stephen told him. He seemed amused.

"No, Ah didna, yon boggart got owd o' me an' dragged me down 'ere. Its 'ands were reet cowd, Ah'll tell thee!"

"Ah'm not surprised th' boggart's 'ands felt cowd," laughed Stephen. "There were no boggart, lad. Tha were cowd because thy feet were i' th' brook!"

Cockeye told the story of his meeting with the boggart in the dell until his dying day, but from that night onward he became a sober man, held up as an example to all by the abstemious minister.

25

Rowland and Emmot

In the little church in Eyam, the famous Derbyshire plague village, there is a beautiful stained-glass window commemorating the story of Emmott Siddall. Emmott lived with her family in a thatched cottage in the heart of Eyam. She fell in love with Rowland, the son of the miller in Stoney Middleton.

George Vicars, the first victim of the Eyam Plague, lived in the cottage directly opposite the Siddalls. He died on 7 September 1665. As the plague began to spread, the wealthier residents left in a panic, but the rest stayed and put the village into voluntary quarantine, inspired by the rector, William Mompesson. Food was left at the boundary stones by the good folk of neighbouring villages, and when the villagers of Eyam collected it they left money in exchange, dipped in vinegar to disinfect it.

Emmot parted from Rowland at the village boundary and wouldn't even let him take her hand for fear of spreading infection to him. The church and

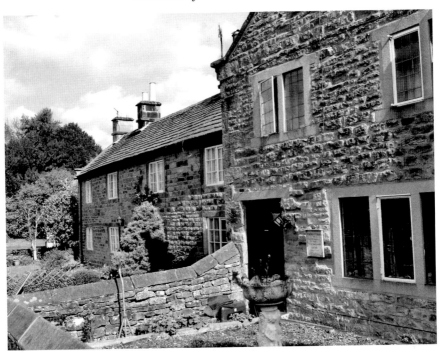

The seventeenth-century "Plague Cottages" in Eyam.

churchyard were closed, and Mompesson preached to his dwindling congregation every Sunday from a lofty rock in a dell called Cutler's Delph, which bordered Stoney Middleton. At every service, Rowland stood patiently on the other side of the Delph, hoping to catch sight of Emmot among the worshippers.

Emmot's sister Sarah was the fifth victim of the plague. A month later, on 11 October, her brother Richard became the thirteenth victim. Three days later her father died and a day after that her sister Ellen. Her sister Elizabeth died on the 22nd and Alice on the 24th. Then the Siddall household was free of the plague for six months. Emmot and Rowland "met" each other across the Delph with renewed hope. Calling to each other over the space that separated them, they planned to marry during the following year's wakes week, if the plague had gone by then.

Emmot's mother Elizabeth remarried on 24 April 1666; her new husband was another surviving Eyam resident, John Daniel. But perhaps an infected person attended the small wedding reception; Emmot contracted the plague and died six days later.

When she failed to appear at the usual trysting place, Rowland began to fear the worst. Finally, the news of her death was confirmed, and he was heartbroken.

An open-air service is held at Cutler's Delph every year in memory of that terrible time. During the service a few years ago, a little girl plucked her mother's

sleeve and whispered, "I can see a ghost." Her mother reprimanded her but the child was insistent. She described a young woman with long flowing hair, dressed in an odd shapeless gown, wandering among the congregation of the living and looking hopelessly lost.

Had Emmot Siddall returned to Cutler's Delph to try to make contact once more with her beloved Rowland?

<div align="center">26</div>

Charles Huntley of Eyam

The Reverend Charles Huntley obtained the living at Eyam around the year 1800, thanks to the generosity of a maiden aunt who had doted on him since his childhood. She purchased the advowson of the living from the Duchess of Devonshire just as young Charles was finishing his university studies and preparing for ordination. It was an expensive purchase, because for many years the benefice had averaged an annual income of £1,600, thanks to the profits from the lead mines. The mines were no longer profitable so the living now paid very little, but the purchase price was based on past records, not present circumstances and future prospects.

The Reverend Charles and his wife soon became popular in the village, and they were respected in spite of their youth. They were attentive to the poor, the old and the sick, they knew the names of all the children, and they involved themselves in village affairs as much as their station in life allowed.

When Charles officiated at the funeral of Robert Alsopp, an elderly lead miner, he became concerned about Robert's widow, Edith, who was distracted with grief. She would sometimes wander into the graveyard at night and call for her deceased husband to rise from his grave and go home with her. Charles usually managed to calm poor Edith down and return her to her cottage, but her nightly wandering continued.

Charles's life was otherwise content and unruffled, until one day he received shocking news: his aunt, his benefactress, had died. Shortly afterwards, the Duchess also passed away. The young Duke and his man of business could find no record of the purchase of the benefice of Eyam, so they demanded the sum of £2,000 from Charles. He had no means of raising such a sum. His aunt's house was searched from end to end for evidence of the purchase, but to no avail. Charles's repeated protestations fell upon deaf ears. Finally, the Duke's man of business lost patience and instituted legal proceedings.

Unable to see any solution to his difficulties, Charles assembled his congregation in the church and explained the situation. Sympathy was universal

Eyam church. Between the two small yew trees stands the Saxon cross.

and unalloyed, and the villagers expressed their determination to protect their preacher and keep the law-hounds at bay. So a watch was kept, and whenever the limbs of the law were seen near Eyam, Charles was concealed in a cave, or a mine shaft, or someone's cottage, until the coast was clear again.

This continued for five years while Charles continued to minister to his flock; he had to go into hiding whenever officials of the law were seen nearby. The Duke and his man of business grew more and more frustrated. At last, they secured the services of two Bow Street Runners called Digby and Brownlow.

Digby and Brownlow rode to Derbyshire, found their way to Eyam, and entered the village secretly at night. They planned to apprehend the Reverend Charles Huntley as he made his way to church the following morning. They secured their horses, tiptoed along the village street and entered the churchyard. The moon was high in the sky, casting deep shadows under the lime trees and the yews, and there were long pools of blackness beside the gravestones and the ancient cross. It was completely silent; no one stirred. The two Bow Street Runners hid beneath a yew tree near the path to the church door.

For two men accustomed to the ceaseless hubbub of the capital, it was strange and unsettling. Aware of the numerous graves around them, they sat beneath the yew and began to reflect on death – how all those who lay beneath the earth had once been innocent children, lively youths or comely maidens, strong yeomen

and respected elders. The village churchyard, they decided, was a school of humility, but it made them nervous.

Then, in the light of the moon, they saw the figure of a woman clad in a white gown approaching them across the graveyard. They began to shake with fear. And when the figure cried out, in a faint and unearthly tone, "Robert! Robert, come on out, come 'ome to me!" Digby and Brownlow fled from the churchyard and out of the village, faster than they'd ever run in their lives.

The Reverend Charles was never again troubled about the supposed debt he owed for the benefice of Eyam, and he continued to minister to the people of the village for the rest of his long and peaceful life.

27

The Scottish Peddler

In the year 1800, just before Eyam Wakes, Peter and Betty were busy preparing their cottage for visitors. Friends were coming to stay, hoping to see something of the Peak District. The night before they arrived, Peter had a nightmare, and he told Betty about it in the morning. He dreamed they'd taken their friends for a walk in Middleton Dale and had gone into Carlswark Cavern. Inside, he'd found a corpse. He thought it was the body of someone he knew.

The friends arrived, and after a meal they went for a walk. Sure enough, they went down into Middleton Dale and one of the visitors wanted to explore Carlswark Cavern. Peter recalled his nightmare, but being a good host he obtained candles for everyone, and into the cave they went. Sure enough, they found a human skeleton. A shock can be all the more intense when it's half-expected, as everyone knows if they've watched a scary film. Peter dropped his candle and ran to the cave entrance as fast as his legs could carry him. His companions weren't far behind him.

They called the constable, but not until the next day did the authorities come to investigate the body. Little remained except bones, and the clothes had rotted away, but the shoes with silver buckles were still in good condition, and those shoes were enough for identification. Everyone who was middle-aged or older would have recognised the buckles.

Until twenty years earlier, a Scottish peddler called Jamie had toured the fairs and markets of the Peak District during the summer, and he never missed Eyam Wakes in the third week of August. Everyone knew Jamie. The most noticeable things about him were his shock of red hair, his fine voice, and the silver buckles on his shoes. Many village men bought trinkets from Jamie for their sisters or wives or girlfriends, and he brought them news from the outside world. He was well liked, and as trusted as any peddler could be.

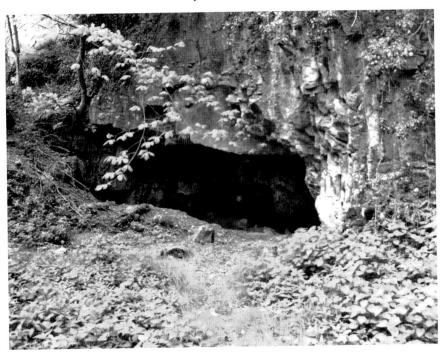

The cave in Middleton Dale.

One August, Jamie went to Eyam Wakes as usual, but he wasn't the only peddler in the village that year. There were five newcomers, four men and a woman. He suspected they didn't have licences, so, since he was losing trade to them, he had a quiet word with his old friend the village constable. The constable wandered around the green and the neighbouring lanes and asked the five new peddlers one by one to show their permits. They couldn't, so he asked them to stop selling, pack up and go. So they went.

When the day ended, Jamie went into the Bull's Head before going to Stoney Middleton, where he planned to spend the night. The landlord told him to beware of the five peddlers, because they were angry with him for reporting them to the constable. He offered to walk down into Middleton Dale with Jamie to keep him company. So they strolled down the hill together, and they met no trouble. The five peddlers were sitting outside the Moon Inn in Stoney Middleton, drinking and playing cards, and they waved to Jamie and the landlord and called a friendly greeting. The landlord's fears seemed groundless, so he said farewell to Jamie and went back up the hill to Eyam.

Jamie wanted nothing to do with the five peddlers, but their invitation was warm: "Come and 'ave a drink with us, mate, an' a game o' cards." So he felt obliged to accept. For a time, there was much laughter and merriment, but card games are good for starting arguments, and soon the five peddlers picked one

with the Scotsman. The argument grew more and more heated. Finally, a knife was drawn and Jamie was stabbed to death.

There must have been witnesses, since it wasn't fully dark, but none came forward. The peddlers went on drinking and playing cards and didn't leave the table until the street was quiet. Then they put Jamie's body on the back of a horse and carried him by the light of the moon to Calswark Cavern. They dragged him into the cave and dumped him more than a hundred yards from the entrance. Two lead miners saw them, but they were so drunk and incoherent that no one believed their story.

Although the five peddlers were never brought to justice, they all lived miserable lives after the murder. The woman's face was disfigured by cancer, and the four men developed painful chronic illnesses. The landlord of the Moon Inn knew about the crime, too. He had to be moved to a neighbour's house when he was dying, because his mind became so troubled.

After Jamie's body was found, no relative came to claim him, so he was buried in Eyam churchyard along with the remains of his clothes. But Matthew Hall the bell-ringer took the shoes with the silver buckles, and he wore them until they fell to pieces.

28

The Red Shoes

When William Oliver died in 1813, the toll commissioners allowed his widow, Hannah, to take his place as toll-keeper at Wardlow Mires. It was a surprising decision: Wardlow Mires was a dark, quiet place; even the inn opposite the toll-house, the Three Stags' Heads, was unfrequented. At forty-six years old, Hannah had no close relatives and few friends. The Peak District was lawless, and a solitary woman in an isolated toll-house might seem easy prey. But Hannah was resolute and armed herself with a stout cudgel, and she proved as capable as any man of enforcing the rules and collecting tolls.

As toll-keeper, her income sufficed for life's necessities and occasional luxuries, such as a silk scarf. One evening in 1814, shortly before Christmas, she made her way to Stoney Middleton, three miles east of Wardlow Mires, to order a pair of red shoes from the pious cordwainer Samuel Marsden. Whenever he made new shoes, Samuel hid a slip of paper bearing a Biblical quotation or a moral injunction inside one of the soles. Every one was different, so his customers could never know what was written on those slips of paper unless they dismantled the shoes, and Samuel's shoes were too good to destroy for curiosity.

It was a harsh winter. Frost gripped the land, and bitter winds dragged snow from the moors and over Wardlow Mires into Cressbrook Dale. Above the

dale, in the hamlet of Litton, farm labourers and their families hovered on the brink of starvation. The Corn Laws had forced up prices, and the government's taxes to finance the war against Bonaparte had hit the poorest hardest, as taxes always do. Anthony and Elizabeth Lingard were ageing and depended on their six surviving children; the other four had died in the smallpox epidemic of the 1790s. Their cottage, crowded and unsanitary, was barely warm enough for life, and work at the spinning wheel and hand-loom was confined to the meagre hours of daylight, for the Lingards could not afford candles. In any case, the new factories were undercutting their prices and killing sales of their produce. Anthony the younger, twenty-three years old and at the peak of manhood, knew his duty to his family: somehow, he must provide for them. But young Anthony had a problem.

Her name was Rebecca Nall, she was a housemaid at Cressbrook Hall, and she was carrying a baby that she claimed was his. Because of his family's needs, Anthony could not maintain a wife and child, and in any case he suspected Rebecca of dalliance with other men. Moreover, he had a secret dalliance of his own, which he hoped he might turn to profit: lonely and ageing, Hannah Oliver was flattered by the attentions of a strong and personable young labourer.

During January of 1815 the wind slackened and thick fogs gathered among the hills and valleys of the Peak District. On the night of the 15th, Anthony Lingard the younger crept from his cottage and picked his way along the lane to Wardlow Mires. If Hannah would give him money, he would pay Rebecca to blame her child's paternity on another man, and he might still have enough to see his family through the winter. Hannah, he thought, should be glad to pay for his kisses.

But he misjudged the toll-keeper, who was no one's fool. His pleas were rebuffed and his cajoling moved her to anger. He grew angry in return, and anger turned to blows. She struck at him with her cudgel; he grasped her silk scarf, tightened it around her neck and strangled her. Scarcely had her body fallen to the toll-house floor when he was forcing open her strongbox and pocketing her money. Then her new red shoes caught his eye. They seemed to call out to him, "Rebecca would like us!" So he took them.

On the following morning he crossed the frozen fields to Cressbrook Hall and placed several pounds' worth of silver coins in Rebecca's hand.

"That's aw Ah've managed fer t' save. But Ah've a gift for thee, an' aw," he said, proffering the shoes.

Rebecca's eyes lit up. "Wheere did tha get 'em?" she asked.

"Off-un a peddler," he said. "I traded a pair o' stockings fer 'em."

He returned to his cottage in Litton with the rest of the money he'd stolen from Hannah, content with his morning's work. Rebecca had been delighted with the red shoes. He'd bought her off. Now she'd stop claiming her baby was his.

But down in Wardlow Mires, the crime had been discovered. Impatient travellers waited at the toll-gate; no one answered their shouts and the gate remained shut. After a while, the commotion aroused Jane Harrison, barmaid at the Three Stags' Heads, and she crossed the road to the toll-house to see what was causing the delay. She found Hannah's body crumpled inside the doorway, the silk scarf still tight around her neck.

The constables were summoned and they began to investigate, taking statements from everyone who might throw light on the murder. But there had been no witness to the crime, and the murderer had left no clue as to his or her identity. Jane the barmaid was one of the few people who had been close to Hannah, so the constables asked her to look around the toll-house and tell them whether anything – apart from money – was missing.

"I canna see 'er new red shoes," said Jane. "Sam Marsden made 'em for 'er, and she were reet proud of 'em. They must 'a been pinched."

It was the constables' only lead: find Hannah's missing red shoes and perhaps they would find the murderer. But was the killer still in the area? And even if he was, or she was, where should they search? They trudged around the neighbouring farms and cottages, villages and hamlets, through fog and frost and snow, asking the same questions of everyone they met. They made no progress. No one knew anything about Hannah Oliver's red shoes.

Three days later, Rebecca Nall hammered on the door of the Lingards' cottage in Litton, seeking Anthony the younger.

"Anthony, tha mun tek these shoes back. Ah canna sleep o' neets!"

"Ah thowt tha liked 'em. Ah got 'em specially for thee."

"Aye, but there's summat up wi' 'em. Ah canna abide bein' th' same room with 'em."

"What dost mean, canna abide bein'…? They're good shoes, them."

"Ah know they are, but they're bad an' aw! Ah dunna know what it is, but…"

Women could be daft, he thought, especially when they were pregnant. He was unwilling to take the shoes back; if they were found in his possession they could hang him. But his blunt refusal achieved nothing. Rebecca dropped the shoes at his feet and ran back to Cressbrook.

Anthony was troubled. What was to be done? He could not be caught with Hannah's red shoes. He hid them under his jerkin, and as soon as darkness fell he went to the far end of Litton and buried them in a haystack. Even if they were found there, they could not be linked to him. He was in the clear.

Two weeks later the constables came to Litton. By then, everyone in the area knew that Hannah Oliver had been killed and the murderer was still at large, and people were afraid and barred their doors at night. But no one in Litton could shed any light on the crime; the constables were welcome to inspect every cottage if it would help. However, they were only interested in one. Rebecca Nall had learned that Hannah's red shoes had been stolen on the night of her

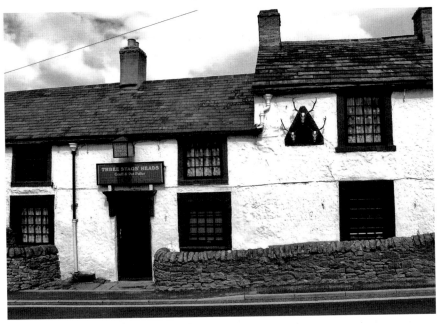

The Three Stags Head, Wardlow Mires, opposite the site of the now-vanished toll-house where Hannah Oliver was robbed and murdered. The Peter Stone stands less than a quarter of a mile away along Cressbrook Dale.

death. Troubled, she had gone to the authorities and told them about Anthony's gift.

"Aye, that's reet, Ah got a pair o' red shoes off-un a peddler and give 'em to 'er," admitted Anthony. He offered a vague description of the peddler.

"And you say you met this peddler on the morning of the 16th?" asked the constables.

"Dunna know what date it were," said Anthony. "It were two Mondays back. Took 'em straight to th' Hall and give 'em to 'er theere an' then."

"Yes, that's what Miss Nall told us. But she returned them to you three days later."

"Aye, said she didna want 'em after aw. Said there were summat up with 'em. Dunna know what she did with 'em."

"She told us," said the constables, "that she left them with you. We need to find them."

"Well, they're not 'ere. Tha con come in an' 'ave a look if tha likes."

The constables searched the Lingards' cottage. There, under Anthony's bed, they found Hannah's red shoes.

Anthony was arrested, charged with the murder of Hannah Oliver, and taken to Derby jail. There he lay in a crowded seven-foot cell, fed on stale bread and water, until 24 March, when he was brought from the jail to face trial for murder.

There were no defence witnesses, but he repeated his story: he had obtained the red shoes from a peddler in exchange for a pair of worsted stockings.

Jane Harrison the barmaid testified to the discovery of Hannah's body and the disappearance of her red shoes. The constables described how they had been summoned to the scene and how their subsequent inquiries had progressed. Rebecca Nall told the court how Anthony had given her the shoes and how she had returned them to him, dropping them outside his cottage when he declined to accept them.

"I 'eard later as 'ow poor Mrs Oliver's shoes 'ad gone a-missin', so I went an' tellt th' constables," she explained.

Anthony denied that the shoes had been left in his possession on 19 January and he refused to admit they could have been Hannah's, though the constables had found no trace of the peddler. He could not explain their presence under his bed. Someone who wished him ill must have planted them there.

Then Samuel Marsden the cordwainer was summoned to give evidence. The shoes were presented to him.

"Aye, that's one o' my pairs o' shoes," he said. "See yon stitchin'? There's no other cordwainer meks 'em like that."

"Are they the pair you made for Hannah Oliver?" asked the prosecuting counsel.

"Canna say for sure, just lookin' at 'em," replied Samuel. "But there's a way o' findin' out." He explained that he hid a quotation inside one shoe of every pair he made, and no two quotations were the same. "I've me book 'ere. Them shoes as I made for Mrs Oliver last December, see, I put this quotation inside th' right 'un."

"Let me see the entry, Mr Marsden."

The judge, Sir John Bayley, extended his elegant gloved hand, took Samuel's account book and studied the quotation. A small smile played around his lips.

"Very well, Mr Marsden. The court requires you to dismantle the right shoe and to recover the slip of paper you placed inside it. We shall see whether it tallies with the entry in your ledger."

The shoe was taken to pieces. There, hidden in the sole, was a slip of paper bearing the injunction copied into the ledger: *Commit no crime.*

At midday on 29 March 1815, Anthony Lingard was hanged in Derby for the murder of Hannah Oliver. On the orders of Sir John Bayley, the murderer's body was not handed over for dissection but was publicly gibbeted at the Peter Stone in Cressbrook Dale, within sight of Wardlow Mires. The Methodist minister John Longden preached beside the gibbet, exhorting his large open-air congregation to penitence.

A year later, Anthony's remains were buried at the site of the gibbet. Subsequent toll-keepers at Wardlow Mires complained regularly about the nightly noise of his bones creaking in the wind. To this day, local people avoid the Peter Stone during the hours of darkness.

What became of Hannah Oliver's red shoes, history does not relate.

Stories 29–34. Relatively few stories have been collected from this part of the Peak District, but they include some excellent (and well-known) tales.

The Murder of William Wood

William Wood of Eyam, no relation to the historian of that name, was a weaver, thirty-two years old, with a wife and three children. On 16 July 1823 he went to Manchester and sold several bolts of cloth for 70 pounds, 10 in banknotes and 60 in a bill of exchange.

On his way home to Eyam, he traded the bill of exchange for banknotes in Stockport, then went to an inn for a meal. There he fell into conversation with three poor men, Charles Taylor, John Platt and John Dale, and treated them to food and drink. They saw he was carrying a lot of money.

He left the inn and followed the turnpike road to Disley, and then turned on to the hill road to Whaley Bridge. From there he could take the turnpike through Chapel-en-le-Frith down to Middleton Dale, and then climb the hill to Eyam. But he never reached Whaley Bridge. Taylor, Platt and Dale had followed him, and on a lonely stretch of the moorland road they ambushed him, beat him over the head with a large stone, and stole his money. He died of his injuries. Some time later his body was discovered by two carters, Edmund Pott and John Mellor, who were on their way home to Kettleshulme. There was a large hole in the ground where the victim's damaged head had landed. They put the body on their cart and took it to the Cock Inn at Whaley Bridge for the Coroner to examine.

Charles Taylor was arrested in Macclesfield on 18 July when he tried to pass one of the stolen banknotes. The bank cashier had kept a record of the numbers of the notes he'd given to William, and tradesmen in the area had been alerted. Taylor confessed to the crime and named his two accomplices. Dale was arrested on 8 August, tried at Chester Assizes, and executed on 21 April 1824 at Chester City Gaol. Taylor tried to commit suicide. He failed, but he injured himself so badly that he died later. Platt was never caught.

The hole that Mr Pott and Mr Mellor had noticed, where the murdered man's head had struck the ground, couldn't be filled in and nothing would grow there. Thirty years after the murder, in 1859, a local resident filled the hole with stones several times, but the stones disappeared within a few days on each occasion. Earth, turfs and everything else that might fill the hole suffered the same fate. The hole refused to be filled.

People have reported strange events around the site of the murder. They heard the flapping of a large bird's wings, but no bird could be seen. One man saw a jacket lying on a wall near the hole, but it disappeared before he could touch it.

The spot is now marked with an inscribed stone. The inscription reads:

William Wood, Eyam Derbyshire, Here murdered July 16th A.D. 1823.
Prepare to meet Thy God.

30

Dickey's Skull

Ned Dickson of Tunstead fought in the Huguenot Wars during the sixteenth century and distinguished himself at the Battle of Ivry, rescuing Lord Willoughby three times when he was unhorsed. On the third occasion, Ned was seriously injured. He lay all night on the battlefield, and when Willoughby sent men to rescue him on the following day, they thought he would die. However, he was well cared for over several months, and he recovered from his wounds. When he was fit to travel he took ship to England and returned to Derbyshire. By then, the campaigning season was over and winter had set in.

News of Ned's death in battle had already reached his cousin Jack Johnson and the latter's wife, and they'd claimed possession of his farm at Tunstead Milton. They treated the place as their own and enjoyed the profits of a good harvest, and then they settled down for the winter, in the house that was rightfully Ned Dickson's. But one dark night in December, as they sat beside the kitchen fire with two wax candles burning, there was a loud knock at the door. Jack and his wife exchanged glances. Who could it be, out in the winter dark? Jack rose from his chair, took a candle in one hand and a cudgel in the other, and went to the door. He opened it a crack and peered through, and the wind blew out the candle.

"Is it thee, Cousin Jack?" came a voice from outside. "It's me, Ned Dickson."

The Johnsons were speechless. How could Ned have returned from his grave on a foreign battlefield? But the figure at the door was no ghost; he was flesh and blood, though he was weary and starving. They invited him in, gave him food and drink, and made up a bed for him.

But their kindness was only an act. They had no wish to be deprived of the income from the farm. So when Ned was safely asleep, they crept upstairs and cut his throat. Then they carried his body from the house and buried him in a nearby field. As they returned to the farm, they sensed someone following them, but they could see nothing. Jack barred and bolted the door, but he and his wife didn't sleep soundly.

Over the following year, things went wrong at Tunstead Milton. The house was haunted by strange, unexplained noises. The crops failed. Jack Johnson and his wife fell ill. Then when winter came on, scarcely a year after Ned's return and murder, something strange and sinister appeared in the nook beside the fire. Jack's wife saw it first.

Tunstead Farm.

"What's that?" she cried. "Jack, what is it?"

The candlelight trembled on it: it was the head of Ned Dickson. Every night after that, the head appeared to them. Weeks passed, and the nightly haunting so distressed Jack Johnson and his wife that they're said to have cut their own throats, and they were buried at the crossroads as suicides; though some say Jack struck his wife and killed her, and then he died when an ancient oak that grew on the farm fell down on him. In any case, the couple died unpleasantly. They're said to haunt the roads near Tunstead.

The head of Ned Dickson, or rather the skull, remained in the house. The next owners took it to the churchyard in Chapel-en-le-Frith for burial, but they were forced to dig it up again and bring it back to Tunstead Milton. While Dickey's skull was absent, weird sounds, screams and disembodied voices haunted the house and the occupants had no rest; crops failed and animals fell ill. Twice more it was taken for burial in the churchyard at Chapel but had to be brought back; once the basket in which it was carried grew heavier and heavier as it was taken further from the farm. On another occasion it was thrown into Combs Reservoir, and all the fish died. While the farmhouse was being rebuilt, one of the builders threw the skull into a manure heap, and when they returned the next day all their building work had been dismantled. Nothing would go right until the skull was returned to its rightful place. Thieves once stole it and took it

to Disley, but it created such an uproar they were glad to return it to Tunstead. All subsequent owners kept it on the window sill or in a stone jar, and woe betide anyone who tried to remove it from the premises.

Dickey's greatest achievement was the diversion of the London and North Western Railway line from Whaley Bridge to Buxton in 1863. The planned route of the line was through Dickey's farmland. An embankment was built to support the line, but the foundations of the bridge built to carry the new track over the road to the farm kept sinking into the ground. After several failed attempts, the road and the line had to be rerouted.

An old lady from New Mills whose forebears lived at Tunstead recalled many occasions on which Dickey had warned the occupants of trouble. When one of the family was ill or an animal on the farm was in difficulty there would be a noise like wagon wheels over the roof of the farmhouse, whereupon her father would call, "Ah'm coming, Dickey owd lad, rest quiet." She also spoke of a black dog that would walk part of the way home with them if they'd been to Combs, and she associated it with Dickey watching over them. One farmer was roused from his sleep by Dickey just in time to prevent a cow from being accidentally strangled by its chain.

Dickey has remained the guardian spirit of Tunstead Milton, a benevolent presence provided he's treated with respect, but a menace when anyone tries to remove him or treats him disrespectfully.

31

Choosing a Servant

Mr and Mrs Shawcross kept a farm near the top of Barmoor Clough, between Chapel-en-le-Frith and Sparrowpit. Their housemaid went to marry a farmhand so the Shawcrosses had to find a replacement.

Farmer Shawcross said, "Ah'll go down to Chapel next Pack-Rag day. There'll be a few lasses lookin' fer work."

Mrs Shawcross said, "Ah'll go wi' thee."

She knew her husband would choose the prettiest housemaid if he were left to his own devices. She wanted a housemaid who would work, no matter what she looked like.

The town was crowded for the Pack-Rag fair. Farmers bartered for cattle and sheep and poultry; knife-grinders, tanners, fishmongers and quack doctors plied their wares; the taverns overflowed with drinkers; pies and sweetmeats were sold, and bonnets and laces and trinkets. At the old market cross in the middle of the cobbled square stood the farmhands, shepherds and housemaids awaiting hire;

A long-house, typical of traditional farmhouses in the Peak District and elsewhere in the north of England. This example – situated not in Barmoor Clough but near Glossop – has been modernised, but the essence of traditional farmhouse architecture is still apparent.

each housemaid carried her own mop. Three of the girls looked as though they might be suitable for the Shawcross household. The farmer was quick to state his preference but his wife wasn't so sure.

"We'll gi'e 'em a test," she decided, and told each of the three girls to come up to the farm at a different time on the following day. Then she and her husband bought food, examined the livestock on sale, and went home.

The next day, Mrs Shawcross stood at the window to watch the girls arrive. There was a stone path leading from the drove road up to the front door of the farmhouse, and Mrs Shawcross laid a besom across this path, not far from the door and in full view of the window.

Soon the first girl came up the path, and she kicked the besom out of her way. Mrs Shawcross shook her head.

"Yon's an idle slut as winna bend 'er back."

So although the girl was quite pretty, she was sent home. Mrs Shawcross put the besom back in its place across the path.

When the second girl arrived, she jumped over the besom and skipped up to the front door. Mrs Shawcross shook her head again.

"She winna do, neither; she'll skip 'er work."

So although the girl was lively and good fun, she too was sent home disappointed. Once more, the besom was put back in its place across the path.

The third girl arrived, and when she saw the besom she picked it up and stood it carefully in a nook beside the wall of the farmhouse. Mrs Shawcross nodded.

"That's th' reet girl fer th' job. She'll be careful, 'ard-workin' an' tidy."

So although the third girl was plain-looking and rather slow-moving, she became housemaid at the farm, and she stayed there for many years, happily working for the Shawcross family.

32

Eldon Hole

On the moor between Castleton and Peak Forest, beyond the top of Cave Dale, the ground opens to reveal a deep, dark, vertical pit called Eldon Hole. This pit was long thought to be bottomless. It was believed to join Peak Cavern deep below the surface of the earth. Both these entrances to the underworld were thought to lead to Hell, so wild garlic was planted around the rim of Eldon Hole to keep the Devil in his place.

Eldon Hole.

The wild garlic seems to have worked, because there are no reports of the Devil appearing in that part of the world. But one incident showed that the precaution was worthwhile. Some of the more inquisitive local people decided to investigate whether there was indeed a connection between Eldon Hole and Peak Cavern. For this purpose, they threw a goose down into the pit and watched it disappear into the darkness, flapping its wings helplessly. Its frightened honking grew fainter and fainter, and then there was silence. Everyone went round to the opening of Peak Cavern to see whether the poor goose would make its escape that way.

Two days later, it did indeed emerge from Peak Cavern. It was still in a state of terror.

All its feathers were singed.

33

The Deer Hunt

After the war between Stephen and Matilda was over and Henry II sat on the throne of England, William Peveril and his retinue went out hunting. They waited on horseback on the Lord's Seat for the hounds to raise the deer. The Lord's Seat, two miles west of Mam Tor, commanded a view over all the Royal Forest of Peak and beyond. But as they waited, the wind brought to their ears the sound of a hunting horn. Peveril was enraged.

"Who dares to hunt in the Royal Forest without my leave? I'll see them hanged for it!"

One of his servants replied, "It's Bruno of Bowden, sir. He's a rich franklin, and his people have always hunted this land."

"Then he'll learn to obey Forest Law," shouted Peveril. "He won't hunt again when I've hanged him from the highest branch of a tree that will bear his weight!"

But Peveril's kinsman, Payne of Whittington, said, "If we seek to capture Bruno there will be bloodshed, because he rides with a strong company of spearmen. I'll go and order him to leave the borders of the Forest and submit to your authority. If he goes peacefully, the Law will have been obeyed and there will be no need for punishment."

So taking two of his men with him, Payne rode down to the valley to order Bruno of Bowden to cease hunting and make his peace with Lord Peveril. But Bruno would have none of it.

"I've always hunted this land and I always will. Go and threaten someone who fears Peveril, for I don't! Let him come to me himself, if he wishes to die!"

Payne returned to the Lord's Seat and confessed his failure to William Peveril.

Peveril said, "Then tomorrow, we'll take all our men-at-arms to Bowden and make an end of this miscreant."

But that very night, King Henry's men arrived to arrest Peveril for the murder of Ranulf of Chester, the king's friend, and Peveril was forced to flee. So Bruno of Bowden went on hunting in what was now the Royal Forest of Peak, as his father and grandfather had done before him.

Forest Law was ferocious, but not always easy to enforce.

<div align="center">34</div>

Wheston Hall

John was only nineteen when his parents moved to Wheston Hall at the end of the First World War. He had a fine bedroom with a view over the fields towards Tideswell. But on the first night he slept there, he was awakened by the door creaking open. Standing on the threshold of the room was an elderly lady wearing a crinoline dress and a poke bonnet. She was holding the edge of the

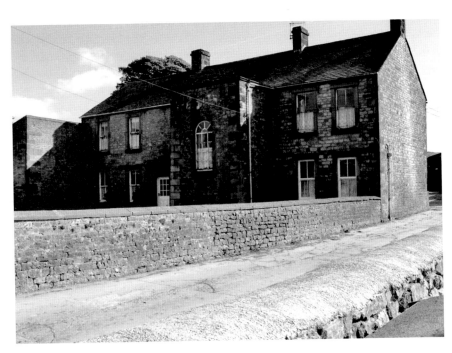

Wheston Hall.

door with her left hand. She gazed slowly and thoughtfully around the room, and then she left. John found himself shaking in his bed and sweating from every pore. He wondered if he'd seen a ghost; he'd never seen one before.

About the same time the following night, the old lady appeared again. This time, John hid under the bedclothes until she was gone.

On the third night, he equipped himself with a torch. When the old lady appeared he called, "Who are you and what do you want?" There was no reply, so he switched on his torch and shone it at her. This time she didn't withdraw from the room; she just disappeared before his eyes.

On the following morning, having slept badly for three nights in a row, he dismantled his bed and moved it to another room, along with all his possessions. Then he went downstairs to breakfast. In the hall he met an old steward who had worked in the hall throughout his adult life. The old man glanced at the boy's face and said, "Tha's seen th' owd lady, Master John."

Being nineteen, John was embarrassed and denied the charge, but the steward wasn't fooled. He declared, "Aye, tha's seen 'er, an' it's no good denyin' it. Ah can see th' ghost fright i' thy face."

He went on to recount many sightings of the old lady over the years. Several generations earlier, a group of young men had been drinking and playing cards one Saturday night in the middle of winter. It was bitterly cold outside and there were two feet of snow on the ground, but it was warm and cheerful in the hall, with the fire blazing high and the place aglow with candlelight. The youths were having such fun that they didn't hear midnight chime, so before long they were drinking and playing cards on the Sabbath. Without warning, the door of the hall burst open and a cold blast of winter air blew out most of the candles. On the doorstep stood an old lady in a crinoline dress and a poke bonnet, looking furious and outraged. The young men leapt to their feet, drinks and cards and chairs flying in all directions, and fled to the kitchen. A few minutes later they recovered their courage and returned. The door was still open but there was no sign of the old lady, and there were no footprints in the snow.

35

Owd Nick o' Wormhill

Mr Bagshaw of Wormhill Hall employed a shepherd called Nicholas Bower, who was known as Owd Nick. Owd Nick was such a fine shepherd that he never lost a single sheep. He was simple and eccentric, but everyone liked him, including Mr Bagshaw. Indeed, Mr Bagshaw often invited him into the hall for supper, even when he had distinguished guests, because he was so entertaining.

Stories 35–40. Again, relatively few stories have been collected from this area, but they include the three-part "mermaid" tale (see also sketch maps 1 and 6) and vary widely in type.

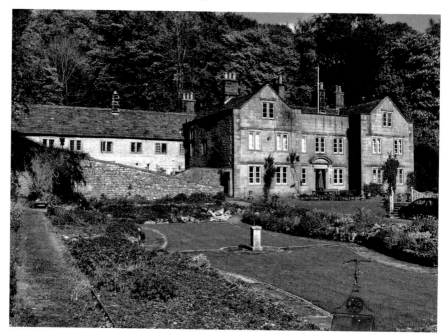

Wormhill Hall.

One night, watching a full moon rise, Nick announced, "If Ah'd a fishin' line, Ah bet Ah could catch yon moon." And once when he'd been fed mutton stew he said, "Ah reckon th' sheep's give us 'and-me-down gress, just like me faither gid me an 'and-me-down coat when Ah were a nipper."

One morning, Mr Bagshaw said to Owd Nick, "Nick, when you're back from the fields this evening, come to supper. An old friend is dining with me. But I must warn you: he has a very large nose, and he doesn't like to be told about it. Whatever you do, don't say anything about his nose!"

Owd Nick went to tend to his sheep, and that evening he came to the hall as instructed, and sat down at table with Mr Bagshaw and his family and some of the more favoured servants, and Mr Bagshaw's guest with the very large nose. Nick usually entertained the company with his unexpected and witty observations, but that evening he was completely silent at the supper table. And after a while, the master of the house asked him what was wrong. So Nick explained:

"Ah remember yer honour towd me this mornin' not to say owt abaht th' gentleman's big nose. So Ah 'avena."

Everyone laughed, including the distinguished guest, who gave Owd Nick a shilling to show that he hadn't taken offence. A few minutes later, Nick got up from the table and left the room and wrapped his shilling up in a piece of cloth; then he hid it in a small hole in the wall. Unbeknown to him, Mr Bagshaw and his guest watched him hide it. So when Nick came back to take the shilling out

of the wall again, just a few minutes later, he discovered there were now two shillings wrapped up in the cloth.

He stared at the coins, thought for a moment, and then he wrapped them up in the cloth again, put them back in the wall and went away.

A few minutes later he was back again. When he took the cloth out of the wall this time and unwrapped it, he found two shillings and sixpence. He studied the coins, scratched his head, hesitated, and then put the money into his pocket.

"It's growin'," he muttered. "It's growin' reet fast, but it may 'a got a blight on it, so Ah'll purrit i' me poke while it's still aw reet!"

And off he went to his shepherd's cottage, two shillings and sixpence the richer for having not said anything about the distinguished guest's big nose.

36

Lovers' Leap

Young Nicholas had two loves: his black horse, Nimrod, who stood at nearly seventeen hands; and the beautiful Rebecca. Nicholas's father had made a fortune in trade and he'd built a mansion for himself on the outskirts of Buxton. Rebecca's father was a gentleman who traced his ancestry back over generations of aristocracy; he lived in Fairfield, which was then a separate village. The two families knew each other but moved in different social circles. Rebecca's father planned to marry his daughter into the nobility, or at least the gentry. Nicholas's father wanted his son to choose someone of his own social class – preferably someone with her own fortune, though he already had more money than he could ever need.

Nicholas had been sent to a good school and then university, where he'd indulged in pursuits that were popular among young men with too much money, too little supervision and too much free time. He'd won and lost small fortunes at the card table, he'd drunk to excess, he'd indulged in boxing matches, he'd fought duels – and he'd done other things of which his father would have disapproved. Most of all, he'd raced Nimrod against other horses; and every time he raced Nimrod, he won. He took great pleasure in hunting. He and Nimrod never thought twice about obstacles that most riders, even experienced hunters, avoided for fear of breaking their necks. Nimrod cleared every hedge and ditch with daylight to spare. Nicholas had been offered huge sums of money for Nimrod, but not for his life would he part with his horse.

Remarkably, Rebecca was as deeply in love with Nicholas as he with her. Such a well-bred young lady would have been expected to favour a steady, sensible man who was careful with money and took no risks. But unsuitable though

Nicholas was, Rebecca wanted to marry him. Of course, neither of their fathers would agree, so the couple were obliged to meet in secret. Only Rebecca's maid knew about their trysts. What were they to do? What could young people do when their families refused them permission to marry?

Nicholas had the answer: they would elope, run away to Peak Forest, and marry as runaways. In those days, the Peak Forest chapel sanctified runaway marriages, as Gretna Green did later. It was not a respectable scheme, and Rebecca was reluctant, but Nicholas persuaded her there was no alternative. So they planned to wait until the next full moon and to make their escape at midnight.

When the appointed night came, Rebecca crept out of bed fully dressed, collected her riding habit and hat, and stole out to the stable. Her mare, Auster, was already saddled. She'd followed her lover's instructions and wrapped cloths around Auster's hooves so her departure wouldn't be heard. She led the horse from the stable, mounted, and trotted quietly into the road. There, in the light of the full moon, Nicholas awaited her, upright in his saddle on the great black horse, Nimrod. The horses neighed softly and sniffed each other. Nicholas and Rebecca embraced quickly, then turned and rode down the hill from Fairfield and into the Wye Valley.

But an interfering servant had witnessed Rebecca's departure. Quiet though Rebecca had been, one old family retainer was a light sleeper. Looking out of the casement, he'd seen the master's daughter riding out of the stable. Guessing what was afoot, he'd gone to the master's room and wakened him. The old man summoned the household in fury. He was dressed and ready for the road more quickly than any of them had ever seen, and within minutes he and two of his sons were on their horses and pursuing the runaways. He sent two servants to rouse Nicholas's father, and a few minutes later the wealthy trader and two of his toughest manservants had joined the chase. The eloping couple weren't far ahead, and with Rebecca riding side-saddle on old Auster, their progress was slow. The pursuers whipped their horses to a gallop and soon they were hard on their heels.

Nicholas knew they were being followed. If he and Rebecca took the new turnpike that followed the river through Ashwood Dale, they'd soon be overtaken. So he led his fiancée and Auster up the hill to the right of the valley and followed the old drove road, a rough track he knew well. But his father knew it, too, and guessed his son's choice of route. So the pursuers also left the turnpike and cut up the hill to the drove road. Within minutes, Nicholas and Rebecca could hear them close behind.

Then Auster cast a shoe and went lame.

"It's no use, Nicholas!" cried Rebecca. "Poor Auster can go no further, and our families will be upon us in less than a minute!"

Nicholas made no reply. Instead, he lifted Rebecca out of her saddle and placed her behind him on Nimrod's back. Ordering her to cling tightly to him,

The Lovers' Leap in Ashwell Dale, a deep fissure in the limestone cliff beside the Wye Valley.

he drove his knees into the horse's sides and dropped his hands. Nimrod tossed his head and whinnied, then despite the double load he was carrying, kicked up his hooves and galloped along the drove road as though it were the racetrack at Newmarket. Yet the pursuers were close and coming closer.

A mile or so beyond Buxton, the old drove road detoured around a deep chasm in the rock. Nicholas knew about the detour, and about the chasm, but he knew that if he and Rebecca were caught, their chance of happiness was gone forever. So he urged Nimrod into an even faster gallop and rode straight at the chasm. Looking over her lover's shoulder as he stooped low in the saddle, Rebecca could see the black gulf ahead of her, twenty yards wide, and the moonlight shining on the bushes on the far bank. Surely Nicholas would not try to jump his horse over such a distance? She shut her eyes and screamed. Nimrod reached the edge of the chasm. He jumped.

Behind them, the pursuers had found Auster, and one of the servants had taken the old lame horse back home. The rest set off again with renewed purpose. Even such a fine horse as Nimrod must be slowed by the double load. Very soon they came to the bend where the road deviated around the chasm, and they rode on. But Nicholas's father reined his horse to a halt.

"Stop! If I know my son, he'll have tried to jump the chasm to make up for lost time!"

"Impossible, sir," snapped Rebecca's father. "It's too wide. No horse could jump that distance in full daylight, let alone at night – and carrying two riders!"

"You're right," agreed Nicholas's father. "No horse could. But Nicholas will have tried."

So while Rebecca's two brothers galloped on around the bend of the drove road, seeking the runaways, the two older men rode back to the turnpike. They entered the black chasm with heavy hearts, dreading what they might find. Nicholas's father lit a lantern, and shadows sprang up around them. But of Nimrod and the eloping couple there was no sign.

Rebecca thought an eternity had passed after Nimrod's hooves left the earth, and she prayed. But then the horse's front hooves struck the ground at the far side. For a long moment he seemed to scrabble with his hind hooves, seeking a purchase, and Rebecca almost fell from his back. Only by holding tightly to Nicholas did she stay mounted. Then, suddenly, they were on level ground, and Nimrod was galloping forward once more. Rebecca's brothers were too far behind them to be heard.

Within half an hour the runaways were at Peak Forest, rousing the minister and demanding to be married forthwith. And so they were. After the wedding they rode south and settled near Derby. It's said that they lived happily ever after. If so, we must suppose that Nicholas mended his ways, perhaps under the influence of a good wife.

<div align="center">37</div>

The Chelmorton Hob

One night long ago, a farmer from Chelmorton called Joseph Swindells was walking home from his sister's cottage. He'd taken a sackful of provisions to her family and stayed late into the evening, drinking ale, and now he was carrying the empty sack back to his farm. He was staggering a little but he was in no danger of losing his way: he knew the path like the back of his hand, and in any case it was a clear night and the moon was full. It was completely silent, except for the tinkling of a little stream and the occasional hoot of an owl and faint scamperings of small night creatures among the grass.

Then, beside the path in front of him, what should Joseph see but a hob!

He couldn't believe his luck. He wasn't married, and he couldn't afford to keep house servants as well as farm labourers. And since he'd no taste for housework, especially after a hard day's work in the fields and among the livestock, his farmhouse was dirty and untidy – to the point that his sister wouldn't bring his little nieces and nephews to visit him. Now as everyone knows, if you can tame a

The hob's cave, high on the steep
slope of Deepdale.

hob it will do all your housework in an evening, and ask no more payment than a
glass of ale and a bowl of porridge every day. So Joseph decided to catch the hob
and take it home with him.

Moving very carefully and quietly, he crept up behind it and then – just as it
sensed his presence and made to run away – he picked it up, put it into his sack,
and tied the neck of the sack tightly. Then off he went again, still staggering
slightly but whistling a happy tune. Soon his house would be clean and tidy, and
it would cost him no more than a glass of ale and a bowl of porridge every day.

But as Joseph walked on, the hob started to cry and to beg his captor to
let him go. Joseph wasn't an unfeeling man, and the little creature's sobs and
pleading touched him. He said, "Ah winna 'urt thee; Ah only want thee fer t'
look after me 'ouse." But the hob's cries grew louder, and soon heart-wrenching
wails issued from the sack.

Either Joseph was afraid of disturbing the peace, or he took pity on the hob,
but he couldn't stand the cries any longer. He lowered the sack to the ground
and untied the top. The little hob leapt out and scampered all the way back
to its home in a cave in Deepdale, a little way below Topley Pike. Joseph was
disappointed that he'd have to clean his own house after all, but he was pleased
with himself for showing mercy.

Today, the hob's cave is known as Thirst House. Just outside it there's a spring.
It's said that the hob charmed that spring in gratitude to Joseph Swindells for

releasing him, and that anyone drinking from it on Good Friday will have all their ailments cured. But if you go there, you probably won't meet the hob. There's an invisible doorway inside the cave that leads to the land of Faerie, and you can never find that doorway – unless you're a special kind of person, and you have the right kind of key.

<div align="center">38</div>

The Quiet Woman

The inn sign of the Quiet Woman in Earl Sterndale depicts a headless woman in a long dress. The motto reads "Soft words turneth away wrath". There are two stories about the origin of that sign.

The first concerns Chattering Charteris, a shrew of a woman who lived in Earl Sterndale in the twelfth century. Chattering Charteris was a scold who never stopped nagging except when she was asleep. Everyone in the village

The inn sign of the Quiet Woman, Earl Sterndale.

detested her. She made her husband's life a misery; the poor man never got any rest. Finally, she began to talk in her sleep as well, and that was the last straw; her husband couldn't stand it any longer, so he cut her head off with an axe. When he confessed to his neighbours what he'd done, they collected money for him by way of celebration. Some of the money was spent on a headstone for Chattering Charteris, with a warning to all nagging wives inscribed on it, and the rest was given to the grieving widower as a present. He lived happily ever after.

The second story is less gruesome. Every market day, the landlord of the inn at Earl Sterndale went to Longnor market, about two miles away. Being a man of fixed routine, he always arrived home at the same time. But after one market he was delayed by bad weather and a fallen tree that had blocked the road. When he finally reached home, his wife was angry with him for being late. He was angry, too, because in spite of the awful weather she'd sent one of the young servants to look for him. The result was a long, loud and heated argument. The argument ended when the landlord walked out of the inn declaring that if he couldn't have a quiet woman inside his house, he'd have one outside instead; so he had the inn sign painted.

<div align="center">39</div>

Lud's Church

Near Gradbach in the upper reaches of the Dane Valley, where the Back Forest slopes down to the river, lies a deep gloomy cleft in the limestone called Lud's Church. Here, in the years around 1400, Walter de Ludauk celebrated Christian services with his fellow Lollards. One day during the reign of Henry IV, Lancastrian soldiers seeking Lollards discovered this secret meeting place and de Ludauk was arrested. During the skirmish, his granddaughter Alice was killed.

Even in daylight, it's easy to recognise that Lud's Church is haunted. It is 50 feet deep and 200 feet long but no more than 10 feet wide over most of its length, so even on the brightest summer day it is dark and dank. The limestone walls are green with mosses and plants of many kinds, and small holly bushes have taken root in the upper slopes. At twilight, and later, it takes on a sinister air. Alice's ghost has been seen there, and weird floating lights hover above and around the place.

Alice is probably the Ghost of Back Forest, described 150 years ago, but there is also the fearsome Bosley Boggart, who in years past terrified the neighbourhood. It is hard to imagine the ghost of a child killed during a fifteenth-century skirmish setting out to frighten the inhabitants of Gradbach.

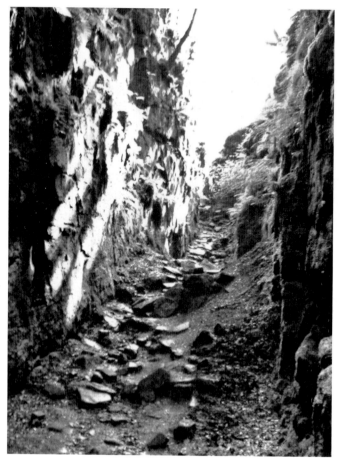

Lud's Church.

40

Three Mermaids

The Peak District is a long way from the sea, but it's home to three creatures that local tradition calls mermaids. They are not like the nature spirits that guard our wells, which are kind if you respect them. The three mermaids are dangerous. If you go to visit them, take a sprig of rowan with you. It might not be enough to protect you, but it could be better than nothing.

The first of the three is beautiful, though her home is remote: a cave hidden among the rocks of the western shoulder of Kinder Scout. Every day she creeps out into the light to bathe in the pool beside her cave, a stretch of cold dark water fringed with brown reeds, but she is seldom visible to mortal eyes. Only on Easter Eve may you be fortunate enough, or unfortunate enough, to see her

Blake Mere.

swimming. If you do see her, she may grant you the gift of a long life. Aaron Ashton, a soldier who had fought against France in the days of George III, often walked to the Mermaid's Pool from his home in Hayfield, and when he died in 1835 he was 104 years old. But sometimes the Kinder Scout mermaid leads people to their deaths. Many men have drowned in her pool, trying to outswim a phantom. A witch who troubled Hayfield in the eighteenth century also drowned there; when malevolent forces compete, the immortal one always wins.

Several miles to the south, high upon Morridge on the Staffordshire moors, lies a circle of water called Blake Mere, or Black Mere, which is bottomless. If you gaze for long enough on the shimmering surface of Blake Mere, especially at midnight, the second mermaid will rise from the depths, combing her hair like the sea-maids of old. She will call out to you, and when she does so, curiosity or some other impulse may tempt you to walk to the water's edge and approach her. Many unwise young men have done that, and they've never been seen again. There's an old local rhyme:

> *She calls on you to greet her,*
> *Combing her dripping crown,*
> *And if you go to meet her,*
> *She ups and drags you down.*

Many unexplained deaths have occurred in that neighbourhood, and wise travellers avoid Blake Mere. Even at midnight, of course, you might not see the mermaid, or not all of her. You might see no more than an arm rising from the middle of the water, beckoning you slowly and hypnotically.

If on a clear day, well before the sun sets, you stand beside the shore of Blake Mere and survey the hills to the north-west, the jagged line of Ramshaw Rocks and the Roaches, you're looking towards the Doxey Pool. They say it was named after Hannah, daughter of the notorious highwayman, Bowyers of the Rocks; "doxy" was one of the more polite names for Hannah. The waters of the Doxey Pool are perfect for scrying, but even among those with the power of scrying, few dare to try. The Doxey Pool is where the third and most dangerous of the mermaids dwells. She is hideous and hostile, and her name is Jenny Greenteeth. If you stray too close to the Doxey Pool, or decide to swim in it, as Mrs Florence Pettit did in 1949, then Jenny Greenteeth may rise before you, a thing of slime and weeds growing from the pool to a height of twenty-five or thirty feet, her feet brushing the surface of the water, her eyes fixed menacingly on you, her long bony fingers reaching out for you, her mouth agape and her pointed teeth dripping. And then you had best run as far as you can from the reach of her watery arms, or no more will be seen or heard of you. Mrs Pettit survived her encounter with Jenny Greenteeth because she ran.

They say that the three pools – the Mermaid Pool on Kinder, Blake Mere on Morridge and the Doxey Pool on the Roaches – are joined by watery ways that lie beneath the land on which we walk. Some even say that they're linked to the sea, which is why they are salty. No animal will drink from those pools; no fish swims in them; no bird will fly above them. And they say that the three creatures that inhabit them, although they appear different to our eyes, are sisters. Indeed, they could be one and the same being, which manifests itself in three different forms in those three watery places.

41

The Girl who Fetched Water
in a Riddle

In a small cottage at the edge of Calver village lived a little girl called Rebecca. Her stepmother made her do all the hard work about the house. Every morning she had to take the bucket to the well to fetch water so she could cook dinner for her father and stepmother, clean the floors and wash the clothes. Sometimes she had to fill the bucket four or five times, sometimes even more.

Stories 41–55. The area surrounding Bakewell has proved a considerably richer source of stories. The two locations for story 46 ("Prince Arthur and the Vision at Haddon") indicate the Hassop crossroads, now a roundabout, north of Bakewell, and Haddon Hall itself.

One day, Rebecca found the bucket was split and the handle was missing.

"How can I carry water from the well without my bucket?" she cried. "I must fetch water, but how?"

"You will have to find something else to carry the water," said her stepmother, "and be quick about it!"

"But what else can I find?" asked Rebecca.

In the hedge beside the cottage sat two robins. They sang, "Use the riddle, Rebecca. Fetch water in the riddle!"

"Silly robins!" said Rebecca. "How can I carry water in a riddle?"

But the robins sang again, "Use the riddle, Rebecca. Fetch water in the riddle!"

So Rebecca took the riddle from the nail in the shed wall on which it hung and set off to the well, and the two robins followed her. She poured water from the well into the riddle, but as fast as it went in, out it came again. The robins chirped loudly. It sounded as though they were laughing.

"Silly robins!" said Rebecca. "I can't carry water in a riddle! I shouldn't have listened to you!"

And the robins sang:

Stuff your riddle with moss,
And daub it with clay,
And carry your water
Right away.

But Rebecca was angry with the robins and she said, "No, I shan't, you ugly birds." And she poured water into the riddle once more. But as fast as she poured it in, it came out again.

Once again the robins sang their song:

Stuff your riddle with moss,
And daub it with clay,
And carry your water
Right away.

So Rebecca gathered moss and clay, and she stopped up the holes in the riddle as the robins had told her, and this time the riddle held the water from the well and she carried it home to her cottage. Her stepmother was angry because she had not expected the little girl to find a way of fetching water without a bucket, and had been considering how she might punish her.

Outside the cottage, the robins sang with joy.

William Cundy and the Eagle Stone

William Cundy of Baslow kept a night-long vigil in the church porch every St Mark's Eve (25 April) so he'd have a vision of all those in the village who were to die during the coming year. According to one writer in the early twentieth century, Mr Cundy was "esteemed as having a knowledge of medicine and herbal healing superior to that of the local general practitioner". Mothers went to him to request potions to cure sick children, and he dispensed charms to restore the affections of those who'd jilted their sweethearts. Local farmers sought his help for treating sick animals.

One day a little girl from Baslow went missing and a frantic search for her brought no results. Her parents went to see old Mr Cundy. He used various charms and studied an astrological chart, and then directed the girl's father to the Eagle Stone on Baslow Edge.

"She'll be theere, safe an' sound, fast asleep wi' 'er bonnet aside her," he promised.

Her father scrambled up Baslow Edge and sure enough, there was the little girl, unharmed and sleeping soundly in the shadow of the crag, with her bonnet beside her.

The Eagle Stone.

The Calver Thieves

Fred and Harry were cheerful lads who never did an honest day's work; they stole from neighbouring villages during the dark hours of the night. They never hurt anyone, but they'd have been hanged if they'd been caught thieving. But the prospect didn't stop them.

One Hallowe'en early in the 1800s, they planned to steal a sheep from a field beside the Derwent at Baslow. Butchered and salted, a large sheep would provide them with meat for much of the cold winter to come. But Harry had doubts.

"Ah dunno, Fred. Yon field's reet next to th' manse. Th' parson's bound for t''ear th' sheep blartin' while we're catchin' it."

"Th' parson winna do owt, 'Arry." Fred's voice was deep and rumbling; it frightened the constables. "'E's too fat for t' shift 'imsel' unless someb'dy carries 'im. An' they reckon 'e's got gout bad. Not surprised, road 'e drinks."

So when darkness fell, Fred and Harry crept away from their native Calver and crossed the fields to Baslow. They'd known the land since they were children, so a three-mile walk each way was no obstacle to them, and the prospect of bearing a heavy sheep carcase on the way home scarcely gave them pause for thought. They were big strong lads, Harry especially.

In the churchyard, they completed their plans. Fred would hide in the church porch to keep watch while Harry went down to the field to catch the sheep.

"Mek sure tha fetches us a good big fat 'un," rumbled Fred.

As he intended, he had the easier task, and he could indulge himself while he waited in the cold Hallowe'en darkness of Baslow churchyard. Earlier in the day he'd stolen a bag of nuts from a farm up in Curbar, so while he sat in the porch waiting for his companion to return with a fat healthy sheep, he started to crack and chew the nuts.

The sheep Harry had selected didn't want to be caught. While Harry was chasing it round the field and Fred was cracking and chewing nuts in the church porch, the village sexton came to ring the curfew. The sexton was a superstitious man who didn't enjoy wandering the gloomy churchyard at night, particularly on Hallowe'en, and he picked his way among the gravestones shivering, glancing over his shoulders as he went and muttering a prayer to ward off evil spirits. As he approached the church he heard the sound of cracking and chewing, but he could see nothing in the darkness.

"'Tis th' Devil devourin' wayward souls!" he moaned. "And there's plenty on 'em i' this parish!"

With that, he took to his heels and fled to the manse to fetch the parson. Now the parson was a fat, jolly, lazy man who enjoyed good food and drink, plenty

The porch of Baslow church.

of both, several times a day. Fred was right about him: he was so crippled with gout he could walk only a few steps, and had to be carried from the manse to the church in a chair so he could conduct services. He wasn't impressed by the sexton's story.

"Go and ring th' bell, tha fool, an' dunna talk such twaddle!"

But the sexton wouldn't go back to the church alone. He insisted the parson come with him. At length the parson realised that if he didn't consent, the curfew wouldn't be rung; but his gout was very painful.

"Aw reet, then, Sexton. I'll go wi' thee. But tha''ave for t' carry me."

The sexton was obliged to agree, and the parson climbed on to his back. He was no lightweight. By the time the sexton had managed to stagger from the manse to the churchyard, his knees were buckling; and as he neared the church, he moaned again with terror, for the sound of cracking and chewing could still be heard. Even the parson was alarmed: it seemed the sexton was right, and after all it was Hallowe'en. But they had to enter the church to ring the curfew bell.

At that moment the moon came out from behind a cloud. Fred, still cracking and chewing nuts, saw a man approaching, carrying something large and plump on his back. So he called out from the black darkness of the porch, in his deep growling voice.

"'As tha fetched us a good big fat 'un?"

The sexton shrieked, dumped the parson from his back on to the path, shouted "Aye, an' tha con tek it if tha likes!" and fled, clearing the wall of the churchyard in a single bound. He didn't stop running until he'd reached his cottage and bolted the door behind him.

Shortly afterwards, Harry caught the sheep, a fine fat animal, and brought it to the churchyard, and the two thieves made their way home to Calver. They'd done the Devil's work that night. They left nothing behind them except a few nutshells scattered around the church porch – which the sexton, to his shame, discovered the following morning.

As for the parson, lying in the mud and believing that the Devil was about to seize him and chew his soul, he followed the sexton at full tilt and was back in the manse faster than he'd ever run in his life. It was a miracle. He'd discovered a cure for gout.

<div align="center">44</div>

Hulac Warren and Hedessa

When giants roamed the Peak District and the old gods walked the earth, Fin Cop was the stronghold of a powerful clan that controlled Dymyndale to the west and the Portway to the east. The chief of the clan was known as Fin, in honour of his fortress and of Fin the sun god, and his people were called the sons and daughters of Fin. The sons of Fin ploughed the stubborn slopes and hunted boar and deer and learned the arts of war, and the daughters of Fin looked after the flocks and herds and cared for their homes and their children.

Fin and his priests spoke through Hob Hurst the Fiddler, who lived on the north face of Fin Cop. When Hob Hurst played his fiddle on the high slopes of Fin Cop, the sons of Fin sang and danced and the gods heard.

The Old Woman, the Mother of the Clan, led the daughters of Fin in rituals to honour the goddesses of rivers, hilltops, springs and wells. When the moon was full they danced in the valley beside Shacklow Wood to the tune of the horned piper of the wood, Cernunnos of the Wild Hunt.

The men of the clan didn't intrude on the women's rituals, or the women on the men's. Only when some common need affected the clan did they summon the help of all their gods. Then the Mother of the Clan called them together through Hob Hurst the Fiddler and Cernunnos the Piper:

The Piper of Shacklow,
The Fiddler of Fin,
The old woman of Dymyndale
Calls them all in.

Hedessa was the fairest of the daughters of Fin, a gentle girl who tended the flocks in the valley by day and danced to the Piper of Shacklow at night when the moon was full. Many youths paid court to her, but if she favoured any of them, she gave no sign. But news of her beauty spread far and wide, and the giants heard. When the Festival of Imbolc was passed and spring arrived, and the flowers bloomed in the meadows and the lambs were born, the ugly giant Hulac Warren came to Dymyndale to see Hedessa. Sheltering under rocks and in caves from the wind and rain, he kept watch. As soon as he saw Hedessa, he was determined to have her for himself.

So one morning, when Hedessa left her hut above the river bank to attend to the milking, Hulac strode down the hill towards her and begged her to return with him to his home amid the rocks. But she was repelled and frightened, and she ran away and asked the Mother of the Clan what she should do about the ugly giant.

"Ask the gods to protect you, Hedessa," said the Old Woman, "for if Hulac Warren touches you it will bring death to you both."

So Hedessa returned to her flocks and herds and asked the gods for protection, and she shouted, "You may never touch me, Hulac Warren, for it would be the death of us both."

After that, if one of Hedessa's lambs wandered away from the flock, the gods gently guided it home again so Hedessa would not be at risk.

Hulac returned to his shelter amid the rocks, half-mad with desire for the daughter of Fin, and heeded no warning. One evening, as Hedessa was driving the herds to the safety of the meadows near the clan's huts, he came to her again and begged her to return with him to the home he had made. Hedessa ran to the Mother of the Clan again and asked what she should do.

Once again the Old Woman warned her, "Ask the gods for protection; if Hulac Warren touches you it will be the death of you both."

So Hedessa returned to the meadow and to her flocks and herds and asked the gods again to protect her, and she shouted, "You may never touch me, Hulac Warren, for it would be the death of us both."

The Old Woman spoke to Fin the Chieftain of the Clan and told him that Hulac Warren would bring trouble on them all because of his desire for Hedessa. Fin was troubled, and he told Hob Hurst the Fiddler.

"Although the gods are protecting Hedessa," said Hob Hurst, tuning his fiddle, "they will do nothing to Hulac Warren because he's caused no harm." And he played a tune that made the sons of Fin dance and forget their troubles.

Then one moonlit night, after the women had danced to the Piper's tune below Shacklow Wood and were returning home, Hulac Warren lay in wait among the bushes beside the river bank. As Hedessa passed, he seized her and carried her away to his lair among the rocks at the top of the hill. Hedessa wept bitterly and begged the gods to save her. Whether what followed was an accident, or

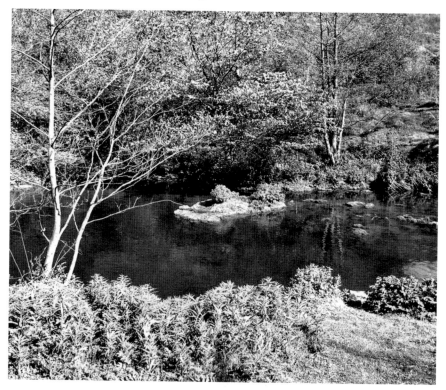

The Warren Stone in the River Wye below Fin Cop.

whether she threw herself down the cliff, or whether the gods took her life, no one knows; but she fell from the hill, and her body struck the ground beside the River Wye, and she died. Fragments of rock fell from the precipice and made a protective circle around her body, and a spring of pure water began to flow from the bank where she lay.

Hulac Warren saw Hedessa's body and was enraged that his prize had been stolen. He raised his giant fists and cursed the gods for their cruelty. The gods heard the giant's blasphemy, and they turned Hulac Warren to stone. Then Aigle, with his mighty strength, hurled him far out into the valley, where he fell into a bend of the river; and there he remains to this day, a great rock that people call the Warren Stone.

The warm spring still flows from the hillside where Hedessa fell and died. They say it's the tears of the fairest daughter of Fin, and they call it the Hedess Spring. But those who pass along that section of the river bank keep as far away as possible from the Warren Stone, which they say is cursed.

The Wizard of Monsal Dale

Shortly after the end of the Napoleonic Wars, an old man called Neddy Higgins lived in a cave in Monsal Dale with his daughter Becky. The cave was said to be haunted by Faerie folk, so it was a good home for Neddy and Becky; Neddy was reputed to be a wizard, and Becky was a witch.

Tom Middleton farmed the fields on the north side of the Wye. One morning, Tom found that two dozen of his sheep had disappeared during the night. He took his dogs and a couple of farm hands and searched all around the area, over to Wardlow, towards Litton and up to Monsal Head, but no one had seen the animals. They'd been stolen.

Two old labourers said, "Why does t' na go an' ask Neddy 'Iggins an' is dowter? They'll tell thee where tha sheep 'ave gone."

Tom didn't believe in magic, but he'd run out of ideas. So off he went, across the river and up the north side of Fin Cop to the wizard's cave. He could smell it before he saw it: smoke from many years of fires, cooking, unwashed bodies, exotic spices and strange animal odours. As the cave came into view, he saw bones scattered among the limestone boulders scattered down the hillside. He didn't stop to see what kind of bones they were. He nearly had second thoughts about visiting the wizard, but he couldn't afford to lose twenty sheep, and Neddy and Becky were his last hope. So he climbed to the cave entrance and shouted, "Neddy 'Iggins! Are t' at 'ome?"

And from the darkness inside the cave, a voice replied, "Aye, Ah'm 'ere, Tom Middleton! Come on inside."

That seemed friendly enough, but Tom wondered how Neddy knew his name, since they'd never met. So he hesitated again, thinking he'd be better off going home; but he remembered his lost sheep, so into the cave he went.

It was very dark. When Tom's eyes adjusted, he saw a little old man sitting on the cave floor beside the embers of a fire. He was dressed in filthy rags, his head was bald, his face was wrinkled and his long white beard was uncombed; but his eyes were bright blue and full of life. He grinned a toothless grin and asked, "What's to do, then, Tom, that's made thee come an' see owd Neddy?"

Tom said, "Ah've two dozen sheep gone a-missin' Wednesday past, and nub'dy between 'ere an' Litton knows owt about 'em. Canst tha work it out?"

Neddy sat quietly on the cave floor beside the dying fire, resting his head in his hands. Minutes passed, and he didn't speak. Tom didn't know what to do; should he say anything else, or should he go away? Was the old man ill? But at length, Neddy moved again. He raised his head from his hands, reached into the embers

Hob Hurst's House, Fin Cop – probably the wizard's cave.

of the fire and took out a burned stick. With the end of the burned stick, he drew lines on the cave floor and stared at them long and hard. Then he chanted:

Up be Tidser and round by th' moor,
John, at the gate, 'as dug up a floor.

He fell silent, threw the stick back into the dying fire and sat still. Tom asked what the rhyme meant, but there was no answer; it was as though Neddy no longer knew he was there. So Tom went away.

Next morning he set off for Tideswell, went to the nearest inn, and asked whether anyone knew of a man called John who lived round by the moor. All the drinkers at the bar were local lead miners. They stared at him and their faces were not friendly.

"'Oo's askin'? What's thy business i'Tidser?"

"We knows John as lives round by th' moor, but we dunna know what tha wants wi''im, and th' art a stranger."

Tom said, "Ah think he might 'ave some o' me sheep."

The atmosphere changed immediately. One of the miners said to his companion, "See? Towd thee 'e were up ter no good, yon John. Pinchin' sheep, is 'e? 'E wants 'angin'."

"Aye, th' art reet," said another. "Come on, mate, we'll show thee where 'e lives."

"Aye, that we will," said a third, "an' we'll fetch th' constable an aw."

So a dozen strong miners and the village constable left the inn with Tom and led him to a ramshackle old farmhouse up on the hill. There seemed to be no livestock around the place, and certainly no sign of sheep. The constable and the miners shook their heads. But the constable forced his way into the house to see what might be there, and a minute later he shouted, "Come 'ere, you lot, an' see what Ah've found!"

Tom and the miners entered the house in his wake. There in the kitchen, just beside the rear door, half the floor had been taken up; and in the space beneath were Tom's missing sheep.

Realising his theft was discovered, John ran, but he didn't get far. The constable was fat and slow, but the miners were fit men.

And so, thanks to the wizard of Monsal Dale, Tom Middleton recovered his missing sheep. John was taken to Derby and tried at the Assizes. He had no defence.

46

Prince Arthur and the Vision at Haddon

In Haddon Hall there's an apartment called the 'Prince's Chamber', which is where Prince Arthur slept when he stayed in Derbyshire. Prince Arthur was Henry VII's eldest son, so he was heir to the English throne; the future Henry VIII was his younger brother. Sir Henry Vernon of Haddon, known as the King of the Peak, had been appointed Arthur's guardian and treasurer. The young prince and his guardian were fond of each other, and Arthur loved Haddon and the countryside around it.

When he was twelve years old, Prince Arthur was betrothed to Catherine, fourth daughter of Ferdinand of Castile and Aragon, and the marriage was performed by proxy in the Chapel of the Manor of Bewdley. Of course, Arthur had never met Catherine, who would later be married to his brother Henry.

In September 1501, when he was sixteen, Prince Arthur was at Haddon as usual. Something about his demeanour made his guardian uneasy; he seemed unwell. He made no complaint and there were no obvious symptoms, but he was tired and withdrawn and looked sad. Most evenings, he walked alone along the river bank or sat on the hillside overlooking the hall, often staying out until after dark. However, it was a lovely autumn – the trees in the grounds of Haddon and along the Wye shone with glorious colours – so Sir Henry was content to let the young prince follow his own devices, thinking it would do him good.

The tenth-century cross
beside Bakewell church,
which allegedly stood at
the Hassop crossroads in
times past.

At that time, five hundred years ago, the carved cross that now stands in
Bakewell churchyard marked the crossroads between Bakewell and Hassop,
about two and a half miles across the fields from Haddon. Arthur sometimes
walked there, and he did so one calm, clear October evening. He reached the
cross just as the sun was setting and sat down to rest on the grassy mound at its
base.

Whether he fell asleep and had a dream, or whether he suffered a hallucination
caused by the mysterious illness that his guardian suspected, is not known. But
suddenly he found himself looking upwards into the face of a very tall, thin
woman dressed from head to foot in white. She was standing directly in front
of him, though he'd neither seen nor heard her approach. Her face was very pale
and her features were sunken as though she were starving. She reached out a
hand towards him, and the hand seemed almost fleshless. Then she spoke; but
the prince recalled that "her words came forth without her breath".

She said, "Unhappy Prince, one earthly pageant awaits you, and then you will
fall into the lap of your mother the earth! The lady that comes to England is
both bride and widow of one who should be king."

Arthur sprang to his feet, but the woman had vanished. He returned to Haddon perplexed, unable to rid his mind of the woman's words, or the words he'd imagined.

Sir Henry Vernon and his servants met him as he approached the hall, and they found him lost in thought. But there was no time for inquiry or explanation; they'd been searching for him for hours. A special messenger had arrived at Haddon ordering the prince's immediate return to London. His betrothed wife Catherine had come from Spain, and the king had commanded that the marriage contract be concluded as quickly as possible.

As always, Arthur was sorry to leave Haddon, but he couldn't ignore an order from his royal father. So he set off for London the very next morning, accompanied by Sir Henry and his servants. The wedding took place a few days later. It was a great ceremony, with banquets and tournaments and games aplenty; a memorable celebration was required when the heir to the throne was married. Then Prince Arthur and his bride, Princess Catherine, left London with a large retinue of servants and went to Ludlow Castle in Shropshire, which had been designated their private residence. But their married life was short-lived. The prince's mysterious illness worsened, and within four months of the wedding, he died.

It is said that his last words were: "Oh, the vision of the cross at Haddon!"

Had Prince Arthur lived, Henry VIII would never have become king. The monasteries might not have been disestablished, the rift with Rome might not have occurred, and not so many wives would have been divorced or beheaded.

47

One Tree Hill

During the late eighteenth century, there was a farm near Baslow that had belonged to the Booth family for generations. It was rich even when other farms in the area failed. All the farmers for miles around wanted to know what made the Booth Farm so lucky, but Mr Booth wouldn't tell them. It was a secret he couldn't share.

On a hill that rose from the Booth Farm fields grew three tall trees. People wandering home late at night, perhaps having drunk too much, told of the faint sound of singing and laughter from the hill, and glimpses of three beautiful ladies dressed in green dancing around the three tall trees. No cattle or sheep were grazed on the hill. No one went near it, except Farmer Booth.

Every Midsummer's Eve, Mr Booth went up the hill and left an offering of late primroses beside the roots of each of the three tall trees, as his father and

grandfather had done before him, and their fathers and grandfathers had done before them. They believed that the offerings made the farm thrive. Whenever Mr Booth went up the hill to leave the primroses beside the trees, he made sure he was home again before dark. As he told his wife and his three sons, the primroses made the Green Ladies smile on the farm, but they might not smile on him. A mortal man in their domain could be in peril.

When Mr Booth died, the farm was divided among his three sons. The eldest got the largest share, which included the hill with the three tall trees, and the youngest got the smallest. The first attempts at crop rotation and stock breeding were being made in England at that time, and all three brothers were keen to try the new farming methods. But only the youngest continued to leave the offerings of primroses beside the three tall trees on Midsummer's Eve; his brothers had no time for old superstitions. The youngest brother's farm prospered, his oats and barley ripened healthily and his cows yielded plentiful milk; but the other shares of the Booth land, though they did well enough, were less fruitful.

"'Oo's 'elpin' thee?" demanded the two elder brothers. "What are th' doin' as we are na?"

"Ah'm leavin' primroses for th' Green Ladies, like Dad did."

"Th' art daft," said the eldest, "an' tha con stop doin' it. Yon 'ill's *my* land, an' if tha goes up theere th' art trespassin'. Any road, Ah'm bound fer t' chop one o' them trees down. Ah need th' wood fer me barn repairs."

The following day, the eldest brother took a horse and cart up the hill, followed by two of his men carrying axes, and they started to chop down the tree. As soon as the first blow of the axe fell, there came a cry like a woman in pain, and the horse bolted, dragging the cart back down the hill. The two farmhands ran away. But the farmer continued to swing the axe until at last the tree fell. He was careful to stand on the right side of the tree; nevertheless it fell on top of him, pinning him to the ground and killing him instantly.

When his two younger brothers heard the news they went up the hill, cut up the fallen tree, recovered the farmer's body, and attended to his burial.

Now the middle brother took over the largest portion of the Booth Farm, in addition to his own, leaving the youngest brother with just his own small piece of land. But it was the small piece of land that continued to prosper. Every year on Midsummer's Eve, its owner climbed the hill and left the offering of primroses beside the two surviving trees. Meanwhile, the rest of the estate grew less and less productive. Despite the new farming methods, animals died, crops failed, milk and egg yields fell, and the middle brother became more and more frustrated and angry.

He shouted at his brother, "Ah've seen thee goin' up my 'ill again wi' them daft flowers, an' tha's 'ad thy cows grazin' up yonder an' aw! Ah'm goin' fer t' chop them other two trees down an' mek 'em into a fence fer t' keep thee an' thy cows off o' theere!"

The very next day, he took a horse and cart up the hill, followed by farmhands with axes, and attacked the second tree. Once again there came the cry of a woman in pain, and the horse bolted, and the farmhands ran away. But the farmer continued to chop at the base of the trunk until the tree was ready to fall, and then – remembering what had happened to his brother – he turned to run out of the way of danger. But he tripped on one of the upturned roots of the surviving tree, and when he fell, a great branch came down and struck him on the head and killed him.

So the youngest brother inherited the whole of the Booth Farm, and every Midsummer's Eve he climbed the hill and left an offering of primroses beside the one remaining tall tree. Sometimes, he heard distant singing from the hill, but it was the sad song of a single lonely voice, and there was no laughter. Once, under the light of the moon, he saw a solitary Green Lady dancing a sorrowful dance around the tree. She seemed old and careworn.

The youngest brother never married, and after his death the Booth Farm passed to another family. Perhaps they remembered to climb the hill each Midsummer's Eve to leave an offering of primroses; perhaps they didn't. But even today, people avoid One Tree Hill, which they say is haunted, though most of them don't know why.

<div align="center">48</div>

The Duck Tree

One summer's day in the late 1600s, a duck flew over Sheldon and crashed into the trunk of a tall ash tree in the middle of the village, whereupon it disappeared. The villagers supposed it had flown right into the wood of the tree, which had then closed over it, trapping it forever. Thereafter, the ash tree was known locally as the duck tree.

More than two hundred years later, the duck tree blew down in a winter storm. Most of the wood was sound, so the trunk and the main branches were cut up, loaded on to carts and hauled away to the sawmill in Bakewell.

At that time, Great Batch Hall in Ashford was being renovated, so wood from the duck tree was used to make cupboards and mantelpieces for the Jacobean manor house. One slice through the trunk revealed a lighter-coloured patch of wood in the exact shape of a flying duck. It was made into a mantelpiece and set above the drawing room fireplace in Great Batch Hall, where it remains to this day.

Sheldon village.

<div align="center">49</div>

The Magpie Mine

Near Sheldon stand the ruins of one of the Peak District's many lead mines: the Magpie Mine. It was opened in 1740, when the lead mining industry was flourishing, and it prospered. There were disputes with other neighbouring mines because the veins of ore ran in all directions and no one was certain who had the right to which vein, but the Barmote Court settled most of the arguments fairly.

In 1824, however, there was a dispute that couldn't be settled. It was between the Magpie men and the workers in the Maypitt Mine, who had broken into the Magpie Mine workings in the Bole Vein. Claims and counter-claims were presented to the Barmote Court over the next nine years, but the dispute was not resolved. By the summer of 1833, both groups of miners were guarding their territory fiercely. Then a blast in the Magpie Mine injured one of the Maypitt workers.

By way of revenge, the Maypitt men lit a straw fire to smoke out the Magpie workers from the disputed section of the vein. The Magpie men replied by lighting a fire of their own, making the Maypitt Mine unworkable for several days and giving the Magpie workers the access they wanted. During their

The Magpie Mine. The half-ruined building in the background housed the steam-driven pump that was installed to drain the mine during the nineteenth century.

attempts to regain possession of their portion of the vein, three of the Maypitt workers – Isaac Bagshawe, Francis Taylor and Thomas Wager – were overcome by smoke and died.

Twenty-four of the Magpie miners were arraigned before Derby Assizes, and ten of them were charged with the murders of the three men. They were acquitted thanks to a clever lawyer, William Brittlebank of Winster, who argued that his clients had acted in self-defence and the deaths were the fault of the Maypitt agent, who had sent his men down the mine in spite of the danger from the smoke.

Enraged by the court's verdict, Isaac Bagshawe's widow pronounced a curse on the Magpie Mine. A series of accidents followed, and the great wealth of lead ore that lay in the ground beneath could not be reached because of floods.

In 1839, John Taylor took over the Magpie Mine and installed pumping engines with the help of Cornish engineers. But the venture failed, and Taylor became bankrupt.

In 1864, the mine was acquired by John Fairburn, who opened a sough to drain the lower depths and installed a new pumping engine. By 1881 he had invested some £18,000 in the venture, and mining began again. But two years later, operations had ceased; Fairburn was bankrupt and died shortly afterwards.

The Magpie Mine never reopened. They say the curse still lingers, and the mine is haunted.

The Bakewell Witches

During the spring of 1608, a watchman in London happened upon a sparsely clad and penniless Scotsman sleeping in an unused cellar. Suspecting that the Scotsman was planning mischief, the watchman took him before the magistrate. His Worship asked the fellow where his clothes were. He replied that they were at Mrs Stafford's house in Bakewell, Derbyshire. His Worship was puzzled by this answer, and wondered if the vagrant had walked all the way from Bakewell with only a torn shirt on his back. The Scotsman offered the following account.

He had lodged with Mrs Stafford and her sister in Bakewell the previous night. The women were milliners who eked out their modest income by running a lodging house. In the early hours of the morning he had been awakened by an unexpected light from below his room, shining through chinks between the

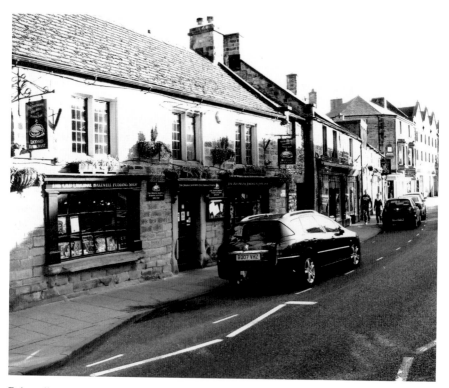

Bakewell town centre, showing one of the claimants to be the "original Bakewell Pudding shop". The location of Mrs Stafford's establishment is not certain, but it was probably up the hill beyond the right of the picture, somewhere near the church.

floorboards. Moved by curiosity, he had crept from his bed and peered through a crack in the floor, only to perceive Mrs Stafford and her sister preparing to go out. He watched their activities, which were strange and ritualistic and were accompanied by incoherent mumbling, and then he heard Mrs Stafford say:

> *Over thick, over thin,*
> *Now, Devil, to th' cellar i' Lunnon.*

As the last word was spoken the women disappeared and the light went out.

The Scotsman returned to his bed, but was too puzzled to sleep again. While he was thinking about the scene in the room below, he mumbled the rhyme to himself. His bedclothes immediately fell to the floor and there was a rush of wind, and he felt himself lifted into the air and carried through space until he landed in a cellar beside Mrs Stafford and her sister. At first, the women didn't notice him; they were busy tying up parcels of expensive cloth, which they might have stolen from neighbouring stores. When at last they saw him, they gave him wine to drink and he immediately fell asleep. The next thing he knew, he was being awakened by the night watchman.

Not surprisingly, the magistrate recognised a case of witchcraft in the Scotsman's story. James I was king of England at the time, and as young James VI of Scotland he had written much about witches; the case of the North Berwick witches remained fresh in his mind; so magistrates and other authorities were always quick to see evidence of dark arts. The magistrate ordered clothes to be brought for the Scotsman, and he ordered the arrest of the two milliners of Bakewell. The authorities went to Mrs Stafford's house and found some of the traveller's clothes, which were taken as corroboration of his story. Mrs Stafford and her sister were arrested for witchcraft.

The two women gave a different account of events. The Scotsman had come to Bakewell, they said, and when he inquired where he could stay, he was directed to the milliners' lodging. He remained there for several days before the women asked him for rent money. He declared that he had none, whereupon Mrs Stafford took some of the clothes he was carrying by way of payment and turned him out of the house. He was indignant, but had gone on his way to London, ill-clad and penniless. He had probably slept in the cellar because he could afford no legitimate lodging. As for the charge of witchcraft, they pleaded innocence.

The pleas were vain. The women were taken to Derby Assizes, convicted and hanged.

Whatever the truth of the matter, the Scotsman was thoroughly revenged for the indignity he had suffered.

Parson's Tor

One Thursday night in October 1776, the Reverend Robert Lomas, parson of the church at Monyash, suffered disturbing dreams. They seemed full of ominous portents. Even prayer failed to settle his mind, so on the following morning he saddled his horse and set out for Bakewell, hoping to see the vicar of the parish after his morning service so he could tell him about the dreams. His servants, Hugh and Betty, were unhappy about the parson riding so far on a Friday, which is an unlucky day, but off went Mr Lomas, and he reached Bakewell church safely.

After the service, the vicar said, "I'm happy to see you, Mr Lomas, but I cannot stay to hear you this morning. One of my parishioners is on the point of death and I must go to him. When I return, however, I hope you'll dine with me, and then we can talk together in private."

Mr Lomas was glad to accept the invitation, so he whiled away the next hour or two in Bakewell and then made his way to the vicarage. He and the vicar ate and drank together, and they talked about the parson's strange and disturbing dreams and what they might portend. Their talk continued for several hours, so by the time Mr Lomas took his leave it was after six in the evening. He saddled

Parson's Tor, Lathkill Dale.

his horse again and rode away up the hill from Bakewell towards Over Haddon, from where he could follow the valley of the Lathkill back to Monyash.

It was a dark, wet night, and as Mr Lomas passed Over Haddon the rain turned to sleet. When he reached Haddon Grove, thick mist covered the moor, despite the gale-force wind that blew the sleet into his face. Before long he had lost his way. He dismounted and led his horse forward, but there came a point when the horse refused to walk any further. Mr Lomas tugged at the reins and the horse jerked backwards. The reins snapped, and the parson fell from the edge of Fox Tor down into the Lathkill Valley.

On the following morning, when his servant Betty went out to the shed to milk the cow, she saw Mr Lomas sitting on a stone in the yard, pale and bare-headed. She thought he was ill, and went about her milking duty, but then she heard a groan and the sound of falling; and when she turned again, the parson had disappeared.

Betty went indoors and told the other servant, Hugh, that she'd seen the parson's ghost.

"A Friday venture's no luck, as Ah've 'eard say," said Betty.

The servants agreed that Mr Lomas should never have ridden out on a Friday, and they spread news of the ghostly appearance around the village. A search was made, and soon the parson's body was found amid bloodstained rocks at the foot of Fox Tor, and they carried him back to Monyash, where he was buried in the churchyard.

Today, Fox Tor is known as Parson's Tor.

52

The Little Red Hairy Man

Long ago, a poor lead miner lived in Wensley, and he and his wife had three sons. The eldest son thought the mines would not give him enough money to keep body and soul together, so one summer day he set off to seek his fortune, taking with him a small loaf of bread and a lump of cheese. After he had walked half the day he came to a wood, and he sat in the shade of the trees to eat his bread and cheese. And as he ate, he heard a soft voice saying:

"Please, give me some of your food. I'm hungry."

He turned round and saw a little red hairy man peering at him from among the branches.

"Be off wi' thee! Ah've nowt fer t' spare fer th' likes o' thee!" shouted the youth.

He kicked the little red hairy man back into the wood and he went on his way. But although he searched for a year and a day to find his fortune, he returned home to Wensley as poor as he'd been when he left.

Shortly afterwards his younger brother set out in the same way, taking a small loaf of bread and a lump of cheese, and after he'd walked half the day he came to the wood and sat down in the shade of the trees to eat his food. He had almost finished when he heard a soft voice saying:

"Please, give me some of your food. I'm hungry."

He turned round, and there was the little red hairy man peering at him from among the branches.

"Ah'll need th' rest o' me food fer later," said the youth, "but tha can 'ave th' crumbs."

The little red hairy man ate the crumbs.

"In the middle of the wood," said the little red hairy man, "there is a mine. Try your fortune there."

So the youth left the road and walked into the middle of the wood, and there he found the mine. But it looked a sorry place, almost worked out, and he thought there was little or no ore to be found, so nothing was to be made of it. He went on his way, but he never found his fortune, and he too returned home to Wensley as poor as he'd been when he left.

Then Jack, the youngest son, set out to seek his fortune. Like his brothers he took a loaf of bread and a lump of cheese, and after he had walked half the day he came to the wood, and he sat in the shade of the trees to eat his meal. As he ate, the soft voice said:

"Please, give me some of your food. I'm hungry."

He turned round and saw the little red hairy man peering at him from among the branches.

"Aye, come on, then," said Jack, and cut bread and cheese for the little red hairy man. "Tha can 'ave more if tha wants it."

The little red hairy man ate the bread and cheese and said, "In the middle of the wood there is a mine. Go there and try your fortune."

So Jack left the road and walked into the middle of the wood, and there he found the mine. But the little red hairy man was there before him, standing beside a windlass with a rope, on the end of which was a large bucket.

"Climb into the bucket," said the little red hairy man, "and I'll lower you down the shaft. There you'll find your fortune."

So Jack climbed into the bucket, and the little red hairy man turned the windlass and lowered him down the shaft, down and down and down. It grew darker and darker as he went, but then, to Jack's surprise, it grew lighter again. When he reached the bottom he found the little red hairy man beside him.

"In this land," said the little red hairy man, "there is a princess imprisoned in a castle of copper. If you rescue the princess and let her go back to her home, you'll be on the way to finding your fortune."

He gave Jack a suit of armour and a sword, and he rolled a copper ball along the ground, and Jack followed the ball to the castle of copper, where it struck

the door with a resounding clang. The door opened and out came a giant clad in copper armour.

"Who dares disturb my rest?" thundered the giant.

"It's me, Jack, an' Ah've come fer t' set th' princess free," replied Jack.

The giant drew his sword and hefted his mace and charged at Jack, but Jack was too quick for him. He tripped the giant up and cut off his head. Then he went into the castle, broke down the door of the room where the princess was imprisoned, and set her free. She thanked him for rescuing her and ran away home. Jack went back to the bottom of the mine shaft, and there was the little red hairy man waiting for him.

"There's another princess," said the little red hairy man, "imprisoned in a castle of silver. If you rescue the princess so she can return home, you'll be on the way to finding your fortune."

Then he rolled a silver ball along the ground, and Jack followed it to the castle of silver, where it struck the door. The resounding clang had hardly ceased when the door opened and out came a giant clad in silver armour.

"Who dares disturb my rest?" thundered the giant.

"It's me, Jack, an' Ah've come fer t' set th' princess free," replied Jack.

The giant drew his sword and hefted his mace and charged at Jack, but once again Jack was too quick, and very soon the giant was dead. Then Jack went into the castle, broke down the door of the room where the princess was imprisoned, and set her free. She too was glad and grateful and she ran away home. Once again Jack went back to the bottom of the mine shaft, and once again the little red hairy man was waiting for him.

"There's a third princess," said the little red hairy man, "who is very beautiful, and she's imprisoned in a castle of gold. If you rescue her, your fortune is assured."

With those words, he rolled a golden ball along the ground, and Jack followed it to the castle of gold, and when the ball struck the door, out came a giant bigger and more fearsome than either of the others, clad in golden armour.

"Who dares disturb my rest?" he bellowed.

"It's me, Jack, an' Ah've come fer t' set th' princess free," replied Jack.

The giant looked down at Jack and gave a loud and angry laugh, and then drew his sword and hefted his mace and charged. Although Jack was quick, this giant was not so easily beaten. Jack dodged the mace and ducked under the sword and tried to stab the giant, but the golden armour was too thick. Again the giant charged, and again Jack had to dance and dodge to avoid the sword and the mace. Again he tried to thrust and stab, but to no avail. He was becoming exhausted. Then the giant raised the mace as high as he could reach, almost to the clouds, and brought it down with all his might. Jack skipped away from it just in time, and the mace buried itself in the ground; and as the giant tried to pull it out again, Jack cut off his head.

Wensley village today. Matlock, the county town of Derbyshire, is visible in the background.

Then he went into the castle of gold and broke down the door of the room where the princess was imprisoned. As soon as he saw the beautiful princess he fell in love with her.

"Have you fought the giant and defeated him?" she asked.

"Aye," said Jack. "It were a tough fight, but Ah've cut 'is 'ead off an' that's finished 'im."

The princess was overcome with gratitude and embraced her rescuer, and promised to marry him. So he took her back to the mine shaft and the little red hairy man married them, and then he helped Jack to bring a cartload of gold from the golden castle, and went back to the windlass and lifted Jack and his bride and all the gold up to the surface.

Jack built a fine house for the princess and himself, and another fine house for his father and mother, and they were never poor again. But Jack's brothers were jealous, and wanted some of the gold for themselves so they could be as rich as Jack. So they went to the mine in the middle of the wood. But as they struggled to be the first one in the bucket, the rope broke and they both fell down the shaft to the bottom.

When Jack and his father went to look for them, they found the sides of the shaft had caved in, burying the land below and its castles forever.

The Riddle

Amy was a servant at the big house and she'd caught the eye of Tom the gardener. Tom was a big strong lad with a cheerful smile, and like many girls, Amy was impressed by big strong lads with cheerful smiles. So she decided she'd persuade Tom to marry her. Tom knew the effect that big muscles and nice smiles have on young women, so he decided he'd take advantage. Tom's brother Joe understood his intentions, but he also understood Amy's.

"Tha'll need fer t'watch thysel' wi' that 'un, Tom lad," said Joe.

"Nay, Joe, Ah can 'ave a bit o' fun, can't Ah?"

"It's more nor a bit o' fun yon Amy's after." Joe looked dour.

The courtship progressed as such courtships usually do, with seeming innocence, until one Thursday afternoon when Amy said, "Tom, when we get off work at th' end o' th' day, let's meet at yon stile at th' far side o' th' field next to th' wood. There'll be nub'dy else around."

And she smiled in a way that made Tom's eyes dilate. But the more he looked forward to the evening, the more he remembered his brother's warning. So he went to Joe and told him about the scheme.

"It's no use, Tom, th' art in too deep wi' 'er," said Joe. "Tha'll 'ave for t' get rid on 'er."

"What do'st mean, Joe?"

That evening, Amy reached the stile ahead of the appointed time, before Tom arrived. She was surprised to find a freshly dug hole in the ground and a pick and a spade lying nearby. What's this, she thought – a freshly dug hole and a collection of tools at the scene of a planned tryst? It would make any girl suspicious. So Amy climbed a tree and sat on a branch, hidden from below by the thick leaves, and she stayed quiet and kept watch.

A few minutes later Tom arrived and Joe was with him. Amy wondered what sort of man brings his brother to a tryst with his girlfriend. The two men looked around but they couldn't see what they expected. After they'd searched for a few minutes and glanced back towards the big house, they stared at each other and shrugged.

"She's none comin' after aw," said Tom. Amy thought he sounded relieved.

"Ne'er mind, she'll be 'ere tomorrow," said Joe. "We'll deal wi' 'er then."

The two brothers left the scene, and as soon as they were out of sight, Amy slid down the tree and ran all the way home, where she poured out the story to her father.

Her father thought it over for a few minutes and said, "We'll 'ave a party this weekend. We'll invite aw th' folk round about for a bite o' food and some ale, and we'll ask Tom an' Joe an' aw. Then we can play a game o' riddles."

The story of the Riddle is usually associated with the southern part of the Peak District, but this setting – mature trees growing above a stile – was photographed in Chee Dale, near Wormhill.

So they held a party, and all the neighbours came, and the servants from the big house came as well, including Tom and Joe. And late in the evening, when everyone had had a few drinks, they played a game of riddles. Each of the guests stood up in turn and recited a riddle for the others to guess.

What goes round th' 'ouse and into th' 'ouse but ne'er touches th' 'ouse?
What con tha keep after tha gi'es it to someb'dy else?
What walks around on its 'ead aw day?

And so it went on. Amy was last, and her riddle went as follows:

Ah'll rede thee a riddle, Ah'll rede it thee reet:
Where were Ah last Thursday neet?
Th' wind did blow an' th' leaves did shek,
When I saw th' 'ole what th' fox did mek.

As soon as she'd finished, Tom and Joe rushed out of the house and disappeared. They were never seen in that part of the world again.

The Nine Ladies

One May morning a young woman from Stanton-in-the-Peak accepted a secret proposal of marriage. Straight away, she went around the village and confided the exciting news to each of her friends in turn, so everyone in the village knew about it before sunset. Her parents might disapprove of the engagement, but if everyone in Stanton – and for several miles around – had heard the news, they'd find it difficult to prevent the marriage.

The following Saturday evening, the girl and eight of her friends decided they'd celebrate the betrothal by holding a dance. They asked the village fiddler to play for them, and he agreed. There was nowhere in the village big enough for a dancing party, so because the evening was dry and warm, they went up on to Stanton Moor instead. There, in a clearing beside the trees, the fiddler tuned his fiddle and began to play, and the nine ladies began to dance.

One tune followed another, some lively and quick, some slower and more romantic, and to every tune the fiddler played, the nine ladies danced. As they danced, they sang and laughed, and the noise of merrymaking could be heard all

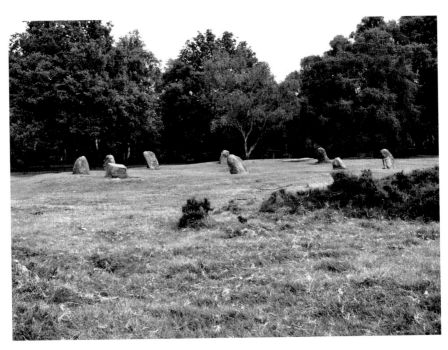

The Nine Ladies, Stanton Moor.

across the moor. By and by the sun set, the evening darkened, the stars shone and the moon rose, but still the fiddling and dancing and merrymaking went on.

When the church clock in the village struck midnight, the ladies and the fiddler paid no heed. They were enjoying themselves so much they scarcely heard it. But now it was Sunday, when dancing is forbidden, and laughter and merrymaking become a sin. And so, as the nine ladies danced together in a circle, they were turned to stone, and the fiddler with them.

The ladies stand there to this day, a circle of nine stones. Ninety feet away stands another solitary stone, which people call The Fiddler.

55

Faerie Pipes

One fine summer afternoon early in the 1800s, a lead miner was walking across Brassington Moor when he found a tiny white clay pipe lying among the grass and heather. It must have been a Sunday, after church, because a lead miner wouldn't have been free to walk on the moor at any other time. He almost trod on the pipe, but it shone so brightly in the sunlight that it caught his eye just before his boot came down. He stopped and looked at it, then he picked it up and put it into his left-hand waistcoat pocket. As soon as he did so, an uncomfortable prickling ran down the left side of his body. The prickling continued and it grew steadily worse. He moved the pipe to his right-hand pocket, and the prickling moved to his right side and grew even more intense. Finally, not wanting the pipe too close to his skin, he put it into the pocket of his jacket. The prickling stopped, but the cloth of his jacket began to smoulder; and then the pipe disappeared.

It was a faerie pipe.

Faerie pipes are common among the fields and the limestone hills of the Peak District. It might seem that their makers are careless, since we find so many scattered around our countryside. But perhaps it isn't carelessness at all. Perhaps each pipe is taken from the Perilous Realm and planted in our world in the hope that the right sort of mortal will find it, a mortal with the imagination and the courage and the wisdom to use it as it should be used: that is, to find a window or a door into a different, delightful and dangerous world, to which a faerie pipe may serve as a key. When the *wrong* sort of mortal finds a faerie pipe, its makers recall it swiftly. They'll have no truck with the wrong sort of mortal. That's why the lead miner on Brassington Moor suffered the unpleasant prickling and a singed jacket, and why his pipe vanished: he was the wrong sort of mortal.

Another White Peak lead miner found a faerie pipe one day, and he picked it up and took it back to his village. That evening, after he'd eaten and before

he went drinking with the other miners, he stood outside his cottage and lit his new pipe. Smoke issued from the bowl and hung around him like a sweet-smelling mist, and it seemed to be crowded with beautiful people. They looked small because they were really very distant, but at the same time they were close enough to vent their anger on him. They seemed to fly around him on iridescent wings, but that could have been his fancy, or a trick of the evening sunlight on the smoke. At any rate, they swarmed around his head and pinched him and scratched him and bit him and fired tiny darts into him until he was in agony. Then he dropped the pipe. As soon as it fell, the faerie folk picked it up and disappeared with it. He was the wrong sort of mortal, too.

Such incidents are hard to understand unless we remember that time and space are different in the realm of Faerie. Some stories tell us that the folk of the Perilous Realm are tiny, like miniature flying humans. But that's just a trick of the distance from which we see them; and unless we find a faerie pipe or some other kind of key, we're not likely to see them at all.

A man from Baslow dug up a small clay pipe in his cottage garden. When he looked closely at it, he saw a tiny, wizened old man dressed in green sitting on its stem. The little man jumped on to the bowl, glared spitefully at the gardener, and then vanished into thin air and took the pipe with him. You can't explain that unless you know that time and space change when you cross the border between our world and the Faerie Realm – and that border is everywhere. The Baslow man's pipe was in his cottage garden, but at the same time it was also in a far-off place beyond the limits of normal sight. The old man dressed in green looked tiny to the gardener because he belonged to that distant place; the gardener probably seemed tiny to the old man in green because he belonged to our everyday world. Anyway, the Baslow gardener was another wrong sort of mortal. He never had any other visions of Faerie.

But around the time that the miner on Brassington Moor found his pipe, a farm labourer called Elijah Sheldon found another one. The sun was setting, and Elijah was resting after a hard day's work in the fields near Elton, leaning against one of the stones of Nine Stones Close, listening to the birdsong and breathing in the cool evening air. Nine Stones Close is well known as a place where the folk of Faerie meet in their hundreds at midnight when the moon is full and dance to their pipes and fiddles.

As he scratched the ground in front of him with the toe of his boot, Elijah unearthed the pipe. He picked it up, cleaned it as well as he could with his fingers, filled the bowl with tobacco and began to smoke it. The tobacco gave off a peculiarly sweet and delicious scent, more fragrant than he'd known from any other pipe; the tobacco itself was quite ordinary but the pipe – and perhaps the location – transformed it. A strange sensation filled him. Then the earth beneath the stone circle became transparent.

Far below the surface of the world in which he lived and laboured, Elijah saw another world, more beautiful than any he'd ever dreamed of, a realm of

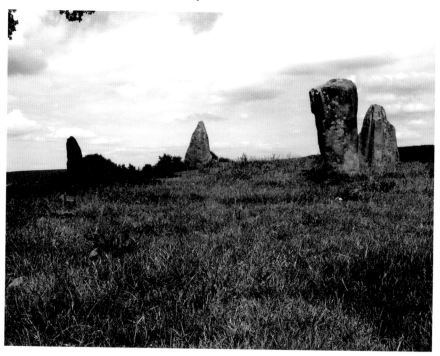

Nine Stones Close, Harthill Moor.

rocks and streams and trees and flowers of glorious colours, and lovely towns and palaces peopled with brightly clothed beings and the sweetest music you could imagine. He was enchanted, in the true sense of the word. He couldn't withdraw his gaze from the vision, and he lost all sense of time. But at length his eyes began to smart, and that window into the Perilous Realm grew misty, and he awoke again to find that the tobacco was burned and the pipe had gone out. He went home filled with wonder and joy, and he took the pipe with him.

Elijah returned to Nine Stones Close many times after that evening and lit that little clay pipe and smoked the sweet tobacco from it, and he was always rewarded with the same vision: for a brief time until the pipe went out, he was transported to Faerie. Then, one evening, he walked to Nine Stones Close and never returned. To this day, no one knows where he went; no one in our world, that is. Those who live in the Perilous Realm had decided that Elijah was the *right* kind of mortal, and they'd transported him there in body as well as spirit.

To Elijah's mind, it may still be the same evening when he was last seen on Earth. Perhaps, to him, he's still resting in Nine Stones Close, relishing his vision of the beautiful world below, because the tobacco in his pipe is still burning.

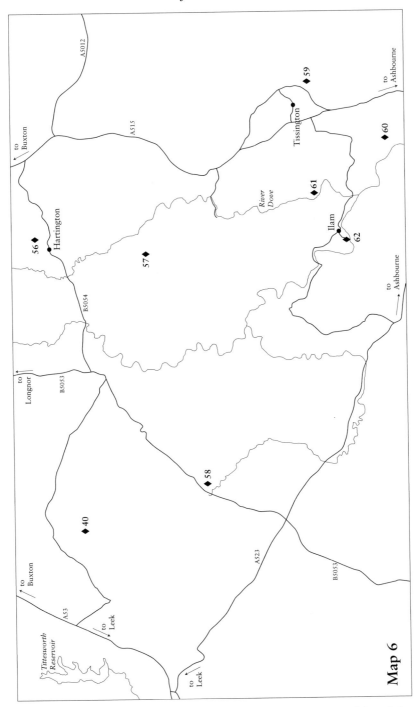

Stories 56–62. The southernmost part of the Peak District includes Dovedale, and also the traditional birthplace of well-dressing, Tissington. Further west, it incorporates part of the Staffordshire moorlands. The third location of story 40 ("Three Mermaids") is Blake Mere on Morridge, at the edge of the moorlands.

William de Rossington

Charles II and his Royalist troops marched into England in 1651, confident that the Commonweath was about to end and the monarchy would be restored. Events soon turned against Charles, who hid in an oak tree after the decisive Battle of Worcester and then left the country, and the Restoration was delayed for a further nine years. But during that summer of 1651, when Charles marched south leaving Cromwell and his army in Scotland, numerous young men armed themselves and flocked to the Royalist cause.

Young William de Rossington lived with his sister Maude in their ancient family seat near Rowsley. William had become head of the family when his elder brother died in battle during the Civil War. He had also fought in Charles I's army. In 1651 he raised a company of local volunteers and trained them for battle in the meadows beside his home, and he communicated with other Cavaliers in Derbyshire and Staffordshire. All the leaders agreed to assemble their troops on Hartington Moor in the middle of August and then march to Wigan to join forces with the young king.

William took fond leave of Maude and of his betrothed, Anna Egerton of Hulme Hall, Bakewell. But as he was about to depart for Hartington, Anna reported a terrible dream: she'd seen Cromwell emerge from a dark wood and order William's arrest and execution. William dismissed the fancy and set off for Hartington Moor with his troops. There they met other detachments, totalling about six hundred men, and William was appointed their overall leader. They planned to march to Wigan the following morning.

But Cromwell had learned of their gathering. He dispatched Colonel Lilburn with a regiment of horse from Lancashire, and commanded reinforcements from Yorkshire and Cheshire to join him and to march with all speed to Hartington. They were ordered to disperse the Royalists and to seize their leader. Lilburn and his army arrived at Hartington before William's six hundred were able to depart for Wigan. The Royalists were outnumbered and the Commonwealth's army was trained, battle-hardened and very well equipped. The outcome of the battle was a foregone conclusion.

William led several charges against Lilburn's guns and horses, but he was wounded and finally killed. By the end of the day he was lying among a heap of dead and injured Royalist volunteers. Lilburn's men searched for him, but in vain, and they thought he'd escaped. As daylight faded, Anna Egerton arrived with four men on horses. She searched the battlefield and located William's body, and she ordered it to be taken to Hedburn Wood near Cressbrook, about ten miles

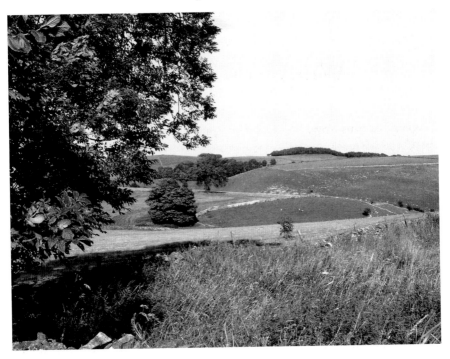

Hartington Moor.

away. Her four servants lit a lantern and dug a grave for William de Rossington, there in Hedburn Wood. Cromwell offered a reward for information that would lead to his discovery, dead or alive, but no one revealed the site of the grave. William rested in peace.

In the 1830s, almost two centuries after the battle, a farmer near Hedburn Wood found the grave while he was setting up a gate-post. The body was identified by the helmet, sword and other armour, the unmistakable garb of a Royalist leader.

57

Mr Armaley's Journey

Three things were remembered of the Reverend Mr Armaley: his black tricorne hat, without which he was never seen abroad in the streets of Ashbourne; his kindness to his mare, Polly; and his fearless commitment to the Word of God. Mr Armaley was an upright man, respected by all, and the fame of his preaching spread throughout the Peak District.

Early one October morning a boy came to his door bearing a note from the Reverend Mr Grisham, asking Mr Armaley to dine with him at his manse on the third Saturday of the month, and to conduct the service at Hartington on the following morning. He wrote a letter accepting the invitation, and the boy took it back to Mr Grisham at Hartington; on the third Sunday of the month, he decided, his curate would preach in Ashbourne in his stead.

When the third Saturday of October came, Mr Armaley took lunch with his curate and gave him instructions, and then went to saddle Polly, but he found she was lame. He sent for the farrier, who declared that the mare must be re-shod, but afterwards she would have to rest for a week to cure the swelling of her fetlock.

"Then I must walk to Hartington," declared Mr Armaley, patting Polly. "No doubt Mr Grisham and I will dine late, but the way is not far."

Had Polly been fit, they would have reached Hartington in less than two hours. But although Mr Armaley was tall and vigorous and his long strides covered the ground swiftly, walking was not as quick as riding. He took the shortest route, along the old tracks over the moors above Ilam, but the autumn daylight was fading before he began his descent into the valley. Worse, a storm was building, and soon it broke, drenching the lone traveller and casting him into darkness. Before long, he lost his way among the winding tracks.

"I must find shelter until this storm has passed," he thought, "but where? I see neither farmhouse nor cottage, and certainly no inn. In truth, I can see very little."

He wandered over the moor for more than an hour, the wind swirling his cloak and tearing at his black tricorne hat, the rain beating upon his face. The narrow track had become a stream and his boots were soaked. He prayed for guidance; and at last he saw before him a small cottage, a few yards from the path. It was a poor place, its thatch broken and rotted and its garden choked with weeds. Its gateway was covered with an ancient thorn tree, twisted and gnarled. Mr Armaley ducked under the branches of the thorn and staggered through the saturated garden to the rough limestone wall of the dwelling. Under the dripping eaves he found a low door of unvarnished oak. He knocked.

There was no answer. He knocked again, and again. At length he heard the lifting of a bar. The door creaked open some six inches. The sour face of a little old man peered up at him.

"Who are you, and what want you here?"

"I am Mr Armaley of Ashbourne, and I am benighted in this storm on my way to Hartington. I seek shelter from the rain and wind, and if possible, of your charity, a bite to eat." For Mr Armaley was very hungry.

"Hmm. Well, tha con come in, I suppose. But we've no food nor drink for thee."

The door creaked all the way open and Mr Armaley took off his hat, ducked beneath the lintel and entered a dark, grubby room with an earthen floor. It

was cold and damp and ill-smelling, the furniture was sparse, a miserable peat fire smouldered in the grate, and a single tallow candle burned on the stone mantelpiece. A little old woman, as unwelcoming as the man, sat beside the fire. When Mr Armaley sat beside her, seeking the little warmth the fire yielded, she glanced once at him and spoke not a word.

He looked around the room. There was little to see. A spinning wheel rested against the far wall, broken and cobwebbed, and it saddened him. His family were weavers, Flemings who had settled in Derbyshire; their spinning wheels were bright, and sang merrily as they turned out yard after yard of yarn. The spinning wheel in the cottage had lost its songs.

Outside, the wind howled and the rain beat on thatch and shutters.

"We're goin' to bed," grumbled the little old man. "Tha can sleep upstairs if tha wants."

Mr Armaley thanked him, and the old man opened a small door in the wall, revealing a narrow stair that led to the roof-space. There among the rafters was a truckle-bed with a damp straw mattress. Mr Armaley knelt and prayed in the pitch darkness, silently thanking God for this shelter from the storm, and then he climbed on to the bed. Cold, wet and hungry though he was, he fell into a fitful sleep.

It was still dark when the rattling of pots and dishes awakened him. He listened, and soon he could hear a number of people moving around the room below. He frowned, puzzled. Then he heard the small door open and a voice called from the bottom of the stair, "Master Armaley, come to thy supper! Master Armaley, come to thy supper!"

He rose from the bed and groped his way downstairs. A dozen candles burned, the fire was high and the room was warm and clean. In the middle of the floor was a table laden with food and drink, and beautiful men and women were seated around it, bidding him welcome. He took his place among them and said, "Before we eat, my friends, I will say grace."

Silence fell, and Mr Armaley recited:

> *God bless to us this drink and food;*
> *Keep us from sin and make us good,*
> *On hope of Heaven to live and die,*
> *And may all devils fear and fly.*

No sooner had the final words left his lips than a great wind rushed through the cottage, and the candles were extinguished, and the fire went out, and cries and screams surrounded him. So great was the force of the wind that he was lifted from his seat and fell senseless upon the ground.

When he awoke, there was no sign of the food and drink, or of the table, or the beautiful people, or the old man and woman. Even the spinning wheel had

The former vicarage in Hartington. The date above the door is 1759.

vanished. There were holes in the roof where the thatch had blown away, and there were gaps in the walls, and the door had gone. Dawn had broken, cold and clear; the storm had passed. Mr Armaley rose to his feet, picked up his black tricorne hat, and walked out of the ruined building and back on to the track. Beside the gate stood the rotting stump of a thorn tree.

Offering a prayer of thanks he resumed his journey, and soon he reached the manse at Hartington. Mr Grisham was surprised at his late arrival and his wet and dishevelled clothes, but he gave him food and drink and listened to the story of his journey from Ashbourne.

"In faith, Mr Armaley, that is a strange business! The ignorant folk of this valley tell tales of faeries, but never have I heard the like from the lips of a learned man!"

"Nevertheless it is true, sir, else I had been with you last night. Now, if you will guide me to the church, I will hold to my promise and preach to your flock."

It is said that Mr Armaley's service in Hartington that day was the finest that anyone could remember. He was an upright man, respected by all, and the fame of his preaching spread throughout the Peak District.

The Headless Horseman of Onecote

If you walk in the lanes and fields around Onecote, in the south-west of the Peak District, late in the evening or under the light of the moon, you might have the misfortune to meet a rider on a white horse whose appearance may be an omen of doom. It is easy to recognise the rider because unlike most horsemen he has no head. Shortly before the Second World War, one local man who met the horseman at a crossroads was struck with horror. "It were an awful gory sight," he said.

But at least he survived. Many of those who have met the headless horseman have been less fortunate. Another local man who was out riding met the spectre, and although he lived to tell the tale, his dog and his horse both died.

Joe Bowden was a farmer near Onecote. Late one night he was walking home from Leek market when he was suddenly lifted from the ground and found himself sitting on the white horse behind the headless rider. They galloped over the fields, leaping over hedges and ditches and even over trees, until they approached Joe's farm. There, without warning, the horse stopped and Joe was flung to the ground. He lay there dazed until morning, when he was found by passers-by and carried into his house and put to bed. He told them what had happened to him, but he died a few days later.

Crossroads, Onecote.

Some say the horseman is the ghost of a murdered peddler, or of a knight killed in battle with the Scots. However, the local clergy thought he was one of four evil spirits cast out of Heaven and condemned to wander the Earth until the end of time, so they decided they must exorcise the spectre. Seven clergymen gathered and succeeded in trapping the horseman and compelling him to speak in order to break his power. How the spectre managed to speak when he had no head is not recorded. In any event, the exorcism was not a complete success, because the horseman has been seen several times since then, usually riding over Butterton Moor towards Warslow.

59

The Widow and the Hob

An elderly widow lived in a lonely limestone cottage on the higher land overlooking Tissington. Her little house and its garden were neat and well tended, and there was a spring nearby that she decorated with flowers from the garden every spring, to thank the water spirit who protected it. A local farmer, a close friend, used to bring turfs for her fire and straw for her bed, and he always asked whether there was anything else she needed.

"Ah've food an' fire, an' sweet water at me door, an' there's plenty o' folk worse off nor me," she told him.

But in truth she was lonely, living on the hill with no family and no neighbours.

One wet day, the farmer called with a new supply of turfs and straw. She invited him in and gave him a mug of ale while he sat beside her meagre fire.

"Ee, missus, it's sylin' down out theere. Thy straw's damp, and yon turfs winna burn in a month o' Sundays. There's nowt Ah can do about it. It's aw th' new squire's fault."

The new squire had upset the villagers of Tissington. He was a London man who didn't believe in the old ways, so he'd stopped the traditions that his uncle, the old squire, had encouraged. In particular, he'd driven the hob of the hearth away from the hall. The old squire had always insisted that ale and porridge be left on the hearth for the hob, and he'd enjoyed a long and fortunate life. But the new squire kicked the servant who left out the ale and porridge, saying he was wasting good food and drink, and he threw the porridge on to the fire and drank the ale himself. The farmer was ready to blame him for all misfortunes, including the weather. All the people of Tissington felt the same.

It rained all day after the farmer had left, and the old woman's fire went out, and she shivered and her bones ached. There was nothing for it, she thought, but

to go to bed early, wrapping herself up to keep warm because the mattress was damp. She felt lonelier than ever. She slept badly, with the rain battering on the thatched roof and the wind tugging at the door; and in the borderland between sleeping and waking she fancied she heard a thin, reedy voice singing outside her cottage:

When the rain do fall and the wind do blow,
What shall I do and where shall I go?
Ah, poor me, poor me!

She sat up in bed, and she seemed to hear the sad little song again. So she limped to the door and opened it wide, and called into the stormy night, "Th'art welcome fer t'come in, though Ah've no fire and th'straw's damp; but Ah'll leave a bit of food on th'table fer thee."

There was no answer, and she could see nothing in the darkness except something like a thin wisp of peat smoke that passed her in the blink of an eye. She closed the door and went back to bed, still lonely. At last she fell asleep.

But when she awoke in the morning, what a change there was! The fire was burning brightly, the straw was steaming on the hearth, a pot was bubbling over the flames, and the turfs were dry and stacked neatly beside the door. In the corner of the room, where it was still dark, she could see the faint outline of a figure sweeping the floor with her broom, singing in a voice like a curlew calling across the moors:

Let the cold wind blow, let the rain down fall,
Hob o' the hearth has come to your call.

And so the old woman had company. But although she chatted to the hob while she was spinning or busy with other tasks, she knew better than to look at him; hobs are very shy and will run away if they think you can see them. When she spoke, he replied with a sigh like the breeze through long grass, or a chuckle like a mountain stream. She never failed to leave out a mug of ale and a bowl of porridge for him, and every morning she awoke to a clean house, a bright fire and freshly baked oatcakes, which she loved.

When spring came and the widow spent more time in her garden, the hob followed her. Perhaps he befriended the water spirit who lived at the well, for the spring water seemed to taste sweeter and fresher than ever that year. The widow felt she had to make a special effort to decorate the well because of all the help the hob had given her, and she worked hard all day cutting and arranging various flowers around the rocks from which the spring rose. The hob must have liked the display, for on the following morning, as she breakfasted on her oatcakes and the contents of the pot that bubbled over the fire, she saw that all

A Peak District village well dressing. This (unusually nationalistic) display decorated a well in Stoney Middleton in July 2011.

the flowers around the spring had been rearranged. They'd been made into the most beautiful picture she'd ever seen, a picture of her cottage and the trees and hills around it.

It so happened that the farmer arrived just then, bringing fresh turfs and straw for the widow, and when he saw the picture of flowers that the hob had made, he swore he must bring everybody in the village to see it. So all of Tissington came to the widow's cottage; and the villagers decided there and then, in a body, that from then on they would make pictures out of flowers to garland their wells, and they'd give a prize for the best picture. And that was what they did.

When the squire saw the well-dressing pictures and heard the reason behind them, he began to wonder whether the hob he'd driven out of his house was real after all. He'd suffered bad fortune ever since the hob had left; he'd lost money, his wife had fallen ill and his eldest son had disappeared. He wondered if the hob might come back to him now, if he let his servants put out a bowl of porridge and a glass of ale every day.

But the hob never returned to the hall. He stayed with the old widow in her cottage, and she lived a very long and happy life; for when hobs are made welcome, they take care to guard their own.

Every year since that time, the people of Tissington have decorated their five wells with beautiful pictures made of flowers, and now nearly every village in Derbyshire dresses its wells in similar fashion.

Spend Lane

If you drive or walk from Ashbourne to Thorpe, you'll probably go along Spend Lane, a notorious accident black spot. The local paper reports accidents in Spend Lane at regular intervals. This is strange. It isn't a busy route, and it affords better visibility than many lanes in the Peak District.

Around ten o'clock on a November evening in 1977, Harold Maddock was driving from Ashbourne to collect his wife and son from the Dog and Partridge in Thorpe. It was a fine night, frosty but dry and windless, and there was a good moon. But when Harold turned a bend near Spend Lane, the car was suddenly full of rushing wind, though all the windows were shut. There was a noise like tearing upholstery. Then he felt a violent blow on his stomach. The disturbance

Spend Lane.

only lasted a few seconds, but Harold was shaken. As soon as he reached the pub he had a stiff whisky, then he told his wife and son what had happened.

When they checked the car they found not a mark on it; all the upholstery was intact. However, a 1½-inch metal disc that had been attached to the fascia, perhaps where a clock could have been fitted, was lying on the floor. It was this metal disc that had hit Harold in the stomach while he was driving.

Harold's wife, Nerida, recalled an incident from more than twenty years earlier. She'd been at a wedding reception where the top tier fell off the cake, and some of the guests feared it was a bad omen. Almost immediately, they received news that a car carrying other guests had crashed into a ditch in Spend Lane. Fortunately, no one was injured. Then Harold's son recalled that a girl he knew had been riding a well-behaved, placid pony down Spend Lane, and it had inexplicably taken fright and thrown her.

It's interesting to recall that in the middle of the seventeenth century, a bride on her way to her wedding in Ashbourne left her home in Fenny Bentley and got into her carriage, and the coachman took the route along Spend Lane. In Spend Lane, the carriage overturned and the poor young woman was killed instantly.

Several roads in the Peak District have sinister reputations. Spend Lane is one of them.

61

The Woman who Disappeared

One fine summer night, a horseman was riding up the path beside the River Dove towards his home in Hartington. The moon sparkled on the water and shone white on the rocks and shrubs that lined the valley's sides. The rider had seen no one since he had left Milldale, for it was late; only a few sheep moved, and occasional night creatures stirred in the grass and reeds. Suddenly, beside the path, he saw a woman. She was young and she seemed distraught. His horse was startled. He reined it to a halt.

"You surprised, me, ma'am," said the rider. "Are you lost, or ill?"

She stared up at him, tears shining in the moonlight. Her reply was choked with sobs.

"It seems strange," he said, "that you're out here all alone so late at night. I'd do wrong to ride on and leave you unattended. I'm going to Hartington, where I can find safe lodgings for you at a decent inn. If you'll allow me to help you mount my horse, I'll be glad to take you there."

She went on sobbing but she nodded, seeming to agree, and so he dismounted and lifted her on to the back of his horse. Then he climbed back into the saddle

The River Dove at Milldale.

and urged the animal forward at a gentle trot. The woman behind him grew quiet.

After they had ridden some distance he asked, "Can you tell me where you live? Perhaps I can bear a message to your family."

There was a whispered reply, but he couldn't understand it.

"I'm sorry, I couldn't hear what you said. Please tell me again."

This time there was no response. He turned his head, and found there was no one behind him; the woman had disappeared. She must have fallen from the horse.

Once more he drew to a halt, turned, and rode back the way he had come, scrutinising the ground to left and right as he went. He could see no sign of his passenger. He called to her, but there was no answer. Soon he came to the place where he had first seen her, and he turned again to ride upstream. He went on studying the ground to left and right, and still he saw no woman. He called again, but there was still no answer.

He never saw the woman again.

Saint Bertram

Bertram was king of Mercia during the eighth century. He became interested in the new religion, Christianity, which was now established in Northumbria, Kent and East Anglia. But since he wasn't on good terms with the rulers of those kingdoms, he left Mercia in the care of his kinsman, Offa, and went to Ireland to learn more about the new faith. There, in the land of Patrick and Columba, he heard the Christian message. He also met and fell in love with a beautiful Irish princess. Her father didn't approve of his daughter marrying an Anglian king, even one who might become a Christian, so Bertram eloped with her.

Their journey home to Mercia was long and difficult. After a hard sea crossing and troubles on the Welsh marches, Bertram and his bride became lost in the forest. For weeks they lived a nomadic life, Bertram hunting for food every day to keep them alive, and guarding her at night. By that time she was expecting a child.

At length they reached the area we now call Staffordshire. But there, while Bertram was away hunting for food one day, wolves came to his camp and killed his wife and unborn baby.

Bertram was overwhelmed with grief, and prayed as he'd been taught for solace and understanding. He came to believe that God had punished him for abducting the Irish princess against her father's wishes, and he vowed to spend the rest of his life as a Christian hermit. Disguising himself, he went to see Offa, who had taken the throne of Mercia in his absence, and asked for a gift of land where he could build a hermitage. Offa didn't recognise Bertram, but he gave him a grant of land in what is now Ilam, in the south of the Peak District. Bertram went there and began life in a cave, close to a well of fresh water. He taught the Celtic version of Christianity to the local inhabitants and gained a reputation for healing the sick.

But the new king of Mercia disliked Christianity, which he associated with his enemies, the Northumbrians, so he changed his mind about the land grant. He ruled that Bertram had no right to the cave and the well. Bertram insisted that he had, since the land had already been granted. So Offa cunningly decided that the matter would be settled by single combat: he and Bertram would each name a champion and they'd fight it out. Of course, Offa chose the biggest and strongest swordsman in his retinue, while Bertram had only the choice of a few local peasants who lived around Ilam, and they were armed with nothing more than pitchforks.

Bertram prayed again for help and guidance, and one morning a dwarf named Edmund appeared at the entrance to the cave.

St Bertram's well and bridge, Ilam.

"I'll fight for you, Hermit," said Edmund.

Bertram looked at the dwarf and measured him in his mind against Offa's swordsman. It would be an ill-matched fight. But then he remembered the tale of David and Goliath and he accepted the offer.

When the appointed day came and the two champions took the field, Offa and his retinue laughed. But Edmund the dwarf proved a nimble and clever swordsman, and within ten minutes the king's champion was defeated. So Bertram went on living at his hermitage, preaching the Gospel, converting many pagans, healing the sick, and comforting those in distress.

Many years later, long after his death, Bertram was canonised as a saint.

St Bertram's church at Ilam contains the saint's tomb, and a short distance from the church is St Bernard's well. A few yards beyond that, St Bertram's bridge crosses the River Manifold. Although the one-time king of Mercia attracts fewer pilgrims to Ilam than he did in years gone by, some still come, and there are still people in the village who will gladly tell you the history of their local saint.

Notes on the Stories

1. The Butcher and the Devil

Litchfield included a similar version of this story, and the storytellers I have heard follow it quite closely. Variants are to be found in several other collections.

2. The Steward of Longdendale

This is a Middleton story, but I've heard it recited. Some historical details in this version (but absent from Middleton's) are correct: the area did belong to the earls of Chester, and both Adam Kingsley and John Scollehaw are recorded as bailiff or steward during the time of the Black Prince. Also, it is true that Longdendale was densely wooded during that period, hence the name 'Woodhead' at the upper end of the Etherow Valley.

3. Married under the Ash Tree

This story has been located in various parts of the Peak District, including Glossopdale. Addy collected it "from North Derbyshire", and Merrill echoes this general location in *Derbyshire Folkore*; these versions also contain the priest's rhyme. It is one of a number of strange Peakland wedding stories recounted by Merrill and others. Several have charm, such as the following:

Early in the nineteenth century, William Brightmore married Ann Ball in Wormhill church. Ann's father John was a gardener at Wormhill Hall and she was a maid there. William, the bridegroom, was a builder who was working on the roof of St Margaret's church. When the time for the ceremony came, William climbed down from the roof holding his trowel, and Ann ran from the hall in her apron holding a brush, so the marriage was performed with the groom holding a trowel and the bride holding a brush. The couple proved to be as devoted to each other as they were to their duties, and Ann lived to be 103 years old.

Around 1800, a couple were getting married in Bradwell. Shortly after the ceremony began and the couple were standing before the vicar, the bridegroom, Adam Morton, heard the call of the hounds. Being a keen huntsman, he turned on his heel, ran out of the church and joined the hunt. The ceremony was completed the following day with no further interruption, indicating an unusually understanding bride.

Late in the seventeenth century, Joseph Hunt, a young rector of Eyam, acted the part of a groom in a mock marriage at the Miner's Arms; the landlady's daughter played the part of the bride. When the bishop heard about the game he ordered the couple to marry legally. Joseph was engaged to another woman, who set out to sue him for breach of promise. To escape the law, Joseph and his wife set up home in the church vestry. They spent the rest of their lives there, and two children were born. The couple died in the early 1700s.

St Margaret's church, Wormhill.

4. Bill Shepherd and the Ghost

During my teenage years I was told this story by two different people, one of whom claimed to have been among the trio of practical jokers. Later, I heard it in two other locations in the Peak District, with names and local details changed to suit. This illustrates how a legend (even if it has a genuine historical basis) can migrate and become attached to different individuals and places.

5. The Grey Lady of Glossop Rectory

A new and more compact rectory was built recently, more or less on the site of its medieval precursor; the 1850 building is now an old people's home. The residents seldom complain of haunting. David Clarke and others tell brief versions of this story, which is well known locally; I heard it when I was a child.

6, 7. The Wizard of Mossy Lea *and* The Doctor and the Devil

"The Wizard of Mossy Lea" is another Middleton story that has entered the repertoire of more than one storyteller. "The Doctor and the Devil" is remotely connected with a Middleton tale, but is clearly the Peak District's version of the Faust legend, with a happy ending (except from the Devil's standpoint); Merrill tells it in *Derbyshire Folklore*.

The truth about the place names is more prosaic, though not uninteresting (see Hanmer and Winterbottom). Dr John Talbot, vicar of Glossop from 1494 to 1535, was an illegitimate son of the powerful Talbot family, who leased Glossopdale from the abbey of Basingwerk. The Talbots' main residence was in Sheffield, and Dr Talbot ordered the construction of the paved way now called "Doctor's Gate" to facilitate travel to the manor. (The manor of Glossop is called "Glossopdale" in many Talbot papers of the period.) Doctor's Gate is often marked as "Roman Road" on Ordnance Survey maps, but it was almost certainly not

a Roman road. The Devil's Dyke is one of the several ditches on the high moors around Glossop that served as medieval boundary markers.

The gullible "folk devil" of this story is typical of many folktales; see the Museum of Learning entry http://www.museumstuff.com/learn/topics/the_devil::sub::World_Folklore (accessed 29 January 2011).

8, 9. Tip's Ghost *and* The Lost Lad

The similarity between these two stories is striking, but many people have been lost and died on the moors in bad weather. Joe Tagg's death occurred when I was seven years old. I recall it because my father was among the volunteers who searched for the missing man and his dog. Elizabeth Eisenberg tells the story in her *Tales of Old Derbyshire* and Merrill in *Derbyshire Folklore*. I found the *Derbyshire Life* article by chance during the summer of 2009 when I was researching material for *Murders in the Winnats Pass*, and later discovered that David Clarke had told the same "ghost collie" story in *Supernatural Peak District*.

"The Lost Lad" is a much older story and was the subject of a poem by Richard Furness of Eyam (1791–1857), the so-called Parnassus of the Peak, whose works were collected after his death (Holland, 1858); it was also included in *Tales and Traditions* by William Wood, a personal friend of Furness. More recently, the story has been recounted by Bell and by Merrill, who also gives an alternative version in *Legends of Derbyshire* (Rippon also tells the alternative tale):

The thirteen-year-old son of a forester during the early 1500s took to wandering in the Derwent Valley, and one day he became lost on the moors in the dark. He could not find his way back to the valley and fell asleep in the heather. The next morning he awoke and climbed to the highest point he could see in the hope of discerning familiar landmarks, but in vain. His father's search for him was unrewarding. Finally, the boy sheltered under a rock on Back Tor, wrote "Lost Lad" on the rock, built a small cairn above it to attract the notice of those who were seeking him, fell asleep again, and died of hunger and exposure.

Merrill considers the story of Abraham and Bob the more "authentic" of the two versions.

Sightings of the ghosts of Abraham and Bob in the winter snow are sometimes reported. According to Bell, a Manchester schoolteacher called Trevor Davies saw them in February 1983; he called out to them but there was no reply. In his account of the incident, Mr Davies said, "One moment they were there, and the next moment they were gone." He hasn't returned to Back Tor since that day.

The moors are desolate places and there are numerous "moorland ghosts" in local legend. T' Owd Lad (or Dark Lad, or T' Owd Woman) haunts the high moor of Bleaklow and was seen in a mist by two walkers in the Grains-in-the-Water / Hern Clough area. This is a horned being and has been identified with the Celtic horned god Cernunnos, or Herne (rather than a large sheep, as seems more plausible). A Roman legion in full armour with long curved shields, curious helmets and standards is often seen marching over the moors. It's been seen in the Doctors Gate area, by Torside in Longdendale and at Hope Cross on Kinder. There is also a malevolent "Kinder Boggart". Clarence Daniel wrote a short article on the subject: *Derbyshire Life and Countryside* 1979, 44 (11), pp. 81 and 88. David Clarke devotes a chapter of *Supernatural Peak District* to these sightings.

John Davies of Woodhead is one of several people who have seen a large black slug-like (or whale-like) creature sliding up the Ogden Clough Valley and over the wall at the Devil's Elbow. According to Mr Davies, it made a noise like feet on wet gravel and had a white eye with a black pupil that went round and round.

There are also ghost horses – "white, with their tails billowing behind them as they run" – on the moor's edge above Hayfield. One story, told by Bell, describes a group of gentlemen who heard the runaway horses in Edale, stepped out in the road to stop them and then saw

nothing. It has been conjectured that these ghost horses are related to the Celtic Epona, but the idea that legends and practices could have survived more or less intact from pre-Christian times to the present day is fanciful. There might be connections between some still-extant stories and traditions and an ancient, even pre-Christian, past, but such connections can be no more than tenuous. Various books in the bibliography provide relevant arguments and evidence: Barley and Hanson (1968), Clarke and Roberts (1996), Green (1986, 1996), Moorman (2010), Naylor (1983), Turbutt (2006), Westwood and Simpson (2005).

10. The Parson's Sheep

This delightful young-rogue story is recounted by a number of local storytellers; Addy recorded a short version, complete with the two songs (with subtle differences). The only modern collection in which I have found a version is Pete Castle's.

11. Cutthroat Bridge

This was another of the tales I heard in my youth. It can reasonably be asked: if the unfortunate farmer cut his throat on the spot and there were no witnesses to the incident, how does anyone know the story?

A more plausible account was written in the seventeenth century. According to this version (see Merrill's *Derbyshire Folklore*), a merchant called Robert Ridge was travelling along the drove road towards Dronfield or Sheffield. When he reached the crossing, he found "a man wi' a wound in 'is throat lyin' in Easha Clough". The man was still alive, but he couldn't talk because his voice box had been severed. There was a horrified expression on his face as though something had chilled his soul as well as inflicting a life-threatening wound. A flock of sheep milled around the bridge; they'd just been dipped. There was no other sign of disturbance.

Mr Ridge went to a nearby cottage for help, and he and two other men carried the victim half a mile to another cottage and then on to Bamford Hall. The victim died there two days later. He hadn't been able to tell his story.

The present-day Cutthroat Bridge wasn't built until 1821. By coincidence, another murder victim was found there just a few years ago – minus his head. Two men from Sheffield were charged with causing his death.

12. The Sermon for the Dead

This tale is popular with storytellers and is found in many collections; the version I've given closely follows Litchfield, but other collectors have also obtained it from oral sources. Westwood and Simpson suggest that it reflects residual Roman Catholic beliefs in the parish of Derwent Woodlands, which until the twentieth century was isolated. They compare "The Sermon for the Dead" to stories about those who keep watch for ghosts in church porches, which are widespread in England (see "William Cundy and the Eagle Stone").

13. The Battle of Win Hill and Lose Hill

This story can be found in several collections such as Merrill's *Legends of Derbyshire* and Bell's *Derbyshire Ghosts and Legends*. It was also recounted in Wood's *Tales and Traditions*. There was indeed a battle between the armies of Northumbria and Wessex during which Edwin defeated Cruichelm and his brother, but it is not likely to have taken place in the location assumed in the story. Nevertheless, the names "Win Hill" and "Lose Hill" are interesting. Cameron's study of Derbyshire place names tells us that "Win" is derived from "withy", which is translated wrongly as "rowan"; "withy" actually means "willow". But it seems more likely that "Win" is a corruption of "whin" meaning "gorse", and in times gone by, gorse was valued not only for kindling but also, after it had been crushed to remove all the prickles, as cattle food. Another possibility is that "Win" could denote the bilberry, which grows on high

Eden Tree (Eddentree), near Bradwell.

ground in the Peak District and has several local synonyms (windberry, wimberry, whinberry, winberry). As for "Lose", Cameron tells us that it means "pigsties'". That seems reasonable, because there was a word "lose" for "pigsties" in Old English, but does it really explain the name "Lose Hill"? Do we usually corral pigs on steep hillsides? An alternative possibility (suggested by Dr A. J. Laird) is that "Lose" is a corruption of "loose" and was used in the sense of "free land". This would suggest that the hill, or part of it, was farmed by freeholders, much as part of Whitfield was retained by freeholders when Basingwerke Abbey owned the manor of Glossop (hence the name "Freetown" for that part of Whitfield, still used today). Murray's *Handbook* claims that "Win" should be "Whin" and "Lose" should be "Laws", the significance of the latter being unclear.

The story of the Battle of Win Hill and Lose Hill is a fiction that has grown up around a genuine historical episode, and the names of the hills have been recruited to make it seem authentic. However, there is an interesting footnote: there may indeed have been a battle, or at least a skirmish, in this disputed border territory during early Anglo-Saxon times. That skirmish may have involved a local leader or chieftain called Edwin – a common enough Anglian name – who was the loser rather than the winner. The inn at the junction between the minor road to Hope and the B6049 just north of Bradwell (SK175818) is said to be the scene where Edwin the chief was captured and hanged from a tree. The spot is marked on the map as Eddentree, or Eden Tree. (Wood makes this into a story in its own right, and Merrill recounts it briefly.) There are also names such as Rebellion Knoll and Gore Lane in the neighbourhood.

Sometimes, places can indeed be named in memory of a battle, not least in a part of the world that has long been "border country".

14. Lord of the Wind

No doubt this excellent Wonder Tale has been elaborated by recent storytellers but it has old roots. A short version of it was included in the *Otia Imperialia* of Gervase of Tilbury, compiled between 1200 and 1220 (when Gervase died). Gervase tells us that he learned the story from Prior Robert of Kenilworth, who was born around 1160 in the Castleton area. Since the Peverils were deprived of their position in the Royal Forest of Peak by Henry II in 1157, the tale must have been in oral circulation before Robert heard it, so Gervase probably recorded a version that had been eroded to a skeleton by the Allport-Postman process, referred to in the Introduction.

Westwood and Simpson, who are properly sceptical about the attribution of Celtic origins to traditions that remain extant today, nevertheless suggest that "Lord of the Wind" could embody Celtic notions of the Otherworld. Versions of it could have pre-dated the Peveril era, and *a fortiori* the Normans.

It was widely believed until well into the eighteenth century that winds originated in caves, and Peak Cavern was a prime example.

15. A Strange Banquet

Jewitt presents a bowdlerised version of the sixteenth-century broadsheet ballad of "Cock Laurel", a notorious rascal, probably founded on a much older story. In his introduction to the poem, Jewitt writes: "The copy I here give I have copied from the original broad-sheet in the Roxburghe Collection in the British Museum. It is in some parts exceedingly coarse in its wording, and is therefore unfit to be given entire. It will be seen that Cock Lorrell, the prince of rogues, invites his Satanic Majesty to Castleton, in the High Peak of Derbyshire, to dinner, and the dishes served up for the occasion are people of various disreputable callings and hypocritical habits, against whom the shafts of the writer are levelled." The people of disreputable callings and hypocritical habits include a Puritan as well as those who create items for the fashionable.

16. Kitty Green

This is another popular Wonder Tale from Addy's collection. It seems to be an old story. Versions can be found in a few recent collections, including Pete Castle's. In Addy's version, the girl and her brother are both captured by the giant but the boy runs away (as the alternative to being devoured).

17. The Bradwell Dog

This story seems to have appeared in Bradwell during the second half of the eighteenth century and was recounted by G. L. Hayto in the 1938 issue of *Derbyshire Countryside*. Its first appearance probably coincided with the rise of Methodism in the village and the concomitant aversion to alcohol. There are brief references to it in several recent collections such as those by Daniel, Clark and Armitage.

Our word "boggart" for "ghost" might be derived from the Old Germanic *barghast* or *bargeist*, which denoted a devilish dog with eyes like big saucers. Phantom dogs are common in the Peak District, as they are elsewhere in Britain and indeed the rest of the world. They are usually very large and black, and in different parts of the country they have been given names such as Skriker, Trash and Black Shuck. Phantom dogs have been seen and heard at Bury Hill in Holmesfield, in the Bretton Clough Valley, at the corner of Hordens Road in Chapel-en-le-Frith, near the old ebbing and flowing well beside Barmoor Clough, at Ipstones near Leek, and at Swinscoe on the Leek–Ashbourne road. Their appearance in the south-western part of the Peak District was mentioned in an article by Witcutt in 1942. Even Dickey o' Tunstead has manifested himself as a large black dog. No doubt they've appeared in other places, too, but the stories have been forgotten; for example, a Shuckwood and a

Shuckstonefield are to be found near Crich, north of Matlock. Usually, though not invariably, phantom dogs are portents of doom, as they are in this tale.

18. The Bradwell Ghost

Seth Evans recorded this story in 1912 under the title of "Lumb Boggart". He dated the alleged incident to the mid-eighteenth century and said the story had been commonly believed in the area until half a century before he wrote. "Lumb" and "Lumbly" derive from a Northern Old English word for a pool, so "Lumbly Pool", like "River Avon", is a bilingual tautology. Merrill quotes the magician's strange language in *Derbyshire Folklore*.

19. Little John of Hathersage

Wood devotes a chapter of *Tales and Traditions* to the subject. David Clarke reminds us that Loxley, the supposed birthplace of Robin Hood, was only about eight miles north of Hathersage. Clarke's account of the association of Little John with Hathersage is fairly detailed and includes a reproduction of a sketch of Little John's cottage dating from the 1840s. Other recent collectors who have written on the subject include Bell. Jewitt's *Ballads and Songs* contains a poetic account, embellished by the editor's notes, along with other tales relating to Robin Hood. (Addy's association of Robin Hood, Little John and their comrades with ancient Norse or Celtic deities is now considered dubious.)

Elizabeth Eisenberg wrote a short account of Little John's residence in Hathersage: *Derbyshire Life and Countryside* 1996, 61 (8), 40–41.

20. Nicholas Eyre of Highlow Hall

The Eyres were one of the most prominent families in North Derbyshire from the medieval period until the nineteenth century, and their influence has been described by many authors, notably Mary Andrews. According to one legend, recounted by Merrill in *Derbyshire Folklore*, they arrived in England with William the Conqueror. When William was knocked off his horse during the Battle of Senlac, he was rescued by one of his cavalry, whose name was Truelove. William's helmet had been turned round and was suffocating him, and Truelove removed it. William told him, "From now on your name shall be Air, for you have given me air to breathe." The pun appealed to the Victorian sense of humour, so our early folklore collectors appreciated it, but it doesn't work in Norman French. In any case, the name "Truelove" didn't appear in England until the sixteenth century.

Later in the battle (continues the legend), William found Truelove, alias Eyre, badly injured so his leg had to be amputated. The new king told the injured man that he'd give him land when he recovered. Eyre replied, "Then I'll call it Hope, because you've given me hope." That doesn't work in Norman French either, and it overlooks the fact that *hope* derives from the Anglian word for a small valley. Nevertheless, the Eyre family coat of arms (which can be seen in Hope church and elsewhere) displays a single leg above the shield.

Another legend says that Truelove was renamed Eyre during the battle of Win Hill and Lose Hill. According to that story, the rescued leader tells Truelove that his name will henceforth be Eyre because he will be heir to the valley below the hill. That doesn't work in any language. In any case, the battle of Win Hill and Lose Hill is supposed to have involved the Anglian king of Northumbria, Edwin, and the Saxon kings of Wessex, Cruichelm and Cynegils (see "The Battle of Win Hill and Lose Hill"), and to have been fought hundreds of years before the names Eyre and Truelove were ever heard in England, and before the legal inheritor of property was called an "heir".

But however they came by their name, the Eyres married well and prospered after the Norman era. Early in the thirteenth century, Nicholas's ancestor William le Eyr held land in Hope and the Royal Forest of the Peak.

Some writers (Bell, for example) name Nicholas rather than Robert as the Eyre who murdered the mason.

One of the seven halls attributed to Robert Eyre, North Lees, is a fine Elizabethan manor house on the hill on the other side of the Derwent Valley from Highlow, a little over a mile from Hathersage. In 1845, Charlotte Brontë stayed at the parsonage in Hathersage and her walks acquainted her with North Lees Hall and the Eyre family. Perhaps it is no surprise that the protagonist of her most famous novel was called "Jane Eyre", or that Mr Rochester's house was called Thornfield – "Thorn" being an anagram of "North", and "Field" a translation of "Lees". The description of Thornfield Hall in *Jane Eyre* applies perfectly to North Lees. Hathersage corresponds to the "Norton" of the novel (see http://www. peakdistrictinformation.com/towns/hathersage.php, accessed 12 January 2011).

21. Margaret of Hazelbadge

Fragments of this story can be found in several collections, and there is a fairly full account in Merrill's *Derbyshire Folklore*, but the connection to the Eyre family is tenuous.

22. The Gabriel Hounds

This story was allegedly told to William Wood by John Bowman himself. By then, John was a fine old man in his eighties, and he retained fond memories of his sister and brother-in-law. The versions given by Litchfield and Merrill (*Derbyshire Folklore*) echo Wood's.

The legend of the Gabriel Hounds or rache-hounds is one of the most widespread and ominous of folk beliefs; indeed, Mary Stewart used it in her novel *The Gabriel Hounds*. *Rache* or *ratchet* probably derives from the Old English *ræc*, denoting a dog that hunts by scent. In parts of north-east England, the hounds were called *Gabble-ratchets* because of the noise they made; "Gabriel" could be a corruption of "Gabble", or could be a name for the leader of the wild hunt. The creatures were sometimes portrayed as huge dogs with human heads and sometimes as great birds with hooked beaks and glowing eyes. Their sound was a portent of death in which most people believed. Children were told, "If you're not in bed asleep in five minutes you'll hear the Gabriel Hounds!" The yelping noises seem real enough, and many explanations have been suggested: they're produced by evil spirits awaiting souls condemned to eternal torture, or they're the cries of infants who died before they were baptised and therefore can't enter Paradise, or they're the sounds made by migrating flocks of bean geese.

In the Peak District, the yelping of the Gabriel Hounds was commonly heard on nights prior to a death in the household. John Holland of Sheffield, whose mother came from Staveley, wrote a poem about them. A Sheffield child died in a fire in the 1870s and the neighbours immediately remembered they'd heard the Gabriel Hounds passing over the roof some little time earlier. A resident of Peak Forest heard them in 1987 on the night her brother died, and they've been heard in Castleton, Hathersage, Edale and Shatton within the past few decades. The tale of the Bowman and Birch families might be essentially true; the young people had exploited the widespread belief in the portent.

Clarence Daniel devotes a chapter of *Ghosts of Derbyshire* to the Gabriel Hounds, and Bell recounts some of the recent reports.

23. Fair Flora of Stoke Hall

Stoke Hall was built in 1755 as the Peakland home of the Earl of Bradford, then let to Sir Richard Arkwright's son Robert. It became a hotel in the 1970s. It's said that bells in the hotel sometimes ring unaccountably and the burglar alarm sounds when no one is around. Whether Flora has anything to do with such disturbances is an unanswered question.

Bell and Merrill recount versions of the tale I have included. There are other stories about the statue of Flora: she was a young lady murdered by a jealous lover, a girl who was drowned

in the Derwent trying to elope with a lower-class man of whom her parents disapproved, and so on. According to some versions of the Stoke Hall legend, Flora is a statue erected to the memory of the eloping daughter, or of a maid called Flora who was murdered in the hall. Others say (more credibly) that the statue represents the Greek goddess Flora. According to this view, she was a gift from the Duke of Devonshire to the Bridgeman family, or to a Mrs Taylor who had admired it when she visited Chatsworth. However, its arrival at Stoke Hall was succeeded by a run of bad luck for the occupants.

Stoke Hall is said to have had a screaming skull in the attic at one time, in common with several Peak District houses (see note on "Dickey's Skull").

As for the statue's mobility, that is not unique. Another marble statue of a lady in the recreation ground at Ashbourne will open her eyes and perhaps even talk if you walk around her three times at midnight.

24. Cockeye and the Boggart

The beautiful village of Eyam (pronounced *Eem*) is best remembered for the plague that afflicted it in the 1660s (see, for example, Clarence Daniel's *The Story of the Eyam Plague with a Guide to the Village*). Like most villages in the limestone area of the Peak District, its economy was once founded on lead mining; it is now founded on tourism. This is one of the many Eyam stories recounted by William Wood in *Tales and Traditions*; other versions are told by Litchfield, Bell, Merrill and Armitage. Bell suggests that the boggart was the spectre of a plague victim, which pulled the bedclothes from Eyam residents to warn them – belatedly – of the epidemic.

25. Rowland and Emmot

A highly romantic version of this story is given in Wood's *Tales and Traditions*, and a beautiful stained-glass window in Eyam parish church depicts the couple "conversing" across the Dell (or "Delf"). There are many accounts of the Eyam plague, including the detailed one by Daniel and a clear summary by Merrill. The annual open-air service of commemoration is described by Crichton Porteous in *Ancient Customs of Derbyshire*.

26. Charles Huntley of Eyam

A disproportionately large number of stories and traditions associated with Eyam have survived. It was the birthplace and home of the poet Richard Furness and the historian William Wood as well as Clarence Daniel; few small communities are so richly supplied with collectors of tales. This delightful tale, related to one in Wood's collection, might have a historical foundation.

27. The Scottish Peddler

This is another legend from Wood's *Tales and Traditions*, and again it is generally held to have a historical basis. Merrill gives a version very similar to mine in *Derbyshire Folklore*. Stoney Middleton seems to have been a rough community during the lead mining era, and was the haunt of at least one notorious highwayman.

28. The Red Shoes

The murder of Hannah Oliver and the conviction of Anthony Lingard, the last felon ever to be gibbeted in this part of England, illustrate how a brutal, real-world, high-profile crime can become "the stuff of legend". As far as I can ascertain, the story as I've recounted it is true in all details, including the extraordinary coincidence of the message that Samuel Marsden hid inside the shoe. What is not clear is how the stolen shoes, which Lingard had hidden in a haystack after they'd been returned to him, ended up in such an obvious and incriminating

place in his cottage. Like so many tragic or gory tales that are matters of historical fact, this one has become embellished with "supernatural" overtones. Roly Smith includes an account of the case in *Murder and Mystery in the Peak* and it's recounted by Rippon; it's described in detail in Ian Morgan's *True Tales of the Macabre*.

29. The Murder of William Wood

This incident is described in Merrill's books and by Bell in *Derbyshire Ghosts and Legends*, and also by Clarence Daniel in *The Story of the Eyam Plague*. The murder happened, apparently as described, and the murderers were identified; but it is fascinating to see, as in other historical stories (e.g. "Tip's Ghost" and "The Red Shoes"), how "supernatural" elements tend to accrue around accounts of real tragedies.

30. Dickey's Skull

The story of Dickey's skull is probably the most famous of all Peak District folktales and is found in numerous collections. Lengthy versions are given by Wood, by Clarence Daniel in *Ghosts of Derbyshire*, by Anton Rippon, and by Andy Roberts and David Clarke in *Twilight of the Celtic Gods*; Jewitt's *Ballads and Songs* quotes Hutchinson's account of the skull and includes Samuel Laycock's *Address to Dickey*. In his *Tour through the High Peak* of 1807, Hutchinson wrote:

> … there are three parts of a human skull in the house … I traced to have remained on the premises for near two centuries past, during all the revolutions of owners and tenants in that time … looked upon more as a guardian spirit than a terror to the family, never disturbing them but in case of an approaching death of a relation or neighbour and showing its resentment only when spoken of with disrespect or when its own awful memorial of mortality is removed …

I first heard the version told here when I was a teenager. Like all great folktales it exists in several variants, and it's connected not only with several local traditions but also with similar tales from other parts of Derbyshire, and indeed other parts of England. Some authorities believe that it echoes ancient beliefs and practices, but that's a common canard.

The problem with the version given here is that although the Dickson family owned Tunstead in the nineteenth and twentieth centuries, no one of that name lived there in earlier times. An alternative version tells us the farm at Tunstead passed to the joint ownership of two heiresses, one of whom killed the other. The victim declared as she was dying that her bones should never be removed from the house, and her skeleton was kept in a cheese vat. In favour of this version, an eminent surgeon who examined the skull in the nineteenth century declared it to be that of a woman, probably about eighteen years old. However, the story of the two heiress sisters is also associated with Duscar Farm near Castleton. Sidney Addy described the skull on the windowsill of Duscar around 1900; crops in the surrounding fields failed if it was removed.

Another version of the Dickey story is that the skull belonged to a witch; or that a witch told the owners that they must keep it in the house to act as a guardian – and if it (or he, or she) wasn't treated with proper respect there would be dire consequences.

Dickey's skull is remarkable for its widespread fame, but many of the older farms and large houses of the Peak District have or had similar protective charms, usually a carved stone head or a piece of human or animal bone, typically a skull, buried in a strategic part of the building. The pattern is always the same: the relic must be treated with respect, in which case it will protect the house and its inhabitants and their interests, warding off evil and witchcraft; but disaster follows if disrespect is shown or the relic is removed. At Flagg Hall, a skull is still

kept in a glass case on the stairs, and misfortunes and uncanny events follow if it's removed. Once a servant girl threw it out of a window and it landed in a cartload of manure heading for the fields. The horse pulling the cart stopped dead in its tracks and kicked and reared and wouldn't move again until the skull was recovered and returned to its rightful place.

A few years ago, a Manchester archaeologist announced he'd found 250 previously unrecorded carved stone skulls in the Peak District and surrounding area. This was the southern extent of the territory occupied by the Brigantes in Roman and pre-Roman times, and the Brigantes were head hunters. They believed that severed heads conferred the power of divination and protection on dwellings and even whole communities. On the face of it, this seems to support the conjecture that Dickey and his kindred, and their stone equivalents, represent a distant memory of that ancient Celtic tradition. Indeed, many of the carved heads have three faces, possibly representing – at a long remove – the Celtic triple goddess. However, many of them are no older than the Victorian era, no doubt installed to imbue the premises with an impression of romantic mystery.

Nevertheless, it's interesting to recall that the Latin verbs *dicare* and *dicere*, of which *dici* is an imperative, mean respectively to state or to pronounce, and to dedicate, consecrate or deify. *Dicio* means power, sway or authority. Given the alleged power and communication skills of the Tunstead Milton skull, and its tacit association with primitive religious belief, those meanings could possibly be encapsulated in its popular name.

31. Choosing a Servant

This is a popular local tale, though, as is customary, different tellers place it in different settings; Merrill in *Derbyshire Folklore* locates it in "North Derbyshire", so Chapel-en-le-Frith seems plausible. Pack-Rag Day, the traditional hiring fair in Chapel-en-le-Frith, is colourfully evoked in one of the stories in Elizabeth Eisenberg's collection, though Eisenberg doesn't include "Choosing a Servant". Addy points out a comparison with the Grimm tale "Brides on their Trial".

32. Eldon Hole

Eldon Hole is otherwise known as the Devil's Bolt Hole. It's fairly deep, but not quite bottomless – as the following early accounts allege:

In the fifteenth century, a man called Charlie Cotton was lowered down the hole on a mile-long rope and still didn't reach the bottom.

A century later, the Earl of Leicester had a local man lowered into the hole on a rope and when he was hauled up again he was in a state of shock, unable to speak and with an expression of terror on his face. He died soon afterwards. The Earl deduced that the hole did indeed afford a direct link to Hell and the poor fellow had come face to face with the Devil.

Two eighteenth-century highwaymen forced a young man to step over the edge of the hole and they declared they'd heard the crackling of flames as he fell into the Devil's arms.

33. The Deer Hunt

Llewellyn Jewitt includes a version of this story in *Ballads and Songs*, in the form of a ballad composed by his friend William Bennett. According to Jewitt, the story is "founded on an old Derbyshire tradition".

34. Wheston Hall

This story was recorded in some detail by Clarence Daniel in *Ghosts of Derbyshire* and more briefly by other collectors such as David Bell. John Merrill's *Derbyshire Folklore* tells another story about the female ghost, the victim of a loveless marriage whose husband murdered her lover at Wheston Hall.

Until about a hundred years ago, Wheston Hall was guarded by the life-sized wooden figure of a Cromwellian soldier, which stood in the entrance hall. He was known as Soldier Dick. It was said that if Soldier Dick was removed from the hall, cattle would die, crops would fail and the occupants of the hall would fall ill, and disasters would continue until he was returned to his rightful place – another "guardian spirit" like Dickey o' Tunstead. Soldier Dick is no longer in the entrance hall; he's in a cellar, where he was placed during building alterations, and he's buried under a heap of rubble. But he's still on the premises, so Wheston Hall doesn't suffer strings of disasters.

Oddly enough, Soldier Dick has given his name to a public house on the A6 just outside Disley, which is a considerable distance from Wheston.

35. Owd Nick o' Wormhill

The woman who told me this story a number of years ago had worked in Wormhill Hall and still lived nearby. She claimed to have heard it from a neighbouring farmer and also from a former servant at the hall. It resembles the tale entitled "Nicobore" (= "Nick Bower"?) in Swift's anthology, derived from an item in Addy's *Household Tales*, which was collected from Addy's home village, Norton, now on the southern outskirts of Sheffield. It has the ring of a local legend founded on a historical event. John Merrill tells the story much as I tell it; he may have had the same informant – or my informant could have read his *Derbyshire Folklore*, which was published almost twenty years before I heard the tale.

36. Lovers' Leap

Bell gives us a short version of this legend. There are several Lovers' Leaps in the Peak District. Some of the stories associated with them are matters of historical fact.

Hannah Baddaley, a noted beauty of Stoney Middleton, daughter of William and Joan Baddaley of that parish, leapt from the top of the limestone cliff in 1762, aged twenty-four. She had been courted by William Barnsley and for a year they were enraptured with each other, but then William's attentions cooled and Hannah was distraught. She wandered around in deep gloom for a week until she could stand it no more and decided to end her life. So walking to the summit of the cliff and placing her bonnet and gloves in a hawthorn tree, she cried out on her false suitor and jumped. The drama of the occasion was vitiated by her voluminous dress, which being made of coarse material mushroomed out and served as a parachute. She landed in a sawpit and her legs were injured, so she had to be carried home by friends. She died two years later, aged twenty-six. What became of William is unknown.

At the southern end of Dovedale (SK146517) is a Lover's Leap where a young maiden jilted by her lover sought to end her life; it's about 120 feet above the surface of the Dove. She jumped, but the bushes around the river broke her fall, and she was able to get up and walk away. She never considered her ex-lover again and is reputed to have lived happily single for the rest of her long life.

Jane Hambleton was less sensible. Her lover promised to marry her provided she threw herself off a rock precipice in Lathkill Dale to prove her love. She did as requested and survived with a broken finger; so the young man, wishing to be sure, asked her to repeat the leap. At the third attempt she was killed. The rock is now known as Jane Hambleton's Rock.

Merrill's *Derbyshire Folklore* describes these incidents. Elizabeth Eisenberg records a number of wedding traditions in *From the Cradle to the Grave*, which are entertaining and obliquely relevant to the lovers' leaps.

37. The Chelmorton Hob

There is a brief reference to this story in http://www.derbyshireuk.net/celts.html (accessed 8 May 2011) and versions are told by Bell and Merrill (*Derbyshire Legends*). The cave in Deep Dale and

the spring close to it are popularly associated with a hob, and sometimes with Hob Hurst (see "Hulac Warren and Hedessa"). Water traditionally had regenerative powers at particular times of the day or the year, and each source had its guardian spirit (see Naylor's *Celtic Derbyshire*).

A short article by Jean Fielding mentions various pieces of Peak District faerie lore, including the nature of hobs: *Derbyshire Life and Countryside* 1979, 44 (3), p. 87. More such items are listed in Merrill's *Derbyshire Folklore*.

38. The Quiet Woman

Both these versions of the story were in oral circulation until recently, and both are recorded in Merrill's *Derbyshire Folklore*. The more brutal version seems to be the more popular and is recounted by Bell and other anthologists.

39. Lud's Church

Doug Pickford tells this story and points out that "Lud-auk" means "of Lud's Church", from the Old English *auk* = temple. He agrees with David Clarke that the name "Lud" relates to the Celtic sky god Llud and points out that the Saxon name for a well-known street in London has the same root (Ludes Geat = Ludgate). He also tells us, plausibly, that the River Dane is named after the earth mother Dana. Lud's Church is actually a large landslip, but it is both eerie and impressive.

Alan Gibson attributes the story to Sir William de Lacy, who is supposed (while returning home from a visit to Trafford of Swythamley Hall) to have heard it from an old man he met outside Lud's Church. Gibson adds the tale of a Viking raider called Ludd, who was said to have been defeated in battle nearby by the monks of Swythamley, and acknowledges that this tale is historically implausible.

There is an established belief that Lud's Church is the Green Chapel of the great medieval poem *Sir Gawain and the Green Knight*. The description of the approach to the chapel in the poem applies very well to the short journey from The Roaches down to Back Wood in the Dane Valley, and some scholars believe that the poem, written in the Middle English of North Staffordshire, was composed by a local writer, probably a monk. (Gibson provides a good précis of *Sir Gawain and the Green Knight*.)

It is inevitable that stories of this kind will mutate into ghost stories, but the area was also traditionally haunted by the Bosley Boggart, a fearsome spectre that so terrified the local inhabitants they would not venture out of doors after dark. It is unlikely that the Bosley Boggart could be associated with any of the Lollard worshippers, especially the unfortunate child Alice.

The "weird floating lights" are interesting. Broadly similar lights have also been seen over (and in) old lead and coal mines, where – as Jill Armitage notes – the "fiery drake" was considered a portent of disaster by the miners (one of many mining superstitions). Similar phenomena have been recorded at Lunter Rocks above Winster; Harborough Rocks near Brassington (where there are caves with Roman remains); on the Nine Ladies stone circle (a blue light emerges from the wood and sits among the stones); near the stepping stones in Dove Dale; and, most famously, in Longdendale (see Clarke's *Supernatural Peak District*).

The Longdendale Lights have been seen by many people (the local newspaper reporter Sean Wood, who lives in the valley, has seen them at least thirty times) and they take many forms. Sometimes there's an intense beam of light; sometimes a large illuminated area, making everything as clear as day but very cold; sometimes witnesses see a string of moving or "dancing" lights, usually smaller. The phenomenon has been seen all the way between Nell's Pike and Shining Clough and has traditionally been associated with a bleak rock outcrop, Torside Castle. Reports of these lights date from long before the days of railways and air travel, so they can't be attributed to aircraft lights or reflections from rails.

Such phenomena, alternatively called "earth lights", "anomalous luminous phenomena" and "spook-lights", are common not only in Britain but throughout the world. They're not well understood but have received serious scientific attention, as in Paul Devereux's books and Sean Palmer's online account, http://inamidst.com/lights/earth, accessed 14 February 2011.

40. Three Mermaids

Inland or freshwater mermaids are surprisingly common in England. Westwood and Simpson describe a number of examples in the fen country, notably in Cambridgeshire and Suffolk. Jenny Greenteeth is more frequently met in the north-western counties, where her alternative names include Wicked Ginny and Peg o' Nell. It has been conjectured that she's a folk-memory of sacrificial practices, but more likely she was invented to frighten children away from dangerous waters, especially ponds covered with duckweed, which to the innocent eye might look like solid ground.

The former Mermaid Inn near Blake Mere stands on an old drove road on the Staffordshire moorlands north-east of Leek. There has been a hostelry there for centuries; it's now a private residence. Another legend associated with Blake Mere is that a man named Joshua Linnet fell in love with a young woman who rejected him, whereupon he denounced her as a witch. She was then tied up and thrown into the pool, and as she sank and drowned she cursed Joshua, who three days later was found dead beside the pool. According to this version of the story, the mermaid is the young woman's ghost. Another story, recounted by Boyland, tells of a young man who drowned in the pool in the eighteenth century and occasionally reappears, calling for help.

Boyland adds another anecdote: a man bet his drinking companions in the Cock Inn that he dared to walk to Blake Mere on a wild winter night (and would leave his walking stick on the edge of the pool to prove that he had been there). As he approached the water he was started by the cries of a woman in distress. He discovered that the woman was being drowned by the father of her unborn child, who wished to conceal the pregnancy, and contrived to frighten the would-be murderer away. Wittingly or not, the mermaid saved a life on that occasion.

It's said that Blake Mere (which is not bottomless; it is about three feet deep) has never frozen over because of its high salt content.

41. The Girl who Fetched Water in a Riddle

This is another of the stories collected from Calver by Addy, who drew attention to its similarity to "The Well of the World's End" in Jacobs's *English Fairy Tales*; Jacobs cites Leyden's edition of *The Complaynt of Scotland* (*c.* 1548) as his source. Westwood and Simpson remind us of a tradition that the innocent can carry water in a sieve, and recall that Jacob Grimm found that the sieve makes frequent appearances in folklore as a vessel with magical properties. That tradition goes back to the Danaids of Ancient Greece.

42. William Cundy and the Eagle Stone

The Eagle Stone stands near Wellington's monument on Baslow Edge. It may have been named for the Celtic god Aigle, who was noted for throwing large stones around hillsides and into valleys. Alternatively, the name might be a corruption of Egglestone, or witches' stone; the girls of Baslow refused any proposal of marriage until their suitors had climbed the Eagle Stone, thus gaining the favour of the witches. Like the Turning Stone near Ashover and Stump John on Hallam Moor, the Eagle Stone turns around at cock-crow.

As old Mr Cundy knew, the Eagle Stone had the power to attract the little girl from the village and send her to sleep in its shadow, and then to protect her from harm. Perhaps we should not underestimate the power of ancient stones.

43. The Calver Thieves

This version of the story seems to be rooted in Eric Swift's collection and some of the details could be Swift's inventions. Pete Castle tells it somewhat differently. One of Addy's "unlettered" informants in Calver told him a short version of the story, which involved a bag of nuts being buried with a recently deceased person; the thief exhumed them. Burial of food with the dead is an ancient and widespread practice that persisted in some parts of Britain, including the Peak District, until relatively recently. As Addy pointed out, his version closely resembles "Of the mylner who stale the nuttys and of the taylor that stale a shepe" in Shakespeare's jest-book, *A Hundred Mery Talys* (pp. 31–7), the author of which attributed it to earlier medieval sources. (*A Hundred Mery Talys* was printed by John Rastell, London, in 1526; it became associated with Shakespeare because there is a reference to it in *Much Ado About Nothing*.) Variants of the story are widespread throughout Europe and elsewhere, as illustrated by the following anecdote from an anonymous correspondent in Canada:

On the outskirts of a small town there was a big, old pecan tree just inside the cemetery fence. One day, two boys filled up a bucket with nuts and sat down by the tree, out of sight, and began dividing the nuts.

"One for you, one for me. One for you, one for me," said one boy. Several dropped and rolled down toward the fence.

Another boy came riding along the road on his bicycle. As he passed, he thought he heard voices from inside the cemetery. He slowed down to investigate. Sure enough, he heard: "One for you, one for me. One for you, one for me."

He just knew what it was. He jumped back on his bike and rode off. Around the bend he met an old man with a cane, hobbling along.

"Come here quick," said the boy, "you won't believe what I heard! Satan and the Lord are down at the cemetery dividing up the souls."

The man said, "Beat it kid, can't you see it's hard for me to walk?" But when the boy insisted, the man hobbled slowly to the cemetery.

Standing by the fence they heard: "One for you, one for me. One for you, one for me."

The old man whispered, "Boy, you've been tellin' me the truth. Let's see if we can see the Lord."

Shaking with fear, they peered through the fence, but were still unable to see anything. The old man and the boy gripped the wrought-iron bars of the fence tighter and tighter as they tried to get a glimpse of the Lord.

At last they heard, "One for you, one for me. That's all … Now let's go get those nuts by the fence and we'll be done."

They say the old man made it back to town a full five minutes ahead of the kid on the bike.

44. Hulac Warren and Hedessa

The rhyme "The Piper of Shacklow…" is traditional (Addy recorded it), but it is doubtful whether this tale has Celtic roots as it pretends. (For the names and characters of the gods and goddesses, see e.g. the books by Miranda Green. We must presume that Fin and his priests called upon their tutelary sun god, and on Babdah the raven, Segomo the god of war and Sucellus of the fields and forests; the daughters of Fin would call upon Brigantis the triple goddess, who dwelt in rivers and on the hilltops, and Arnementia of the wells.) The story was told in rhyme in 1816 and was presumably based on local tradition; the rhyme is usually attributed to Eliza Bloor of Ashford but actually appears to have been written by her protégé John Howe (1777–1838), as Bell points out; the rhyme and a romanticised version of the tale are included in a 1865 obituary on Howe (http://www.wirksworth.org.uk/RELIQ-65.htm, accessed 31 May 2011). David Clarke suggests that Ruskin was aware of the tale when

he wrote his famous description of Monsal Dale. The "Dymyndale" of the rhyme refers to the section of the Wye Valley west of Fin Cop and the name dates from at least the fifteenth century, when William of Worcester wrote of "a valley called Dymynsdale, where spirits are tortured, which is a marvellous entrance into the land of the Peke, where souls are tormented" (cited by Clarke).

The "Fiddler of Fin" apparently refers to Hob Hurst, who inhabited a cave, "Hob Hurst's House", in the side of Fin Cop. (For another reference to this cave, see "The Wizard of Monsal Dale". It was probably a Bronze Age burial site). Hob Hurst has several houses in the Peak District, the most famous being on Beeley Moor above Chatsworth. He was a giant with mysterious powers who could perform the work of ten farm labourers in a single night, provided he was rewarded with a bowl of cream, to be placed on the farmer's hearth. The name "Hob Hurst" has been interpreted as either "hob of the wood" ("hurst" deriving from an Old English word for wood) or "the giant hob" (from the Old English "thyrs"). Either interpretation could be consistent with the synonym "Hob Thirst" (= "hob o' th' hurst" or "hob thyrs") and with the name "Thirst House" for this being's homes.

Hobs (hobthrusts or hobmen) are equivalent to the Scottish brownies and the German kobalds, household faerie creatures who acted as servants provided they were treated respectfully and not spied upon. They always required a food reward, which in the Peak District and much of the rest of northern England was usually a bowl of porridge and a mug of ale. They were also nature spirits. Hob Hurst was distinctive in preferring cream to porridge and ale, and apparently distinctive in size, too; though if he could enter the farmhouse to collect his reward from the hearth, he must – like many folk of the faerie realm – have included size-shifting among his mysterious powers.

45. The Wizard of Monsal Dale

The only other written version of this story I have seen is a short account in Merrill's *Derbyshire Folklore*. The cave in the side of Fin Cop can only be Hob Hurst's house (see "Hulac Warren and Hedessa"), so Neddy could be a distant echo of stories about the giant hob.

46. Prince Arthur and the Vision at Haddon

Wood tells this story, which has some historical foundation: Sir Henry Vernon was a favourite of Henry VII and he was the mentor of Prince Arthur, and a room in Haddon Hall is traditionally associated with the prince. The title "King of the Peak", however, was more usually attached to Sir Henry's son and successor, Sir George Vernon. Local tradition tells us that the ancient cross in Bakewell churchyard did indeed once stand at the Hassop crossroads; old way-markers often ended up in churchyards (see Sharpe's *Crosses of the Peak District*).

47. One Tree Hill

I first heard this story from a professional storytelling group in 2007, and when I asked them about its provenance they told me it was "one they had heard". A short variant was collected by Addy. Pete Castle includes a version similar to the one I heard (and have recounted here). In *Derbyshire Ghosts*, Boyland tells a possibly related legend, which is set in the Weaver Hills near Leek, just south-west of the Peak District: five ladies dressed in white dance around a lone tree at dawn on Midsummer's Day while the Devil plays the fiddle. Merrill in *Derbyshire Folklore* tells us that a farmer at Grainfoot's Farm near Ashopton (close to Cutthroat Bridge) planted a tree for each of his three sons. Two of the sons had long and full lives and their trees flourished; the third died comparatively young and his tree was stunted. Again, there could be distant echo here of "One Tree Hill".

48. The Duck Tree

I heard this story from an elderly resident of Ashford, and it seems to be well known in the area, but I haven't seen it in any written collection.

49. The Magpie Mine

Roly Smith gives a clear summary of the history of the Magpie Mine, which was opened in 1682. The main vein of ore, allegedly still rich, is submerged under 150 feet of water, despite the nineteenth-century attempts at drainage. David Clarke tells the tale of the widow's curse in *Supernatural Peak District*.

The Barmote Court, the oldest industrial court in the world, presided over all claims and disputes and administered the laws peculiar to the lead mining industry. Each mining area, usually centred on the village where most of the mine workers lived, had its own Barmote Court, which comprised twelve jurors under the authority of the Barmaster.

There are stories about the Magpie Mine being haunted, for example in David Bell's collection. O'Neil's 1957 article in *Derbyshire Countryside* tells us that a party of speleologists inspecting the mine shortly after the Second World War saw an old man with a candle walking along a tunnel, from which he disappeared without trace. A ghostly dog has been seen prowling the ruins. The mine agent's house, built in 1840 and now housing a field station of the Peak District Mines Historical Society, appears to be haunted by a gentleman in Victorian garb, who has frightened at least one party of students.

50. The Bakewell Witches

This is another historical story, reported in a number of different collections, including Wood's and Merrill's. Stories of witches are relatively uncommon in the Peak District canon, and the unfortunate women in this tale were surely victims of the witch-craze of James I's reign rather than wielders of unusual powers.

51. Parson's Tor

This story appears to have a historical foundation, but the version recited by most storytellers and recounted here owes most to the account in Jewitt's *Ballads and Songs*. Jewitt apparently took it from *The Reliquary* of 1864. I have not seen the alleged original, but John Merrill (*Derbyshire Folklore*) tells us it was written by the Reverend W. R. Bell, formerly curate of Bakewell.

52. The Little Red Hairy Man

Addy collected this story from Wensley in the late nineteenth century; it is one of the longest items in his *Household Tales*. Swift located it in Youlgreave, and there are versions in other modern anthologies. It appears to be a combination of two different stories, one concerning three miners' sons seeking their fortunes, the other a variant of an internationally known Wonder Tale commonly called "The Quest for a Vanished Princess". There is a remote connection with "Jack and his Golden Snuff Box" in Jacobs's *English Fairy Tales*. Westwood and Simpson tell us that an almost identical story was collected in Cumberland early in the twentieth century. One professional storyteller told me that when he recites this tale in the former Derbyshire mining communities, he substitutes "T' Owd Mon" for "the little red hairy man", and his audiences relate to it more immediately.

53. The Riddle

Addy collected a short version of this legend, comparing it with a story called "The Oxford Student" in Halliwell's *Popular Rhymes and Nursery Tales* of 1849. It appears to be related to the widespread English tale "Mr Fox", which is recounted in Jacobs's *English Fairy Tales*.

Pete Castle gives the story an alternative setting with different names, but his version is substantially the same as the one I tell. Merrill's *Derbyshire Folklore* includes a shorter and slightly different variant, complete with the girl's rhyming riddle.

The three riddles included in my rendering of the tale are all traditional. The answers are given below:

- What goes round the house and into the house but never touches the house? *The sun.*
- What is it that you can keep after giving it to someone else? *Your word.*
- What walks around on its head all day? *A nail in a horseshoe.*

54. The Nine Ladies

This is a local variant of an old and very widespread tale, but Westwood and Simpson believe the Stanton Moor story is of recent origin because it isn't mentioned in nineteenth-century sources such as *Murray's Handbook*. It could therefore be an example of a migratory (in this case imported) legend; indeed, Boyland points out a similarity to a West Cornwall story, and to the legend of the lone tree (see the note on "One Tree Hill"). However, the name "Nine Ladies" appears on old maps, so perhaps a similar tale, now vanished, preceded the current one.

55. Faerie Pipes

There are many anecdotes about the little white clay pipes beloved of lead miners and much treasured by the Barmote Court jurors; such pipes can be found occasionally in the areas of old mines. Addy said they were common in ancient earthworks, suggesting antiquity. Along with other personal items such as children's shoes, the little pipes were often placed in mine entrances as good-luck charms or offerings to T' Owd Mon, and they might have been left in other locations as offerings to the faerie folk, who were fond of pipe smoking. The tale I've included here is a compilation of several of these anecdotes, combined with a retelling of a story from Jewitt.

It is believed that Nine Stones Close, otherwise known as the Grey Ladies Stone Circle, did comprise nine stones at one time, but only four are now standing.

56. William de Rossington

A version of this story can be found in Wood's collection, and also in Merrill's *Legends of Derbyshire*. It seems less popular among storytellers than one might expect.

57. Mr Armaley's Journey

Addy's short version of this story was collected in Calver and gives no specific location (Addy's informant called the minister "Armaleg"). I've heard two other versions from local storytellers, giving a setting near Hartington. Eric Swift included another variant in his 1954 *Folktales of the East Midlands*, setting it around Ashbourne. I've combined the main elements of all those versions. There was a widespread belief that faerie folk would flee from prayers designed to ward off the Devil and his minions.

58. The Headless Horseman of Onecote

Brief mentions of the headless horseman can be heard locally; this version of the tale is close to the one summarised by Westwood and Simpson, and by Clarke in *Ghosts and Legends*.

59. The Widow and the Hob

This is one of the few stories in this anthology that I've taken from a single source, namely Litchfield. I read it some years ago and since then I've told the story four or five times in

Children's well dressing from
Stoney Middleton in July 2011.

public. I wrote the version included here after these recitals, and after I'd written it I looked
at Litchfield's book again. It's interesting to see how much I've changed it – unconsciously
– and how much of Litchfield's detail I've retained.

Stories about Derbyshire's most famous tradition, well dressing, are inevitable, and this one
is set in the village where the tradition is believed to have begun. During the Black Death of
1348–49, when half the population of the county (including seventy-seven out of a hundred
priests) died, no one in Tissington fell ill, and their escape from the plague was ascribed to
the purity of their well water. Thereafter, the wells were decorated with flowers every year as
a token of thanksgiving. Some sources tell us that the villagers were reawakening an "ancient
practice", alleged to be pre-Christian. Well dressing in Tissington was probably further
invigorated by the terrible drought of 1615, when "There was no rayne fell upon the earth
from the 25th of March until the end of Maye, and then there was but one shower. Two more
showers fell between then and the 4th of August." Cattle perished and crops were lost, but
the five wells of Tissington continued to flow.

Tissington's well dressing occurs annually on the eve of Ascension Day. Nearly all Peak
District villages have well dressings at different times during the summer. For the history
of the custom and a description of how a well dressing is made, I recommend Crighton
Porteous's *The Beauty and Mystery of Well-Dressing* or John Ravenscroft's online account
(http://www.timetravel-britain.com/articles/history/welldressing.shtml); several illustrations
are given at http://www.peakdistrictinformation.com/features/welldress.php. (Both sites
were accessed 9 February 2011.) Briefly: well dressings consist of natural objects collected
from the local environment (moss, bark, foliage, pebbles, and particularly flower petals) and
impressed in a bed of smooth clay, following a pre-arranged design. The clay bed is prepared
well in advance, in a wooden frame. The picture is prepared the day before the well dressing

goes on display. Many hours of work are involved. In many villages, one well is dressed by the local children, under supervision, so the next generation learns the craft.

60. Spend Lane

This is one of the "road ghost" stories recounted by David Clarke in *Supernatural Peak District*, and he and David Bell both note that Spend Lane is a notorious accident black spot. Bell recounts the incident that in 1977 befell Harold Maddock, whose car was filled with the sound of strong wind and tearing upholstery when he turned into Spend Lane; Mr Maddock was badly shaken, though no harm was done.

61. The Woman who Disappeared

I heard this story in Milldale in the Dove Valley. Its similarity to the ubiquitous phantom hitchhiker story is obvious. The many versions of the phantom hitchhiker legend are thoroughly discussed by Sean Tudor at http://www.roadghosts.com/Introduction.htm (accessed 24 November 2010), but Tudor doesn't include a pre-internal combustion engine variant. I don't know whether this Milldale version really originated in the nineteenth century or earlier or whether it's a "back-formation" invented to add a romantic and faux-historical gloss to a well-known contemporary legend. It *could* be an old tale, since Michael Goss's book gives evidence for earlier manifestations of the phantom hitchhiker. At Jacqueline Simpson's suggestion, I sent the Milldale version to Libby Tucker and it was printed in *Foaftale News* in 2009.

Road ghosts of one sort or another abound in the Peak District, as they do everywhere; some haunt recently constructed highways. David Clarke devotes a whole chapter of *Supernatural Peak District* to them. The A616 Stockbridge bypass is apparently haunted by several ghosts: a man in a long cloak, perhaps eighteenth-century; a monk or priest buried in unhallowed ground; a woman in white and a circle of dancing children, sometimes in medieval clothing; tiny "fairy" figures. There's also a spectral jaywalker as well as the familiar phantom hitchhiker story. A phantom car appears on the A6024 Holme Moss road. It is black with a round bonnet and big headlights. Over the A57 Snake Pass, at the junction with the A6013 Bamford road, a carter with a tall hat and a knee-length smock and a riding whip is sometimes seen, leading a horse and a cart with high sides.

Probably the most sinister road ghosts in the area haunt the aptly named Shady Lane between Hassop and the Longstones. If you venture there at dusk you might meet a cortège of twelve headless men carrying a coffin. Beware: the coffin is intended for you.

62. Saint Bertram

Bertram (otherwise known as Bertolin) is also associated with a one-time hermitage called Bethnei near Stafford, and with Bartomley near Audley, Cheshire. There is a statue commemorating the saint in Longnor church. In Ilam church there is a chapel dedicated to Bertram, dating from 1618; it houses the tomb cover and the shrine, which dates from the late fourteenth century. His life story was written in the 1516 edition of *Nova Legenda Angliae*.

Bibliography

Addy, Sidney O. (1895) *Household Tales with Other Traditional Remains*. David Nutt, London. Published later in 1895, and republished in 1973, under the title *Folk Tales and Superstitions*. E. P. Publishing, Wakefield. The original appeared as a Kessinger Legacy Reprint in 2011.

Allport, Gordon W. and Postman, Leo (1947) *The Psychology of Rumor*. Henry Holt, New York.

Andrews, Mary (1948) *Long Ago in Peakland*. R. Milward & Sons, Nottingham.

Armitage, Jill (2009) *Haunted Derbyshire*. The History Press, Stroud.

Barley, Maurice W. and Hanson, Richard P. C. (eds.) (1968) *Christianity in Britain 300–700 AD*. Leicester University Press, Leicester.

Bell, David (1993) *Derbyshire Ghosts and Legends*. Countryside Books, Newbury.

Boyland, Wayne Anthony (1992) *Derbyshire Ghosts*. Derbyshire Heritage Series. J. H. Hall & Sons, Derby.

Cameron, Kenneth (1959) *The Place Names of Derbyshire*. Cambridge University Press, Cambridge.

Castle, Pete (2010) *Derbyshire Folk Tales*. The History Press, Stroud.

Clarke, David (1991) *Ghosts and Legends of the Peak District*. Jarrold Publishing, Norwich.

Clarke, David (2001) *Supernatural Peak District*. Robert Hale, London.

Clarke, David and Roberts, Andy (1996) *Twilight of the Celtic Gods: Exploration of Britain's Hidden Pagan Traditions*. Blandford Press, London.

Daniel, Clarence (1973) *Ghosts of Derbyshire*. Dalesman Publishing Co., Clapham.

Daniel, Clarence (1975) *Derbyshire Traditions*. Dalesman Publishing Co., Clapham.

Daniel, Clarence (1985) *The Story of the Eyam Plague with a Guide to the Village*. 3rd edition. Private Publication, Eyam.

Devereux, Paul (1982) *Earth Lights*. Turnstone Press, Winnipeg.

Eisenberg, Elizabeth (1992) *Tales of Old Derbyshire*. Countryside Books, Newbury.

Eisenberg, Elizabeth (1992) *From the Cradle to the Grave*. J. H. Hall & Sons, Derby.

Gibson, Alan (2002) *Staffordshire Legends*. Churnet Valley Books, Leek.

Goss, Michael (1985) *The Evidence for Phantom Hitch-Hikers*. Sterling Publishing Company, London.

Green, Miranda (1986) *The Gods of the Celts*. Sutton Publishing, Stroud.

Green, Miranda (1996) *Celtic Goddesses: Warriors, Virgins, and Mothers*. George Braziller, New York.

Greene, Rosalind (2000) *The Magic of Shapeshifting*. Weiser, York Beach, ME.

Hanmer, Jack and Winterbottom, Dennis (1991) *The Book of Glossop*. Barracuda Books, Buckingham.

Henderson, Mark P. (2010) *Murders in the Winnats Pass*. Amberley Publishing, Stroud.

Holland, G. Calvert (ed.) (1858) *The Poetical Works of the Late Richard Furness*. Partridge & Co., London.

Hutchinson, John (1809) *Hutchinson's Tour through the High Peak of Derbyshire*. J. Wilson, Macclesfield.

Jacobs, Joseph (1890) *English Fairy Tales*. David Nutt, London. http://www.authorama.com/english-fairy-tales-44.html, accessed 16 May 2011.

Jewitt, Llewellyn F. W. (1867) *Ballads and Songs of Derbyshire*. Bemrose & Lothian, London.

Litchfield, Richard M. (1992) *Strange Tales of the Peak*. Derbyshire Heritage Series. J. H. Hall & Sons, Derby.

Merrill, John N. (1975) *Legends of Derbyshire*. 2nd edition. Dalesman Publishing Co., Clapham.

Merrill, John N. (1988) *Derbyshire Folklore*. JNM, Winster.

Middleton, Thomas (1906) *Legends of Longdendale*. Clarendon Press, Manchester.

Moorman, John R. H. (2010) *Church Life in England in the Thirteenth Century*. Cambridge Library Collection, Cambridge.

Morgan, Ian (2009) *True Tales of the Macabre*. Breedon Books, Derby.

Murray's Handbook for Travellers in Derbyshire, Nottinghamshire, Leicestershire and Staffordshire (1868). John Murray, London.

Naylor, Peter J. (1983) *Celtic Derbyshire*. Derbyshire Heritage Series. J. H. Hall & Sons, Derby.

Oesterley, Herman (1866) (ed.) *Shakespeare's Jest Book: A Hundred Mery Talys*. John Russell Smith, London, pp. 31–37. http://www.archive.org/stream/shakespearesjestoooestuoft#page/34/mode/2up, accessed 16 May 2011.

Pickford, Doug (1992) *Myths and Legends of East Cheshire and the Moorlands*. Sigma Leisure, Wilmslow.

Poole, Charles H. (1875) *The Customs, Superstitions and Folklore of the County of Stafford*. Romney, Newmarket.

Porteous, Crighton (1949) *The Beauty and Mystery of Well-Dressing*. Pilgrim Press, Derby.

Porteous, Crighton (1976) *The Ancient Customs of Derbyshire*. Derbyshire Countryside Ltd, Derby.

Rippon, Anton (1982) *Folktales and Legends of Derbyshire*. Minimax, Peterborough.

Sharpe, Neville T. (2002) *Crosses of the Peak District*. Landmark Publishing, Ashbourne.

Smith, Roland (2004) *Murder and Mystery in the Peak*. Halsgrove, Tiverton.

Swift, Eric (1954) *Folktales of the East Midlands*. Thomas Nelson and Sons, London.

Turbutt, Gladwyn (2006) *Superstition and Religion in Derbyshire History*. Merton, Chesterfield.

Westwood, Jennifer and Simpson, Jacqueline (2005) *The Lore of the Land*. Penguin, London.

Wood, William (1862) *Tales and Traditions of the High Peak*. Bell & Daldy, London.